Donated to

**Visual Art Degree
Sherkin Island**

VAN DYCK

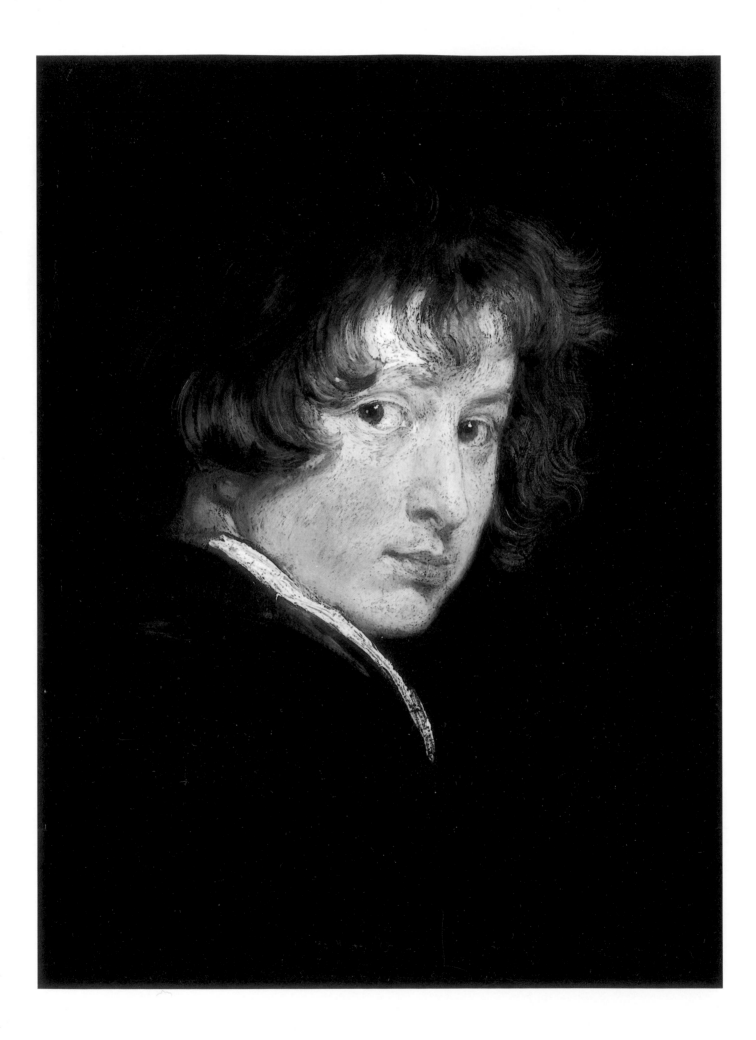

ANTHONY
VAN DYCK

ALFRED MOIR

THAMES AND HUDSON

DEDICATION: To Barbara Moir Condos

Project Director: Margaret L. Kaplan
Editor: Lory Frankel
Designer: Ellen Nygaard Ford
Photo Research: Catherine Ruello

Frontispiece:
1. Self-Portrait. 1614–15.
Oil on panel, 10½ × 7⅝" (25.8 × 19.4 cm.).
Gemäldegalerie der Akademie der bildenden
Künste in Wein, Vienna

First published in Great Britain in 1994
by Thames and Hudson Ltd, London

Text copyright © 1994 Alfred Moir
Illustrations copyright © 1994 Harry N. Abrams, Inc.

British Library Cataloguing-in-Publication Data

A catalogue record for this book is available from the British Library

ISBN 0–500–08059–3

Printed and bound in Japan

ACKNOWLEDGMENTS

When, in the early months of 1989, I first conceived of this
book, I decided to focus on those of Van Dyck's paintings that
are regularly accessible to the public in the museums and gal-
leries in Western Europe and the Eastern United States. With a
few exceptions, I have been able to adhere to this resolution. So
I am greatly in debt to the museum authorities who have been
responsible in recent years for the conservation of Van Dyck's
paintings, which has restored them to their original splendor.
Most notable, of course, are the organizers of the temporary
exhibitions of his paintings in the National Gallery in Washing-
ton, D.C., and the National Gallery and the Queen's Gallery in
London, but just as important are the curators of the great
European and American museums that permanently display gal-
leries of his paintings, most of them restored to the brilliance
with which they left his studio.

Specific debts for various courtesies and assistance that can
not go unacknowledged are to Christopher Brown, Carlos Van
Hasselt, Rolf Kultzen, Francine de Nave, Wolfgang Prohaska,
Pierre Rosenberg, Renate Trnek, Arthur Wheelock, Catherine
Whistler, and Christopher White.

The Duke of Buccleuch and Queensbury received me at
Boughton House to see the *Iconography* oil sketches there.

As usual, the staffs of the Witt Photographic Library in Lon-
don, the Frick Art Reference Library in New York, and the Uni-
versity of California Art Library at Santa Barbara have been
indispensable in my preparation of the book. My greatest debts
are owed at the Witt Library to Rupert Hodge, now retired, and
to Aidan Weston-Lewis, now at the National Gallery, Edin-
burgh; and at Santa Barbara to Felipe Cervera, also now retired,
and to Erica Scranton.

Shirley Russell, Brigitte Dautzenberg, Cynthia Kuziej, and
Sharon Karleskint, under the supervision of Kristina Nash, all
members of the administrative staff of the Department of His-
tory and Art and Architecture at the University of California at
Santa Barbara, found time among their many responsibilities to
type the manuscript.

Finally, at Harry N. Abrams, Inc., Lory Frankel has been the
most thorough editor in my experience, has saved me from sev-
eral errors, has suggested a desirable addition, and has made
a great effort to coordinate the illustrations with the text.
Catherine Ruello has acquired the illustrations and colorplates
with such efficiency as to make that very difficult task seem
effortless. Joan Siebert has coped with the problems resultant
from three thousand miles and three time zones separating
author from publisher patiently, effectively, tactfully, and with
unfailing good nature. I am grateful to Ellen Nygaard Ford, the
designer, for the skill with which she has coped with and solved
the many problems of integrating the illustrations with the text.
Finally, Margaret Kaplan, who suggested that I write this, my
second book in the Masters of Art series, has given me her cus-
tomary sympathetic and helpful support.

PHOTOGRAPH CREDITS

The author and publisher wish to thank the museums, libraries,
and private collectors named in the captions for supplying the
necessary photographs. Other photograph credits are listed
below by colorplate and figure number.

© A.C.L., Brussels: figs. 9, 11; Alinari, Florence: figs: 40, 69,
colorplate 16; Artothek, Peissenberg: colorplates 11, 22, 27;
Bildarchiv Preussischer Kulturbesitz, Berlin: figs. 6, 15, 17, 19;
Bridgeman Art Library, London: colorplate 37; Bulloz, Paris:
fig. 45; English Heritage, London: colorplate 31; © Her Majesty
Queen Elizabeth II: figs. 59, 60, 61, 63, 74, colorplates 30, 39;
The National Gallery, London: colorplate 34; Oronoz, Madrid:
colorplates 2, 4, 26; Louis de Peuter, Antwerp: fig. 3; Pho-
tothèque des Musées de la ville de Paris: fig. 13; Service de la
Réunion des Musées Nationaux, Paris: figs. 8, 35, 46, 48, 54,
55, colorplates 8, 29.

CONTENTS

ANTHONY VAN DYCK *by Alfred Moir* 7

COLORPLATES

A. Van Dyck.

The seventeenth-century Italian art critic and historian Giovanni Pietro Bellori described Anthony Van Dyck's manner of living as "more like a prince's than a painter's," which may have been a little exaggerated. But unlike most painters of his time, Van Dyck was born into a prosperous family and throughout his career had the means to live the good life. Bellori, who was a decade younger than Van Dyck, surely never met him. His account of the painter's career is based on secondhand sources, primarily Van Dyck's friend and patron Sir Kenelm Digby (1603–1665), who was described during his lifetime as the most complete gentleman of the age and who was well-informed and (apparently, with a few exceptions) reliable. Exaggerated or not, Bellori's description conveys the painter's aura, the princely style that he not only discovered within his portrait sitters but also carried within himself.

Van Dyck first saw the light of day on 22 March 1599, in a large house just off the central market square in Antwerp (fig. 3a), from which his family soon moved to a house on the Korte Nieuwstraat (fig. 3b), behind the cathedral. For most citizens of Antwerp, it would have been an inauspicious moment to enter the world. Antwerp had been a rich city during the first half of the sixteenth century, one of the chief economic centers in Europe and the leading North European seaport with a flourishing international trade. It was so prosperous that it also developed into a major center for the production of luxury goods and the fine arts, supporting a host of skilled artisans and artists. The importance of art in the city can be gauged by the fact that in 1560 three hundred artists were recorded, twice the number of bakers in a population of about one hundred thousand.

Antwerp's prosperity was destroyed in the 1560s by a rebellion against its Spanish rulers, who responded with brutal and ruinous oppression. Their reaction devastated the city's commerce. It also drove many of its leading and most skilled inhabitants to flight and into exile. The rehabilitation of Antwerp took a long time, but by 1609, when a truce was established, some sort of a recovery was under way. The terms of the truce divided what had been a single country, the Netherlands, into two separate states: to the south, the Spanish Netherlands or Flanders (modern-day Belgium), still ruled by Spain and Roman Catholic, with a much reduced Antwerp as its commercial and artistic center; and to the north, the autonomous, Protestant, United Provinces (modern-day Netherlands), with Amsterdam as not only its leading city but also the heir to Antwerp's previous commercial preeminence.

An English visitor to the southern Netherlands in 1609, Sir Thomas Overbury, still found "every class of society embittered and impoverished and the cities ruinous," a report repeated in 1616 by the connoisseur and collector Sir Dudley Carleton. About 1620 yet another English traveler, James Howell, described Antwerp as "depopulated" and "impoverished." Nonetheless, Overbury admired the surviving "strong and beautiful . . . splendour" of its architecture. And Howell's description of it as "a stately, spacious place" is confirmed by the bird's-eye view (fig. 3) commemorating the triumphant entry into the city in 1635 of the Cardinal-Infante Ferdinand (see fig. 68). Already it had many of the broad streets that survive today, some fine open plazas, and numerous churches, all dominated by the tower of the cathedral (fig. 3c). Van Dyck's drawing of the city (fig. 2), made in 1632 as a study for the background of his portrait of Marie de Médicis, the refugee queen dowager of France, may seem

2. *View of Antwerp, Seen across the Scheldt River.* 1632.
Pen and brown ink, 6 × 9″ (15.2 × 22.9 cm).
Bibliothèque Royale Albert Ier., Brussels. Cabinet des Estampes

that in 1620 he was described as "very rich." Anthony was the seventh child, the second of three sons. His mother, Maria Cuypers, was noted for her skillful embroidery. She died bearing her twelfth child in 1607, six weeks after her husband's acquisition of yet another family residence, which was very grand in scale, accommodation, and decoration. Otherwise, nothing is known of Van Dyck's childhood. Probably he had more than a minimal education, as would have been appropriate to the family's economic status; some later evidence indicates that he could read Latin, the sign of an educated seventeenth-century person.

Van Dyck's history as an artist begins in October 1609, when he was registered in the painter's guild as a pupil of Hendrick van Balen (fig. 4), a member of the Old Guard of Antwerp painters who had studied with Adam van Noort, the teacher of Rubens and of Jacob Jordaens. Van Balen had visited Italy in the mid-1590s, and there he saw and responded to the work of such late Mannerists as

to exaggerate the tower's height, although it is actually three hundred feet high; he did take considerable liberty with the city's topography.

The house of Van Dyck's parents literally lay in the shadow of the tower, and there he spent his early years. His father, Frans, was, like his grandfather, a merchant with an international trade in textiles. He had survived the city's catastrophic years and prospered, enough so

3. Theodoor van Thulden. *Urbis Antverpiae Iconem*
(map of the city of Antwerp, with the Triumphal Entry of the Cardinal-Infante Ferdinand, 17 April 1635). 1635.
Engraving. Double page 172 of *Pompa Triumphalis Introitus Ferdinandi Austriaci,* Antwerp, 1642 (Hollstein 140)

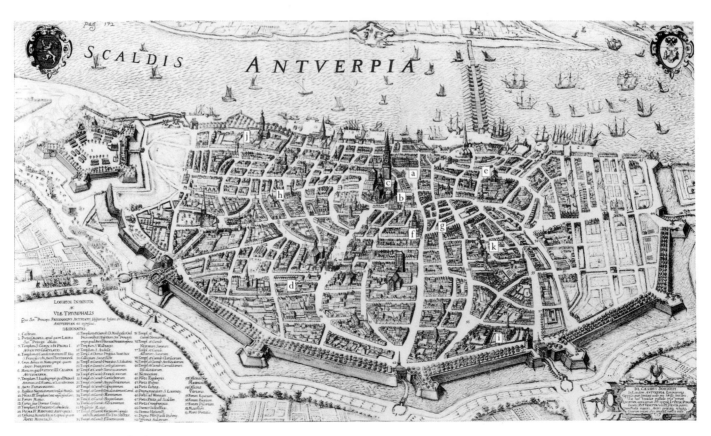

a. Grote Markt b. Korte Nieuwstraat c. The Cathedral of Our Lady d. The house, gallery, and studio of Peter Paul Rubens
e. Dominican Church of Saint Paul f. Jesuit Church (now Saint Charles Borromeo) g. Lange Minderbroederstraat (Van Dyck's house and studio)
h. Augustinian Church i. Church of the Beguinage j. Confraternity of the Bachelors (Saint Michael's Church)
k. Church of the Recollets (Church of Saint Francis)

4. *Portrait of Hendrick van Balen (1575–1632).* 1627–32.
Black chalk, 9⁹⁄₁₆ × 7¹³⁄₁₆″ (24.3 × 19.9 cm).
The J. Paul Getty Museum, Malibu, California

the peripatetic Cavaliere d'Arpino and to painting in Venice, but more to the German Hans Rottenhammer than to the native Venetians. Although he was only two years older than Rubens, van Balen remained relatively conservative, a late Mannerist painter of cheerful, small-scale classical mythological figures in landscapes. He was highly successful—he lived in a luxurious house, with a fine collection of works of art, medals, and rare books, and had twenty-six students registered in the guild under his tutelage.

His success was by no means unique among Antwerp painters. Many of them had, like Frans Van Dyck, surmounted the city's troubles handily, enjoying the prosperity provided by a large clientele that was not simply local or regional but in some instances international. Pieter Brueghel's two sons, Pieter the Younger and Jan, and other masters, like Jan de Wael (see fig. 56), shared in this success. In fact, if in 1616 Sir Dudley Carleton had been saddened by the "solitariness and depopulation" of Antwerp, he should have been cheered by the recovery of art in the city: in that year, no fewer than 216 master painters were enrolled in the guild, one for every 250 in the reduced total population of sixty thousand. And Sir Dudley surely enjoyed his contact with Rubens's wealth and culture.

Rubens's return from Italy in 1608, just before the truce (and, incidentally, just before Van Dyck's admission into van Balen's studio), marked the beginning of the climax of painting in Antwerp. The splendor of the palatial residence he established in the city (see fig. 3d and plate 10), which housed not only his family but also his studio,

his great collection of all manner of works of art, and his spacious gardens, was literally worthy of a prince, as was his income. They were rivaled eventually by Jacob Jordaens (see fig. 7), who, outliving Rubens by almost forty years, succeeded to his international position and clientele. Other members of Rubens's circle, notably Frans Snyders (see fig. 22), were scarcely less successful.

The young Anthony Van Dyck thus began his training in a promising profession at a propitious time. As a member of the city's burgher class, from the onset of his career he would have felt at home in the comfort of its artistic elite. His earliest known self-portrait (fig. 1: frontispiece) is striking, the first of many throughout his career with which he examined and recorded the processes of his physical and psychological evolution. It is a mirror image of his face, framed by stylishly unruly locks of hair, as he looks over his left shoulder. His apparent age of fifteen or sixteen would reasonably place the painting in the years 1614–15, giving convincing evidence of his remarkable precocity. Modest in scale and with few details of costume or setting, it shows a very young, self-aware man who is serious and a little imperious, as if conscious of his genius and of a great destiny and impatient to get on with it. It is his least idealized self-portrait, but despite its spontaneity and informality, it already shows a certain romantic elegance in the characterization.

It is not Van Dyck's first known painting, a distinction that belongs instead to the bust-length *Portrait of an Old Man* (fig. 5), which is signed and dated across the top "AETATIS • SUE 70 • ANNO • 1613 • AVD • F • AETA •

5. *Portrait of an Old Man.* 1613.
Oil on canvas, 23 × 17⅜″ (58.4 × 44.1 cm).
Musées Royaux des Beaux-Arts de Belgique, Brussels

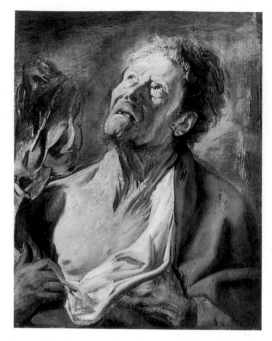

6. *Portrait of the Usher Abraham Grapheus as an Apostle.*
1621? Oil on panel, 25½ × 20″ (64.8 × 50.8 cm).
Gemäldegalerie Staatliche Museen Preussischer
Kulturbesitz, Berlin

7. Jacob Jordaens. *Portrait of the Usher Abraham Grapheus
(died 1624) as Job.* 1621. Oil on oak panel,
26⅜ × 20½″ (67 × 52.1 cm). The Detroit Institute of Arts.
Gift of Frederic A. Gimbel and Dr. Armand Hammer

SUE 14." The inclusion of the artist's age as well as the sitter's seems to be an assertion of the former's prodigy. Working with a palette limited to flesh tones and shades of black and white, Van Dyck was already a skillful technician, both in his handling of the rather heavy impasto and in his convincing treatment of the anatomy. But it is a conventional portrait in the North European tradition of detached, coolly observed, rather severe objective likenesses.

Apparently Van Dyck did not, or could not, immediately follow up on the promise of these two paintings and a third, of another old man seated and three-quarter length (in the Musée de l'Art Ancien, Brussels), which must be nearly contemporary. Not until 1618, when he signed and dated a few other portraits, also traditional in format, is he known to have produced any more. During the intervening years, he was probably subject to professional restraint, because only after his admission as a master to the painters' guild of Saint Luke (recorded 11 February 1618) would he have been permitted to accept commissions openly as an independent artist. Between 1613 and 1618, however, he may have made some, or many, of the studies of anonymous models—either the heads only or the busts—that survive both in the original and in copies, similar to the studies that both he and Jordaens made some years later, when they were working in Rubens's studio (figs. 6 and 7). The model for these two studies was Abraham Grapheus, a member and minor functionary of the Saint Luke's Guild as early as 1572, who died in 1624. The two paintings are so similar as to sug-

gest that they were made at the same sitting, sometime in 1620 or 1621. Van Dyck and Jordaens may have sat down together, with Grapheus, to carry out these quick portrait sketches. Like Rubens and Jordaens, Van Dyck probably kept sketches of this sort at hand for use, in lieu of living models, in full-scale paintings, either immediately or in the future (see plates 3 and 4). These living men and women would be transformed into historic or mythological figures by the simple device of adding an appropriate attribute; for instance, in another painting, Van Dyck gave Grapheus some keys, turning him into Saint Peter.

How long Van Dyck stayed with van Balen is not known. A term of apprenticeship of at least five years would have been normal and a seven-year term unexceptional, which would have kept him in the studio until 1615 or 1616. The question is complicated by a lack of reliable documentation. Some documentation was believed to exist in the testimony from a court hearing of 1660–62, which implied that Van Dyck had already set himself up independently by 1615–16, but the hypothesis is now generally discredited. The only other documentation from the years between the beginning of Van Dyck's apprenticeship in 1609 and his registration in the guild in 1618 is the record of some legal proceedings involving family matters that are not relevant to his professional activity.

Nothing in Van Dyck's surviving oeuvre can be described as immature juvenilia, but a few paintings were probably executed before his official acceptance as a master. *The Lamentation* at the Ashmolean Museum, Oxford (see plate 1), still somewhat reminiscent of van Balen's

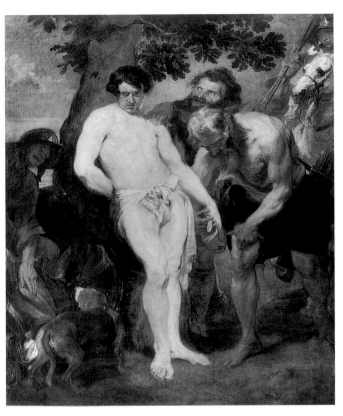

8. *Martyrdom of Saint Sebastian.* 1615–16.
Oil on canvas, 56¾ × 46″(144.2 × 116.8 cm).
Musée du Louvre, Paris

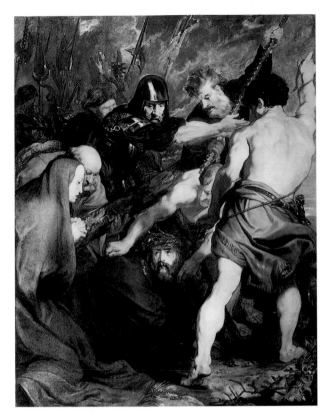

9. *Christ Bearing the Cross.* 1617.
Oil on panel, 83⅛ × 63⅝″ (211.1 × 161.6 cm).
Sint Pauluskerk, Antwerp

Mannerism, may be one, the first *Martyrdom of Saint Sebastian* in the Louvre (fig. 8) another. The latter subject is one to which he returned again and again during his career, his different treatments of it giving us insight, like that provided by his self-portraits, into his evolving personality. They also demonstrate his inventiveness: in no more than twenty years, he created at least six quite different conceptions of the saint's martyrdom, some repeated more than once in similar paintings (see figs. 32, 33, and 46). Whether or not the representations of the saint are narcissistic, as has often been suggested, each different composition seems very personal, as if the artist were somehow haunted by the idea of the beautiful, defenseless, youthful victim.

In this first version, the saint is at the mercy of the dark, hostile executioners who surround him. Perhaps to emphasize this contrast, Van Dyck chose to show the preparation of Sebastian as he is bound to the tree rather than the actual moment of martyrdom. His Sebastian is a big youth, tall, muscular but plump, a little clumsy, and surprisingly languorous. The characterization is remarkably human: he does not face death heroically, triumphant in his faith, but rather passively, resigned, his face apprehensive, dark, and almost sullen. If his somewhat serpentine pose is faintly reminiscent of van Balen's Mannerism, Van Dyck has relegated his teacher and his studio to history with the brilliant color and the very painterly han-

dling. The picture was painted as summarily as an oil sketch. Although the rich surface and the spontaneity of handling have little in common with the smooth, glazed surfaces of Rubens's paintings of the 1610s, the specific influence of the latter can nonetheless be recognized in the satyrlike man binding Sebastian's left wrist, who reappears as Van Dyck's own Silenus (see plate 7) a few years later.

Just when Van Dyck began his close association with Rubens is uncertain. As the older master was privileged with exemption from having to register his apprentices with the guild, there is no document before 1620 specifying any formal relation between the two artists. Probably they were in close contact by 1617, the date appearing on the (later) frame of Rubens's painting of *The Flagellation of Christ* in the Dominican Church of Saint Paul in Antwerp (see fig. 3e). The Rubens was one of fifteen pictures of the Mysteries of the Rosary in the church, the rest carried out by his leading contemporaries in the city, including one by van Balen and the panel of *Christ Bearing the Cross* by Van Dyck mentioned by Bellori (fig. 9). Surprisingly, van Balen was paid the most: 216 florins; Rubens and Van Dyck were paid the same: 150 florins each. Clearly, the fact of the commission itself, together with a payment equal to that of Rubens constitute recognition and acceptance of the young Van Dyck as mature, the peer of his elders.

11

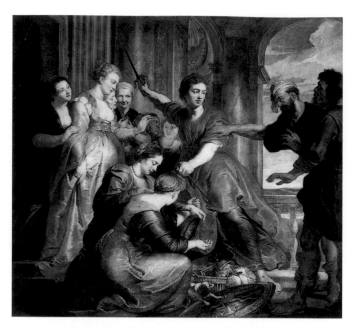

10. Anthony Van Dyck and Peter Paul Rubens.
Achilles and the Daughters of Lycomedes. 1618.
Oil on canvas, 96⅞ × 105⅛″ (246.1 × 267 cm).
Museo del Prado, Madrid

Van Dyck prepared his composition painstakingly, as was his custom. Ten preparatory drawings survive. Only in the painting itself, by adjusting relations among the figures and between them and the format, did Van Dyck finally achieve the tight, dense composition, focused on Christ's haunting face below his executioners, who bear down on him oppressively and humiliatingly. Throughout his career Van Dyck confirmed the steadfast conviction of his Roman Catholic faith. In later years, when he visited The Hague, he even smuggled in over a hundred copies of Roman Catholic books for his coreligionists in the Protestant north. In his youthful religious paintings, he identified himself with the Christian sufferers: with the young Saint Sebastian's natural uncertainty, the discomfort and degradation of Christ bearing the cross, and the helpless grief of his family and friends mournfully carrying his body to its tomb (see fig. 12).

The shallow space in the *Christ Bearing the Cross* and *The Lamentation* (see plate 1), the figures so crowded as to form a kind of relief, is similar to that in the compositions Rubens was producing contemporaneously, although more compact. Evidently, Van Dyck was not only taking specific details from Rubens but also learning his principles of constructing paintings. Although Bellori garbled the chronology somewhat, his statement that Van Dyck entered Rubens's studio and began to collaborate with him when very young lends support to the supposition that Van Dyck had actually become a member of the studio by 1617, if not earlier. Antwerp was small enough a city so that Rubens must have become aware of Van Dyck's prodigious talent well before then. It is also likely that Rubens, with an eye to the future, would have wanted to bring the prodigy at least into his circle and probably into his studio as soon as possible.

As is well known, Rubens followed a centuries-old tradition of operating his studio for the training of young artists as well as for the correlated activity of producing works of art. The system culminated in Rubens's studio, which employed numerous anonymous apprentices as well as a distinguished group of collaborators: Jan Brueghel, Snyders, and Jordaens, to mention only the best known. All were involved in a kind of production line. Brueghel and Snyders painted the flowers and animals, others the landscapes, and Jordaens the figures—all with such skill in emulating Rubens that differentiating among their contributions remains sometimes difficult.

Probably Van Dyck started his career in Rubens's studio more modestly, but in 1616–18, according to Bellori, he participated in painting the series of eight tapestry cartoons representing the history of the ancient Roman hero Decius Mus, based on Rubens's oil sketches. By 18 April 1618 he was confirmed as a full-fledged collaborator with Rubens. In a famous letter to Sir Dudley Carleton, Rubens listed twenty-three paintings he proposed to exchange with the English collector, pricing each and differentiating among those by his own hand, those by members of his studio (including Snyders, who was identified by name), and some collaborative works. One of the collaborative works he described as "a picture of an Achilles clothed as a woman, done by my best assistant [*discepolo*], and the whole retouched by my hand; a most delightful picture, and full of many very beautiful young girls." The painting is the *Achilles and the Daughters of Lycomedes,* in the Prado (where it is attributed to Rubens and Van Dyck; fig. 10), and the "best assistant" was Van Dyck. Sir Dudley refused to accept in trade any pictures that were not entirely by Rubens's own hand. So Rubens kept the *Achilles* until 1628, when he took it with him to Spain and sold it to King Philip IV.

The painting is a convincing authorized production of Rubens's studio, with only a few hints of Van Dyck's participation apparent, notably in the two men on the far right—Ulysses, come to lure Achilles into the Trojan War, and Lycomedes—who will reappear in Van Dyck's *Moses and the Brazen Serpent* (see plate 4). The subject itself, from ancient legendary history, is characteristic of the learned Rubens but not of Van Dyck, who was, however, in no sense unlettered—in addition to his native Dutch, he could write and speak Italian and eventually English, and quite possibly Spanish and French, and he could read Latin. But his cultivation was social, that of a courtier rather than of a scholar. He was sufficiently familiar with classical lore to make intelligent use of it throughout his career (see figs. 25, 48, 49, and 51 and plates 7 and

39), but ancient literature and history were not fundamental to his oeuvre, as they were to Rubens's.

By March 1620, Van Dyck had emerged publicly from the anonymity of the atelier, as a principal participant in the execution of the thirty-nine ceiling paintings in the Jesuit Church (now dedicated to Saint Charles Borromeo) in Antwerp (see fig. 3f). All of these paintings were destroyed by fire in 1718, so they are known only through Rubens's preparatory oil sketches and through the woodcuts made after the paintings for popular distribution. Rubens's contract with the Jesuits stated specifically that Van Dyck was to be responsible (together with other, unnamed members of the atelier) for the actual execution of the paintings. Van Dyck was also to paint an altarpiece for one of the side aisles of the church, which either was not carried out or has never been identified.

Van Dyck's favored position in Rubens's atelier is evident in a letter dated July 1620 to the earl of Arundel (see fig. 24 and plate 36) from his secretary, Francesco Vercellini. Vercellini, who was accompanying the countess of Arundel on a visit to Antwerp, reported Van Dyck to be a twenty-one-year-old working with Rubens, highly esteemed, with parents so rich and Rubens so successful that he would not be easily lured away. Vercellini used the Italian verb *stare* (to live or stay or to be) in describing Van Dyck's situation in the atelier, which probably means he was working there regularly but not living there. In fact, about that time he may have been living in a house on the Lange Minderbroederstraat (see fig. 3g), where he may have maintained a studio with two assistants of his own, although perhaps he did not set himself up there until his return from England in February 1621.

Evidently, like other senior members of the Rubens atelier, Van Dyck was also working independently. His registration in the guild had qualified him to accept commissions of his own. However, apart from portraits, surprisingly few exist. Very possibly Rubens kept him so busy that he had not the time either to solicit commissions for figure paintings or to carry them out. One of his few known independent commissions is the altarpiece of *Saint Martin Dividing His Cloak* (fig. 11), which, exceptionally, is still in its original location, the Parish Church of Saint Martin in Zaventem, a few miles to the northeast of Brussels. According to an appealing but discredited legend, Van Dyck, while passing through the town en route to Italy, fell in love with a beautiful local girl and painted the altarpiece as a pretext for staying to court her. In fact, the fief of Zaventem was elevated to a barony in 1621, and according to an eighteenth-century source, the new baron, Ferdinand van Boisschot, commissioned the altarpiece for three hundred florins to commemorate the event. Although the altarpiece has been placed in Van Dyck's oeuvre as early as 1618, this account rings true. Van Dyck is known to have been in contact with the

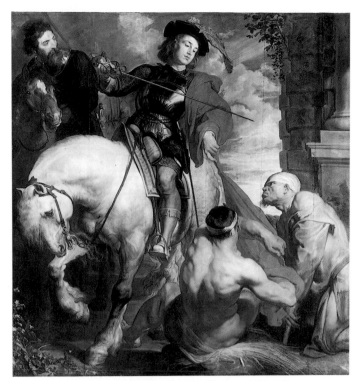

11. *Saint Martin Dividing His Cloak.* c. 1618–20.
Oil on oak panel, 67 × 61¼″ (170.2 × 156.9 cm).
Parish Church of Saint Martin, Zaventem, Belgium

baron, whose portrait he painted, after his return from Italy. Possibly in 1621 Van Dyck provided the new baron with the picture that he had painted two or three years earlier.

Clearly, the *Saint Martin Dividing His Cloak* was carried out while Van Dyck was still under Rubens's influence. The composition is a reedited version of a Rubens panel painting. The varied, clear colors of *The Lamentation* were retained but with the cooler, brighter tonality that differentiates Van Dyck's palette from Rubens's ruddier colors. Appropriate as Saint Martin's generous but practical gesture is to a commission by the lord of the manor for his parish church, it is also indicative of Van Dyck's developing individuality. Already he has utilized the low horizon, a device he consistently employed to place so many of his patrician models above the viewer socially as well as visually. Here, its effect is to emphasize the contrast between the fine-featured young saint on his elegant, spirited horse and the brutish beggars. The theme, Christian charity, becomes in Van Dyck's hands also a beautiful, decorative example of noblesse oblige.

The lack of specific documentation for the altarpiece may offer support to the suggestion that Van Dyck painted it on speculation, hoping to find a patron for it, as he eventually did. Perhaps the drawing for the Caravaggesque *Entombment* (fig. 12), of which no painted composition is known, was also made in the hope of a commission, which either did not materialize or went to some other painter.

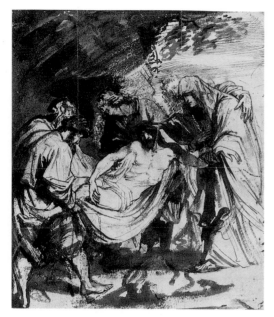

12. *The Entombment.* c. 1617–18. Recto. Red chalk,
pen and brown ink, brown and reddish wash, heightened
with white gouache, 10 × 8⅝″ (25.4 × 22 cm).
The J. Paul Getty Museum, Malibu, California

14. *Christ Seated.* Study for *The Mocking of Christ.*
c. 1618–20. Black chalk and white on tinted paper,
14½ × 10⅝″ (36.8 × 27 cm).
Ashmolean Museum, Oxford

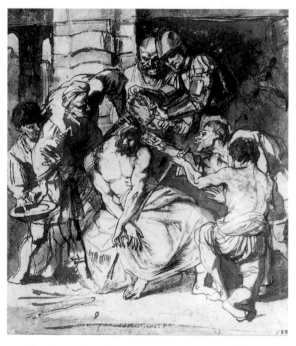

13. *The Mocking of Christ.* c. 1618–20. Pen and brown
ink, brown and gray wash, and black chalk,
8¾ × 7⅝″ (22.2 × 19.4 cm). Musée du Petit Palais, Paris

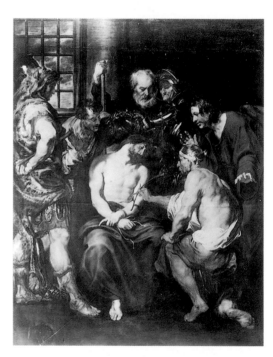

15. *The Mocking of Christ.* c. 1618–20.
Oil on canvas, 103 × 84¼″ (262 × 214 cm).
Destroyed, formerly Kaiser Friedrich Museum, Berlin

Van Dyck's exclusively Roman Catholic clientele
would require repeated images of the Lamentation and
the Crucifixion, as well as of such popular saints (after
whom so many men were named) as Jerome, Martin, and
Sebastian. Van Dyck painted all of these subjects during
these years, as well as the Mocking and the Betrayal of
Christ, each more than once and most on the scale of an
altarpiece—but there exists no recorded commission for
a single one of them. He took each composition through
preparatory drawings and through several painted ver-
sions. There are six or seven drawings for *The Mocking of
Christ,* for instance, both compositional studies (fig. 13)
and studies for individual figures (fig. 14). And there were
at least two autograph painted versions (fig. 15, which was
destroyed in World War II, and plate 2).

The drawings show Van Dyck's transformation of the
theme from the traditional northern European burlesque
of near-caricatural tormentors to the restoration of dig-

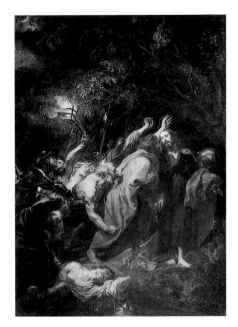

16. *The Betrayal of Christ.* c. 1618–20.
Oil on canvas, 135⅜ × 98″ (343.9 × 248.9 cm).
Museo del Prado, Madrid

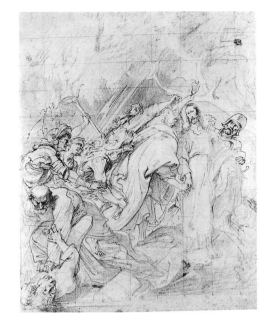

18. *The Betrayal of Christ.* c. 1618–21. Pen and brown
ink over black chalk with touches of red chalk,
squared in red chalk, 21 × 15⅞″ (53.3 × 40.3 cm).
Hamburger Kunsthalle Kupferstichkabinett, Hamburg

nity to the Christ whom he had originally conceived as squirming and contorted. The drawings also reveal the subtle rearrangement of the figures around Christ in the first painted version (fig. 15) to form a slightly more compact and unified group in the second (plate 2).

The seven surviving preparatory drawings for *The Betrayal* or *The Taking of Christ* (fig. 16 and plate 5) allow us to watch Van Dyck work out the choreography of the event. He must have had the subject in mind for some time, because the first drawing (fig. 17), a very summary sketch, dates from as early as 1617. Horizontal rather than nearly square, it shows Christ being led away afterward rather than the actual betrayal. A later compositional study, a flurry of pen and ink lines (fig. 19), is still hori-

zontal but does away with the movement across the sheet by placing Christ on the right and disposing the other figures around him, as if Judas's kiss had already identified him and he had been bound. Obviously, here Van Dyck was considering primarily grouping and actions, although Christ's face and two others are detailed enough to indicate concern about more precise characterization than that conveyed by body language alone.

Finally (after at least two other compositional studies), he settled on the definitive composition, the largest drawing (fig. 18), which is squared off for transfer to canvas. Even then the process continued; there are enough differences in detail between the version in Minneapolis (plate 5) and what was probably the culmination of the

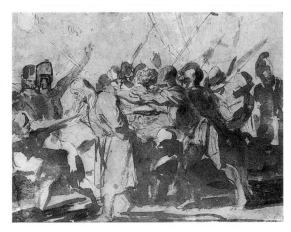

17. *The Taking of Christ.* c. 1617–18. Pen and brown ink
and wash, 6¹¹⁄₁₆ × 8¾″ (17 × 22.1 cm).
Staatliche Museen Preussischer
Kulturbesitz, Kupferstichkabinett, Berlin

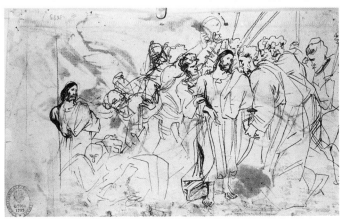

19. *The Betrayal of Christ.* c. 1618–20. Recto.
Pen and brown ink, 6⁵⁄₁₆ × 9⁷⁄₁₆″ (16.1 × 24.3 cm).
Staatliche Museen Preussischer
Kulturbesitz, Kupferstichkabinett, Berlin

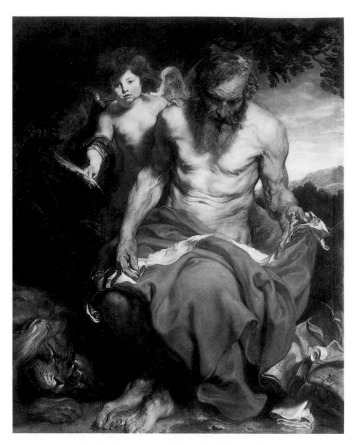

20. *Saint Jerome.* c. 1618–20. Oil on panel,
65 × 51⅛″ (165.1 × 129.9 cm). Museum Boymans-van
Beuningen, Rotterdam. Willem van der Vorm Foundation

series, in the Prado (fig. 16), to prove that he further modified his concept of the subject even with brush in hand. The Prado version belonged to Rubens, perhaps presented to him by Van Dyck before he went to Italy. The French historian of art André Félibien reported that it was displayed over the fireplace in the most magnificent room in Rubens's house. After Rubens's death, it was acquired by Philip IV of Spain for 1,200 florins.

None of these paintings, nor the *Moses and the Brazen Serpent* (see plate 4), nor the at least five different versions of *Saint Jerome* (fig. 20), is dated or documented. Thus, a reconstruction of the chronology of Van Dyck's development during these crucial years can be based only on stylistic analysis of his paintings, and it is necessarily speculative and hypothetical. There is no agreement among scholars—one, for example, would place the *Saint Jerome* in Rotterdam as the second in the series, as early as 1616–17, while another sees it as the last. It is a little reminiscent of Caravaggio's first *Inspiration of Saint Matthew* of 1601–2 in Rome, which the young Van Dyck could only have known through a drawn copy brought back by some traveler. As in Caravaggio's painting, the saint and the boy angel face the viewer and create a recessive space, with the effect of breaking down the barrier separating them from the viewer. As he matured, Van Dyck seems to have

been deliberately destroying this barrier by composing his works on three-dimensional diagonals: both Saint Martin (see fig. 11) and Silenus (see plate 7) move out toward the viewer; Saint Peter and Malchus push Christ and his captors into depth (see fig. 16 and plate 5); the opposing groups in *Moses and the Brazen Serpent* form two walls on either side of a compelling tunnel of empty space into the distance; and even Susanna Fourment and Isabella Brant (see plates 9 and 10) face the viewer at an angle. Perhaps Van Dyck added the ancient fragments in the foreground of the *Continence of Scipio* (see fig. 25) in order to relieve, however ineptly, the friezelike effect of the principal figures. Van Dyck's opening of pictorial space seems to have been accompanied by an increasingly rich *fattura*: starting with the limited impasto details in *The Lamentation,* he increasingly built up the surface, making it rough and loose in *The Drunken Silenus, The Betrayal of Christ* in Minneapolis, *The Expulsion from Eden* (see plate 6), and much of the Fourment and Brant portraits, and finally achieved the dense pigment of Cornelis van der Geest's face and ruff (fig. 21).

In Van Dyck's portraiture, another change can be observed. He began to elaborate the traditionally austere and objective images of his early manner (see figs. 1 and 5), which he had continued in the expanded three-quarter-length paintings of about 1618: first with a coat of arms or a chair; next with a rather tentative architectural setting (see plate 27); then with the fictitious palace background of the portraits of Frans Snyders and his wife Margareta de Vos (figs. 22 and 23); and finally with the colorful appearance of Susanna Fourment full-length and

21. *Portrait of Cornelis van der Geest (1577–1638).* 1620.
Oil on panel, 14¾ × 12¾″ (37.5 × 32.4 cm).
The National Gallery, London

22. *Portrait of Frans Snyders (1579–1657)*. c. 1620–21.
Oil on canvas, 56⅛ × 41½″ (142.6 × 105.4 cm).
The Frick Collection, New York

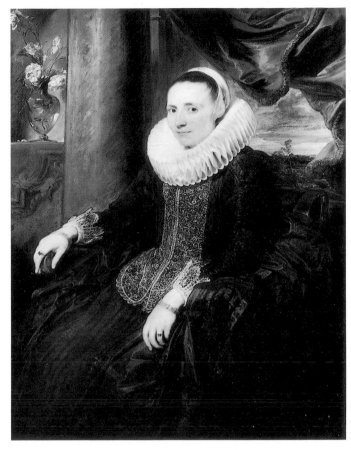

23. *Portrait of Margareta de Vos, Snyders' Wife*. 1620–21.
Oil on canvas, 51½ × 39⅛″ (130.8 × 99.4 cm).
The Frick Collection, New York

of Isabella Brant in front of her own real palace. The head
of the merchant and connoisseur Cornelis van der Geest
proves that Van Dyck had not lost his ability to reveal per-
sonality without props or pretension. But during these
years, he also laid the foundation from which the Grand
Manner portraiture of his maturity would develop.

Vercellini's prediction that Van Dyck could not be lured
away from Antwerp proved wrong. Some time in October
1620, he was reported as newly arrived in London, spon-
sored by Lord Purbeck, the brother of the royal favorite,
the marquess (soon to be duke) of Buckingham (1592–
1628). He found a welcome at court; James I soon award-
ed him an annual pension of one hundred pounds and
another one hundred pounds for unspecified special ser-
vices. But he stayed less than five months, and his only
known commissions were from Buckingham and Lord
Arundel. Vercellini's letter makes clear that by 1620
Arundel was already familiar with Van Dyck and his
work. So it is unsurprising that Van Dyck painted his por-
trait (fig. 24), the earliest of several of Arundel and of
members of his family (see plate 36). Somber in color and
in characterization, the composition is simple, a straight-
forward likeness elaborated only by a background of a
swatch of drapery and a patch of landscape. Lord Arundel

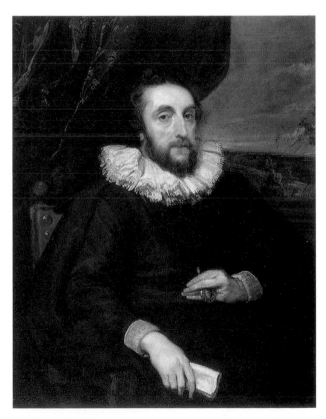

24. *Portrait of Thomas Howard (1585–1646), Second Earl of Arundel*.
1620–21. Oil on canvas, 40½ × 31¼″ (102.9 × 79.4 cm).
The J. Paul Getty Museum, Malibu, California

17

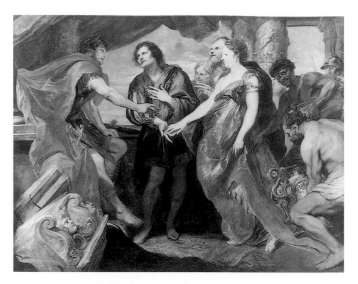

25. *The Continence of Scipio.* 1620–21.
Oil on canvas, 72 × 91½″ (182.9 × 232.4 cm).
The Governing Body, Christ Church, Oxford

holds the badge of the Order of the Garter, which he had been awarded in 1611. Otherwise, the portrait is modest, smaller in scale, less grand in its setting, and less pretentious than the Snyders' portraits, which must have been painted in Antwerp at about the same time.

Not to be outdone, Buckingham, whom Arundel despised as an upstart, was responsible for the two other paintings that Van Dyck is known to have done during this visit. One, recently discovered, is as strange and unprecedented as the Arundel painting is unexceptional. It is a full-length, life-size double portrait of Buckingham and his bride of a few months, strolling nude through a land-

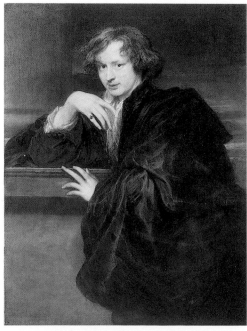

26. *Self-Portrait.* 1620–21. Oil on canvas,
47⅛ × 34⅝″ (119.7 × 88 cm).
The Metropolitan Museum of Art, New York.
The Jules Bache Collection, 1949

scape. Their modesty is preserved visually by means of a few pieces of colorful drapery and allegorically by their presentation as Venus and Adonis. The other Buckingham painting, *The Continence of Scipio* (fig. 25), is less unexpected. The subject, the ancient Roman general Scipio Africanus restoring a captive Carthaginian maiden to her fiancé, was often used to symbolize generosity; an elephant on the rug underfoot symbolizes temperance. Probably the theme was chosen as a compliment to James I, in appreciation of his approval of the marriage. In fact, after his death and Buckingham's, Charles I acted as the protector of the duchess and her children, and the painting was prominently displayed in the great hall of York House, the family's London residence.

Strangely enough, the second-century Syrian relief (now in the London Museum) in the left foreground formed part of Arundel's vast collection of ancient sculpture, probably acquired from Buckingham's estate after his death. The relief, which fits uneasily into the composition, may have been an afterthought; it is not included in a preparatory drawing for the painting (in the Louvre). The composition of *The Continence of Scipio* is based on a Rubens painting, and the nude man kneeling in the right foreground is certainly Rubensian. But the slender, undulating, insubstantial principal figures are just as certainly not, nor are the zigzag rhythms of arms and drapery contours across the canvas, nor the dry, cool colors.

This English interlude ended soon after 28 February 1621, when Van Dyck received permission, signed by Lord Arundel, to absent himself from England for eight months. He returned to Antwerp, but in October, instead of returning to England, he set off for Italy. What he did in Antwerp during the intervening eight months is not known. Perhaps he reestablished himself in Rubens's studio. More likely, having discovered in England that he could fly very well on his own, he took it as an opportunity to take wing gracefully from Rubens's nest and to soar independently. Before his departure he must have carried out some paintings. The most likely is the portrait of Isabella Brant (see plate 10), not only because of the report that it was his farewell present to Rubens but also because it is the most mature of his pre-Italian portraits. Probably some of his most advanced religious paintings were also done during this interlude.

The three self-portraits that Van Dyck painted during 1620–21 are fully self-assured. Similar as a group but each slightly different, they demonstrate the transformation of his personality from an eager sixteen-year-old fledgling (see fig. 1) to an elegant sophisticate (fig. 26). He presents himself as clever but rather languorous, a patrician in a palace rather than a painter in a studio, his beautiful slender useless hands innocent of the paintbrush or any other sign of vulgar manual labor. Frans Snyders he had also portrayed as aristocratic, but in no other portrait before

27. *An Italian Landscape.* 1621–22. Italian sketchbook, folio 1. Pen and brown ink, approx. 8 × 6½″ (20.5 × 16.5 cm). British Museum, London

mountains, and massed clouds windblown in the sky—a formula Karel du Jardin was to adopt for his Italian landscapes a couple of decades later.

Van Dyck probably arrived in Genoa late in November, and he settled in for a few months with his friends the painters Cornelis and Lucas de Wael (see fig. 38), the sons of Jan de Wael (see fig. 56), natives of Antwerp, who were resident in Italy. Genoa was a rich city wedged between the Maritime Alps and the Ligurian Sea. For more than a century, it had been an important center of patronage, most notably for Van Dyck, of Rubens, who during the first years of the century had painted some key portraits there. Apart from its wealth and hospitality to foreign artists, Genoa made a convenient headquarters: once the coastal range of mountains to the north was crossed, the vast Italian plain of the river Po was open to Venice in the east and Bologna to the south; Florence, Rome, southern Italy, and Sicily were relatively easily accessible by sea. Van Dyck did not tarry long in Genoa, although he did return periodically, perhaps, as Bellori reported, to earn enough by painting portraits of the local establishment (see figs. 34, 36, and 37, and plates 12–15) to finance further travel. In February 1622, he sailed down the coast to Rome, and before he returned to Genoa in the autumn of 1623, he had spent the better part of a year there, gone to Venice, toured northern Italy in the entourage of the countess of Arundel, and visited Florence.

Those who have visited Italy, particularly in their youth, should understand how exciting these travels must have been for Van Dyck. He drew in his album as he went. Apart from the single landscape and a few studies of animals, all the drawings are of human figures. A few record remarkable costumes (fig. 28), and there are a few scenes of such local color as a Sicilian witch and some street performers. Most, however, are sketches of works of art, Van

his departure for Italy did he devise so mannered a pose or so affected, even dandified, a characterization.

Van Dyck's immediate destination in Italy was the seaport of Genoa, an independent city-state that maintained close relations with Spain. He may have taken advantage of the so-called Spanish road, traveling from Brussels through Lorraine and Franche-Comté, across the Alps to Lombardy, and then to Genoa. Probably he had not yet acquired the sketchbook in which he was to record quick studies of memorable Italian sights. Nonetheless, the first drawing in the sketchbook is a landscape (fig. 27), the only one, perhaps inspired by his astonishment at the drama of the Italian panorama. The sense of revelation to a native of the flat terrain of the Netherlands is evident in the scribbled foreground valley, distant

28. *Venetian People and Costumes.* 1622. Italian sketchbook, folios 7 verso and 8 recto (facing). Pen and ink, approx. 8 × 13″ (20.5 × 33 cm). British Museum, London

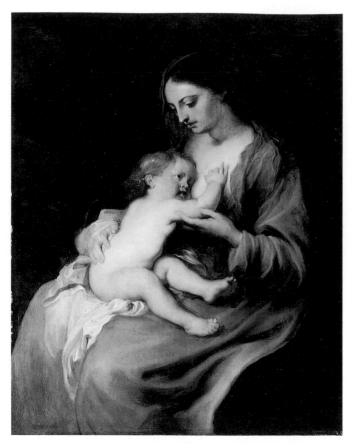

29. *Madonna and Child.* 1621–22. Oil on panel,
25⅜ × 19½″ (64.5 × 49.5 cm).
The Metropolitan Museum of Art, New York. Fletcher Fund, 1951

30. After Titian. *Madonna and Child.*
1621–22. Italian sketchbook, folio 3 verso. Pen and ink,
approx. 8 × 6½″ (20.5 × 16.5 cm). British Museum, London

Dyck's equivalent to the postcards traveling artists might collect today as reminders of what they have seen and admired. A very few are of antique sculpture or of prints. Some are after paintings by Raphael, Veronese, Giorgione, the Carracci, and comparable Italian masters, but the great majority commemorate Titian's oeuvre (see fig. 30).

If these two years of study were a revelation to Van Dyck the student-tourist, they were also productive for Van Dyck the painter. Bellori went so far as to claim that he went to Rome not to study but to advance his career, which he surely did also. Apart from a large *Crucifixion,* which has never been identified with certainty, Van Dyck received commissions for paintings of Saint Ignatius of Loyola and Saint Francis Xavier (now in the Vatican storerooms), who were both canonized in March 1622, during his second visit to Rome. The paintings are reported to have been installed in the Gesù, the Jesuits' chief Roman church, at the time of the canonizations. No doubt, some of Van Dyck's charming, intimate portrayals of the Madonna and Child (fig. 29) were painted for private patrons during these years. Evidently, they were inspired by the Titians recorded in the album (fig. 30).

There is no record of any Titian in Antwerp before Van Dyck went to England. In London, however, both

31. *Portrait of Lucas van Uffel.* c. 1621–22. Oil on canvas, 49 × 39⅝″
(124.5 × 100.7 cm). The Metropolitan Museum of Art, New York.
Bequest of Benjamin Altman, 1913

32. *Cure of Saint Sebastian*. 1622. Italian sketchbook, folio 16.
Pen and ink, approx. 8 × 6½" (20.5 × 16.5 cm).
British Museum, London

33. *Martyrdom of Saint Sebastian*. 1621–22.
Oil on canvas, 78¾ × 59¼" (200 × 150.5 cm).
Alte Pinakothek, Munich

the Arundel and Buckingham collections were rich with his works and those of his contemporaries in Venice, to which hints of reaction appear in Van Dyck's portraits and perhaps in some other paintings, notably *The Betrayal of Christ* in Minneapolis (see plate 5). Not until Van Dyck was exposed to the riches of Venetian painting in Italy, however, did he make his full response, in a cluster of works similar in style and handling that are unmistakably indebted to Titian and Tintoretto. Among them are two portraits, of the English gentleman art dealer George Gage and of the rich Flemish merchant Lucas van Uffel (fig. 31). Both sitters were in Italy, Gage in Rome during 1621–22 and 1623, and van Uffel, a friend of Cornelis de Wael, in Venice from 1616.

Both portraits are painted in dry, thick impasto of grays and browns with a few colorful accents. Composed like so many Venetian sixteenth-century portraits, the three-quarter-length figures have objects typical of the sitters' professions and interests within reach. Van Uffel holds a compass to make measurements on the celestial globe, a reference to his shipping mercantile business, as is the Oriental rug on the table; the red chalk drawing and the carved head of Bacchus or Silenus allude to his activity as an art collector. The characterization is vivid: the pose is momentary, as if van Uffel were springing up from

his chair in response to an unexpected interruption, surprised, alert, and, like so many of Van Dyck's sitters, a little wary.

Van Dyck carried his fascination with Saint Sebastian to Italy, and in his album he tried his hand at another approach to the subject, when, after the first attempt to martyr him, Saint Irene and her pious women (whom Van Dyck transformed to angels) remove the arrows from his body (fig. 32). But not until well after his return to Antwerp did he develop this theme into a painting (see fig. 46). Apparently, while in Italy he decided he had not yet exhausted the possibilities of his first conception of the subject (see fig. 8). He reformulated the theme twice, and the later of these compositions (fig. 33) belongs stylistically with the van Uffel and Gage portraits, together with the *Susanna and the Elders* (see plate 11), all manifestations of this intensely Venetian moment in his career. The neutral brownish tonality of this Saint Sebastian suggests the adoption of Tintoretto's palette, although the dog, the kneeling executioner, and the jumble of bodies crowned by the handsome Longinus on his magnificent spirited horse echo Rubens's *Elevation of the Cross* of 1610–11. The saint, whose brilliantly illuminated body glows in contrast to the dark shapes surrounding him, is graceful as a ballet dancer rather than lumbering like his predecessor

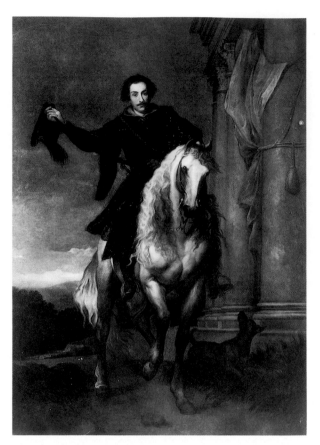

34. *Equestrian Portrait of the Marchese Anton Giulio Brignole-Sale.*
1621–22. Oil on canvas, 113⅞ × 79⅛″ (289.2 × 201 cm).
Galleria di Palazzo Rosso, Genoa

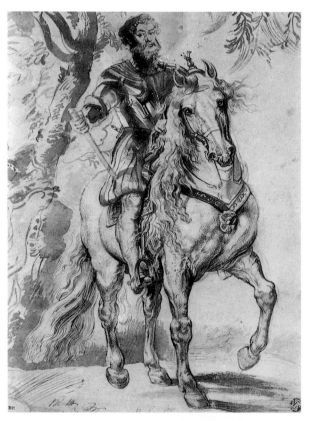

35. Peter Paul Rubens. *Equestrian Study for the Portrait of the
Duke of Lerma* (with a different head pasted on). c. 1603.
Pen and brown ink and wash over black chalk,
11¹³⁄₁₆ × 8½″ (30.1 × 21.6 cm). Musée du Louvre, Paris

in the Louvre version (fig. 8). Van Dyck may have been his own model; the face resembles his (see fig. 26) and the body corresponds to Bellori's description of him as small in stature but well-proportioned, trim, and handsome.

Bellori reports that the other Flemish painters in Rome resented Van Dyck's patrician manner and fine dress. They were a rather rough and ready lot and no doubt felt that he put on airs, with his carriage and four servants. But he managed to establish himself with the Roman aristocracy, Cardinal Bentivoglio rendering him the same service in Rome that the countess of Arundel had in north Italy. Van Dyck repaid his sponsorship splendidly with one of his greatest Grand Manner portraits (see plate 16).

Already in 1621–22, during his first period of residence in Genoa, Van Dyck had perfected the Grand Manner formula developed in the portraits of the Snyderses and comparable works in Antwerp, following a path laid out by Rubens fifteen years previously. Van Dyck's portraits of a young seated noblewoman (see plate 12) and of the equestrian Anton Giulio Brignole-Sale (fig. 34) were both inspired by Rubens compositions. In the equestrian, Van Dyck reworked the composition of Rubens's 1603 portrait of the duke of Lerma, which was then in Madrid (as it is now). It would have been known to Van Dyck through the preparatory drawing (fig. 35) and through Rubens's comparable equestrian of Ambrogio Spinola, the Genoese commander in Flanders. Brignole-Sale was a newly rich merchant, but the vast landscape, low horizon line, giant columns, huge foreshortened horse, and even the eager dog all contrive to affirm his aristocratic status, as if authenticating his commanding, literally superior position.

This portrait was the first of a series of dominating equestrians that Van Dyck was to paint, most of them of military leaders, throughout his career (see figs. 63 and 69). Another Genoese invention to reappear later—for example, in the portrait of the earl of Pembroke and his family (see plate 34)—was the Grand Manner multifigure family portrait traditionally identified as the Lomellinis (fig. 36) and as commissioned by Giovanni Francesco Lomellini, of an old and powerful Genoese patrician clan. Wearing magnificent ceremonial armor, he poses self-importantly on the left and stares patronizingly into the viewer's space. The real center of the group, seated beside him, is his wife, Paola Doria, a member of an even more distinguished Genoese family, with their two children, Agostino and Lavinia. The younger brother, Nicolo, stands slightly behind husband and wife. They are housed in a lofty palace, furnished with the red velvet drapery and Oriental rug that became canonical in portraits of this sort. Van Dyck again utilized the trick of the low horizon line to reinforce the effect of the Lomellinis' exalted position in the world. The three adults, dressed mainly in

watchful glance to the right imply family solidarity: the Lomellini united against the world. Only the tiny lapdog is not awed by the family's dignity and the solemn atmosphere.

The Genoese historians Raffaelo Soprani and Carlo Giuseppe Ratti described Van Dyck's portraits of the Genoese elite as "endowing them with a certain air . . . and revealing the soul of their nobility." Evidently, in such Grand Manner portraits as these and those of Elena Grimaldi and the noblewoman thought to be Paola Adorno (plate 15), this soul also involved a great pride of station, which Van Dyck recognized and satisfied. Children in his portraits were usually spared much of their elders' self-importance, although they did not escape it entirely (see plate 13). In his smaller, more intimate portraits, whether of the aristocracy, like the woman identified as the Marchesa Durazzo (fig. 37), or of middle-class friends like the de Wael brothers (fig. 38), he presents more of their personalities and less of their pretenses. Probably contemporary with the van Uffel painting, the portrait of the marchesa is somewhat more colorful: her dress is black, but most of the background consists of rich red drapery. Although she is unquestionably patrician, Van Dyck has characterized her sympathetically, even tenderly, as gentle, grave, and thoughtful, with what may be a prayer book in her hand. The de Waels, by contrast, might be conversing informally with the painter—or with us. The poses are casual and the brothers restless, Cornelis turning to look over the chair back and Lucas gesturing expositively. Despite its apparent simplicity, it is a subtle portrait. Lucas's pudgy cheeks and glistening, satin open-necked tunic serve as foils to Cornelis's lean

36. *Portrait of the Lomellini Family.* 1621–23.
Oil on canvas, 106 × 100″ (269.2 × 254 cm).
National Gallery of Scotland, Edinburgh

black, form a compact group, with the children, in red and gold, composing a kind of coda. The woman, who strikingly resembles Elena Grimaldi (see plate 14), is hardly less arrogant than her husband, although her hauteur is softened a little by the act of holding the little boy's hand. The brother is in civilian dress, but his hand on the hilt of his sword, his position between the couple, and his

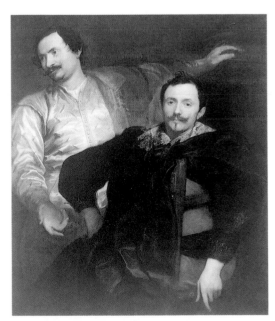

37. *Portrait of a Genoese Lady, Perhaps the Marchesa Durazzo.*
1622–23. Oil on canvas, 44⅝ × 37¾″ (113.4 × 95.9 cm).
The Metropolitan Museum of Art, New York.
Bequest of Benjamin Altman, 1913

38. *Double Portrait of the Brothers Cornelis (1592–1667),
and Lucas de Wael (1591–1662).* c. 1626.
Oil on canvas, 46¼ × 39⅜″ (118.8 × 100 cm).
Pinacoteca Capitolina, Rome

39. *Portrait of Sophonisba Anguissola with Autograph Text.*
1624. Italian sketchbook, folio 110 recto. Pen and ink,
approx. 8 × 6½″ (20.5 × 16.5 cm). British Museum, London

hands the composition is transformed. His regal Madonna floats within a volatile cloud of plump little angels, and Saint Dominic's companions, rather than sober Dominicans, are stately women moving gently in opulent satin dresses. Instead of Caravaggio's solid pyramidal composition, Van Dyck's is a gracefully flowing ellipse. Van Dyck's intimacy with Rubens's first altarpiece for the Chiesa Nuova in Rome (then in Antwerp and now in Grenoble) was no doubt responsible for much of this metamorphosis; both Flemings once again were indebted to Titian—in this instance, to his great altarpiece *The Madonna of the Pesaro Family* in the Church of the Frari, Venice—and Van Dyck at least to Veronese for the patrician ladies and the bright glossy hues.

Van Dyck incorporated into his picture specific references to the plague that broke out in the city during mid-May: the baby boy holding his nose as he flees the putrefying skull at his feet, and the two most prominent saints, Catherine of Alexandria and Rosalia of Palermo, whose intercession against the plague was sought and credited with eventually lifting it. Van Dyck himself lost little time in following the boy's example. The death of the viceroy from plague in August may have convinced

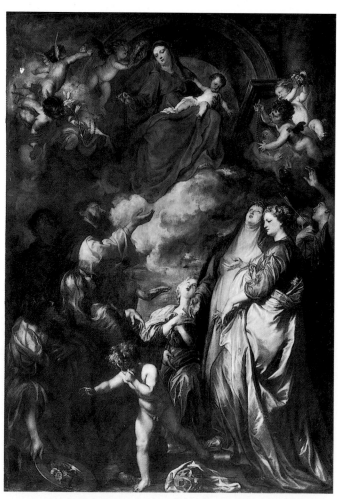

40. *Madonna of the Rosary.* 1624—28. Oil on canvas,
156¼ × 109 ½″ (396.9 × 278.1 cm). Oratorio della Campagnia
del Rosario di San Domenico, Palermo

face and formal black satin costume, but his arms frame his elder brother and their axes form a V, as if they were branches of the same tree. At ease with each other and with Van Dyck (who left Cornelis's hands unfinished), they are speaking likenesses, anticipatory of the so-called English friendship portraits (see fig. 78).

In the spring of 1624, after a few winter months in Genoa, Van Dyck went to Sicily, probably under the auspices of the Lomellini, who owned vast estates on the island. In his sketchbook, he recorded a visit in Palermo during July to a Lomellini in-law, the painter Sophonisba Anguissola, in both words and a drawing (fig. 39). She was ninety-six years old and blind, so, although her hand was still firm, she could no longer paint; she was exquisitely courteous to him and full of good advice on painting, including a demand that he place the light high so as to minimize her wrinkles. Apparently he painted her portrait (which may survive in the collection of Lord Sackville-West at Knole in Kent), and she in turn sponsored him in the city. Whether under her auspices or not, he was awarded a major commission there, his most important religious painting in Italy, the huge *Madonna of the Rosary* altarpiece (fig. 40) for the Dominican Oratorio del Rosario, where it remains today. Van Dyck must have seen Caravaggio's *Madonna of the Rosary* in Antwerp, where it had been since before 1617. The conception of the two altarpieces is similar: the Madonna and Child, enthroned above a group of saints and lesser people, hand down the rosary to Saint Dominic. But in Van Dyck's

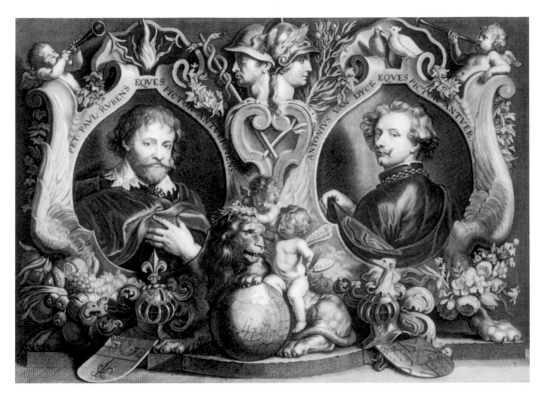

41. Paulus Pontius, after Erasmus Quellinus. *Double Portrait of Rubens and Van Dyck.*
Engraving, 13⅞ × 17⅞″ (35.2 × 45.4 cm). Collection of Municipal Printroom, Antwerp

him that it had no respect for persons, however exalted. In September he decamped to Genoa, taking the canvas with him and completing it there; just when is not known. He was paid for it only in April 1628, through an agent, although delayed payments were not uncommon. He profited from the rehabilitation of Saint Rosalia, who had been neglected for centuries, by painting several images of her (see plate 17).

At last, he settled down to stay in Genoa. Except for possibly visiting Rubens's friend Nicolas Peiresc in Aix-en-Provence briefly during July 1625, he remained there until sometime in 1627. He painted altarpieces and a few mythological or allegorical subjects (see plate 19), and some smaller religious pieces, but principally, he was occupied with portraits of the Genoese elite, improvising variations on his basic Grand Manner full-length formula. Ratti in 1780 identified no fewer than seventy-two portraits by Van Dyck in Genoese palaces. He created an image of its society—and, by extension, of all the Italian seventeenth-century aristocracy—that may have been fictional but, thanks to his tact and skill, still carries the conviction of a seductive myth.

According to Bellori, Van Dyck returned to Antwerp affluent. He was also a practiced courtier who had established himself internationally, as well as an artist unexcelled as a portraitist and rivaling Rubens in his interpretation of religious subjects. Quellinus's double portrait of the two artists (fig. 41) is emblematic, with Rubens in the place of honor on the left but with Van Dyck on the right as his peer. Because the title refers to Van Dyck as "Eques," it must postdate 1632, when he was knighted, and may be posthumous. But the number and importance of the commissions awarded Van Dyck during the years after his reappearance in Antwerp verify popular acknowledgment of his having emerged from the shadow of Rubens's reputation into the full light of his own.

Where Van Dyck lived and worked during this second period in Antwerp is a mystery. Perhaps he occupied the mansion his father had acquired in 1607; perhaps he returned to the house in the Lange Minderbroederstraat (see fig. 3g) that he had shared with Jan Brueghel the Younger before his trip to Italy; or perhaps he set himself up in an altogether new location. In any case, Van Dyck's house, like Rubens's, almost certainly combined his studio and his residence. Although on a less palatial scale than Rubens's, Van Dyck's establishment would have been grand enough to provide a suitable gallery setting for his collection of the sixteenth-century Italian paintings he so admired. It would also have been sufficiently spacious to accommodate the assistants required to help him carry out the many commissions for altarpieces and large-scale official portraits—the Crucifixions almost beyond number, for example, and the many repetitions of his portrait of the governor-general of the Spanish Netherlands, the Infanta Isabella, in the monastic habit of the Poor Clares that she adopted after the death of her husband, the Arch-

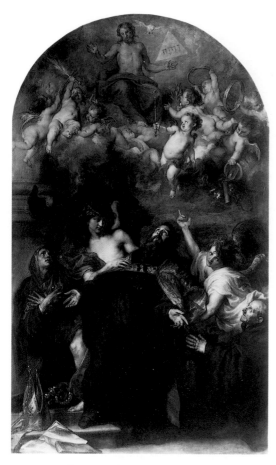

42. *Vision of Saint Augustine*. 1628.
Oil on canvas, 156 × 90″ (396.2 × 228.6 cm).
Kunsthistorische Musea, Antwerp

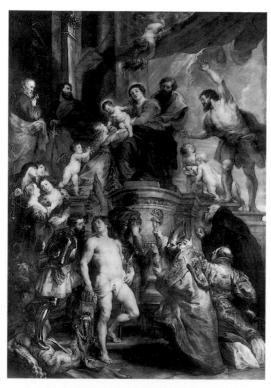

43. Peter Paul Rubens. *Madonna and Child Enthroned
with Saints (The Mystical Marriage of Saint Catherine)*.
1628. Oil on canvas, 222 × 157⅞″ (563.9 × 401 cm).
On loan from the Church of Saint Augustine to the
Koninklijk Museum voor Schone Kunsten, Antwerp

duke Albert—or even the five versions of Van Dyck's portrait of his friend Hendrick Liberti (see fig. 57). The identity of these assistants is uncertain, although probably they included, among others, the Flemings Remigius van Leemput (1607–1675), who may have been one of those recorded in 1632 as in Van Dyck's service, and possibly the John de Reyn (Jon Rijn, 1610–1675) who was with Van Dyck in England in 1634.

Van Dyck's most important and prominent commission was the *Vision of Saint Augustine* (fig. 42) completed in June 1628 for the new Augustinian Church in Antwerp (see fig. 3h). It is one of three paintings over the three main altars of the church: Rubens's great *Madonna and Child Enthroned with Saints* (fig. 43) in the center, over the main altar, with the Van Dyck on its right and Jordaens's *Martyrdom of Saint Apollonia* on its left. The rank of the painters is also demonstrated by the payments: six hundred guilders to Van Dyck and three thousand to Rubens, although for a picture about twice as large with many more figures. Rubens's inclusion of Saints Augustine and Apollonia among the attendants in the Madonna's regal court provides an internal link among the paintings as well.

Van Dyck's Saint Augustine shares with his companions—his mother, Saint Monica; the donor of the painting, Father Marinus Jansenius; and the two angels—his vision of a gloria of the triune deity surrounded by putti. Probably it represents a transcendent mystical experience bestowed on the two saints and described in Augustine's *Confessions,* which may be the open book beside his bishop's miter and crosier. The symbolism, referring to Augustinian piety and contemplation, is complex and must be owing to some learned member of the order. Bellori praised the painting's color and composition. Compared, however, with the dynamic three-dimensional arrangement of Rubens's altarpiece, the composition seems flat and crowded. The only forceful gesture is the angel's, pointing heavenward. His human companions seem enervated and passive beside the excited and passionate engagement of Rubens's figures. The contrast confirms Van Dyck's maturity. Indebted as he was to Rubens, he now had his own independent manner, supplanting Rubens's power with refined restraint.

Van Dyck was evidently devoted to his family and glad to be reunited with his brothers and sisters, to one of whom, Susanna, a lay sister of the Beguines, he dedicated Pieter de Jode's engraving of the Augustinian altarpiece. Their father had died while Van Dyck was in Italy, leaving a deathbed vow to provide an altarpiece for the Dominican church in gratitude to the nuns who had cared for him during his last illness. The *Crucifixion* that Van Dyck painted to fulfill this promise was one of several painted for churches during these years, the first (fig. 45) for the Church of the Recollets in Lille rather than Antwerp.

Exceptional as the diagonal composition with the cross on the bias may seem, it is not unique. Van Dyck had used a similar composition in an altarpiece of 1624 or 1625 in the church of San Michele di Pagana near Genoa, perhaps inspired by a Veronese (now in the Accademia in Venice) or by Rubens's *Le Coup de Lance* of about 1620. The poses and gestures of Saint John and the two women are hardly more impassioned than those in the *Vision of Saint Augustine*, despite their evident grief.

The same quiet pathos pervades the *Lamentation* (fig. 44), another family painting. Van Dyck painted it for the high altar of the Church of the Beguinage (see fig. 3i), the lay order to which three of his sisters belonged. Bellori reports that Susanna was the model for the Magdalene; Paul Pontius's engraving of a slightly different version was dedicated to another sister, Anna; and in his 1628 will, Van Dyck asked to be buried in the church. The crown of thorns and nails appear discreetly in the lower left corner, but Christ's body is unblemished except for the wound faintly visible on his right hand and the beautiful violet of his discolored legs. Van Dyck repeatedly painted the solitary Christ suffering on the cross, and his new conception of Saint Sebastian (fig. 46) shows him no longer narcissistic but in anguish after the first attempt to martyr him. In the *Lamentation*, however, there is little sense of the physical agony of Christ's death. Instead, the Virgin's gesture as she looks heavenward expresses faith and acceptance of God's will, and the actions of the Magdalene and Saint

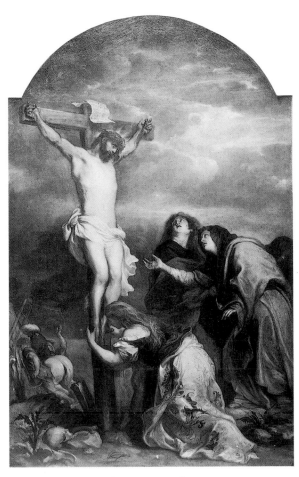

45. *Crucifixion*. 1621. Oil on canvas, 157½ × 85½″ (400.1 × 217.2 cm). Musée des Beaux-Arts, Lille

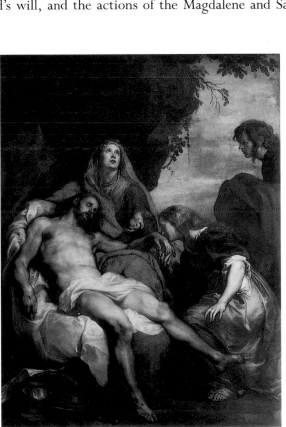

44. *Lamentation*. c. 1628–29. Oil on canvas, 119⅛ × 88⅝″ (303.5 × 225.1 cm). Koninklijk Museum voor Schone Kunsten, Antwerp

46. *Cure of Saint Sebastian*. 1630–32. Oil on canvas, 77⅝ × 57⅛″ (197.2 × 145.1 cm). Musée du Louvre, Paris

27

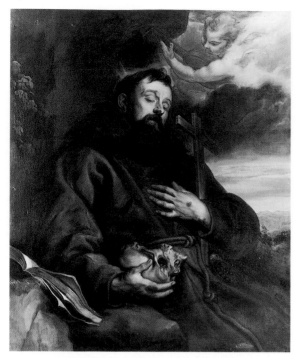

47. *Saint Francis of Assisi in Ecstasy.* 1628–30.
Oil on canvas, 47¼ × 38¼" (120 × 97.2 cm).
Kunsthistorisches Museum, Vienna

Rubens's almost continuous absence from Antwerp from August 1628 until spring 1630 seems to have had no effect on Van Dyck. The Rubens atelier continued to operate and Van Dyck continued to be kept very busy with religious paintings and portraits. Perhaps Rubens's absence gave him a few more opportunities to undertake mythologies, like the *Rinaldo and Armida* (see plate 24). He was wonderfully imaginative, and his sensibility to classical or literary subjects was less burdened by moral messages than it was charming and cheerful, as in the *Venus at the Forge of Vulcan* (fig. 48). His Venus emerges as if she were made flesh from a dream, her lithe little body a carnal reality in an otherwise ephemeral world. The clumsy Rubensian Vulcan is powerless to resist. Who had the good judgment to commission or acquire the painting until it entered the collection of Louis XIV of France is not known. A lesser ruler but active collector, Prince Frederick Henry of Orange, the stadtholder of the United Provinces, had the good sense to order two literary subjects from Van Dyck. The first, from antiquity, *Achilles among the Daughters of Lycomedes* (fig. 49), Van Dyck had painted previously, serving as Rubens's surrogate (see fig.

John seem to commend the devotional life. Van Dyck's membership in the lay Confraternity of the Bachelors (see fig. 3j), which he had joined in 1628, can be assumed to have been responsible for the two altarpieces he painted for that brotherhood, including *The Madonna and Child Enthroned with Saints Rosalia, Peter and Paul* (see plate 21), one of several hieratic works—*sacre conversazioni*—done in Antwerp after his return from Italy.

All of these paintings and many others were carried out for public display in churches. The frequency with which Van Dyck produced paintings on a smaller scale, like *The Resurrection of Christ* (see plate 23), speaks of considerable private patronage of works suitable for chapels or residences. If his Bachelors' Madonna was a queen for the public, in private she was the loving mother of the *Rest on the Flight to Egypt* (see plate 22) or the mediator for sinful humanity (see plate 20). The number of Van Dyck's images of the Madonna and Child is indicative of as enthusiastic a response in the Netherlands as in Italy. Hardly less popular were such devotional images as *Saint Francis of Assisi in Ecstasy* (fig. 47), which was in the Jesuit College in Mechlin until the order's dissolution in the eighteenth century. The saint is near the end of his life on earth, having already received the stigmata. His eyes are closed, as if to see an inner vision, and an angel soothes him with heavenly music as death approaches. Basically an icon, it is neither loaded with symbolic details nor rigidly composed; rather, it resembles an affectionate portrait of a beloved friend. The painting was engraved by Lucas Vorsterman the Younger.

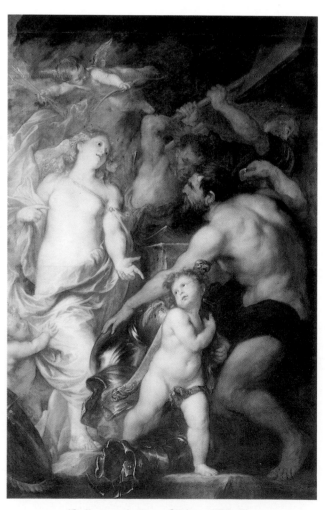

48. *Venus at the Forge of Vulcan.* 1630–32.
Oil on canvas, 86½ × 57" (219.7 × 144.8 cm), with a
17th-century addition at the top. Musée du Louvre, Paris

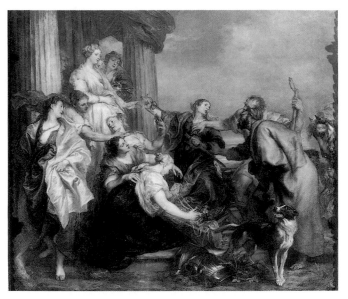

49. *Achilles among the Daughters of Lycomedes.* c. 1631—32.
Oil on canvas, 48⅜ × 54⅛″ (122.9 × 137.5 cm).
Graf von Schönborn Kunstsammlungen, Pommersfelden

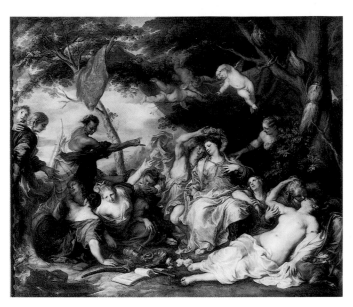

51. *Amaryllis and Mirtillo.* 1631—32.
Oil on canvas, 46¾ × 52⅝″ (118.8 × 133.7 cm).
Graf von Schönborn Kunstsammlungen, Pommersfelden

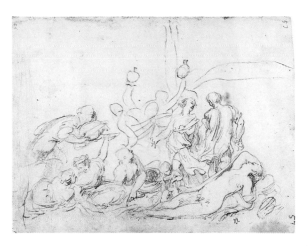

50. After Titian. *Venus and the Andrians.* 1622—23. Italian sketchbook,
folio 56r. Red chalk, reworked in pen and brown ink by a later
hand, approx. 6½ × 8″ (16.5 × 20.5 cm). British Museum, London

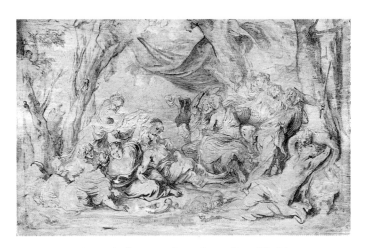

52. Study for *Amaryllis and Mirtillo.* 1628 29.
Grisaille on panel, 9⅛ × 14″ (23.2 × 35.6 cm).
Ecole Nationale Supérieure des Beaux-Arts, Paris

10). He returned to the same composition for this second version, but he transformed Rubens's solid rhetoric into lyrical poetry. The figures are light-footed and lighthearted rather than monumental and grave, and the mood has shifted to lively and festive from melodramatic.

The subject of the companion painting, *Amaryllis and Mirtillo* (fig. 51), came from contemporary poetry, Giovanni Battista Guarini's pastoral *Il pastor fido.* The hero, the shepherd Mirtillo, is crowning his beloved, Amaryllis, whom he has won after overcoming many obstacles. For the composition, Van Dyck looked back to Titian's *Venus and the Andrians,* which he had sketched in Rome in 1622—23 (fig. 50) and had perhaps also copied in oil on canvas. Some details have been lifted direct from the Titian—notably, the two gossiping women in the left foreground and the nude opposite them on the right, who has

been awakened from the languor of Titian's figure by a lover's kiss. Van Dyck prepared the painting with one of his relatively rare grisaille oil sketches (fig. 52), which appears to be as spontaneous as the drawing but also shows a firm control of structure, both of the figures in space and of such details as the drapery overhead. The scene is a kind of idealized kermess peopled not by sweating rude peasants but by merry perfumed nymphs. In the finesse with which its small-scale details have been animated and the range of its colors to near pastel, it is a *fête champêtre* a century before the Rococo.

The paintings were hung in the prince's dressing room, no doubt more to delight his eyes than to inspire the military prowess for which he was distinguished. They must have brightened the gloomy winter days in The Hague. Van Dyck may actually have painted them while

visiting there during the winter of 1631–32. He did a number of portraits, of the prince himself, his wife, and several others, including the young Prince Rupert (see plate 25), one of his masterpieces. At home, in the Spanish Netherlands, he had been appointed a court painter to the governor-general, the Infanta Isabella, aunt of Philip IV and Rubens's great patron. He also portrayed such visiting dignitaries as Marie de Médicis and, in 1634 the Cardinal-Infante Ferdinand (see fig. 68) and Prince Thomas of Savoy-Carignon (see fig. 69). By the time of Marie's visit, Van Dyck's own collection had achieved the status of a gallery worthy of her sightseeing. It was smaller and more specialized than Rubens's collection but very choice, eventually with no fewer than nineteen paintings by (or thought to be by) Titian, most of them portraits but a *Saint Jerome* and the *Andromeda* (now in the Wallace Collection, London) as well. The collection included also some copies after Titian by Van Dyck himself, a few Tintorettos and Bassanos, and miscellaneous works by others.

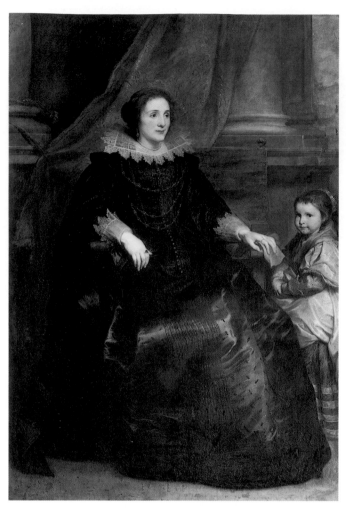

54. *Portrait of a Lady Seated with Her Daughter.* 1628–29. Oil on canvas, 79½ × 53″ (201.9 × 134.6 cm). Musée du Louvre, Paris

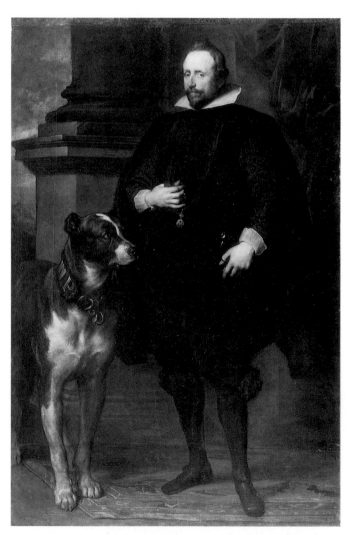

53. *Portrait of Graf Wolfgang-Wilhelm von Pfalz-Neuburg (1578–1653).* 1628? Oil on canvas, 80⅞ × 51⅞″ (205.4 × 131.8 cm). Alte Pinakothek, Munich

Few serving generals and local rulers, like the Count-Palatine Wolfgang-Wilhelm, duke of Neuburg (fig. 53), who passed through Antwerp seem to have failed to commission a portrait by him. The full-length portrait of the duke is typical and, like most representing men, is austere in color; the range of color in those of women depended on their costumes. Despite relative standardization in form, the diversity of these portraits is wide, with corroborative props, like the duke's fierce-looking Great Dane, often included to convey appropriate information. The animal, which wears a collar with the initials WP (Wolfgang Princeps), certainly is a loyal and convincing watchdog. It may convey an allegorical meaning as well. Married to the sister of the head of the Catholic League, the duke had converted in 1614 from Calvinism to Roman Catholicism, which resulted in his securing the duchies of Berg and Jüglich as well as Neuburg. So the dog may also refer to his master as a guardian of the faith. The duke's right hand is toying with the medal of the Order of the Golden Fleece, the most exalted honor conferred by the king of Spain. He stares directly at the viewer (and the

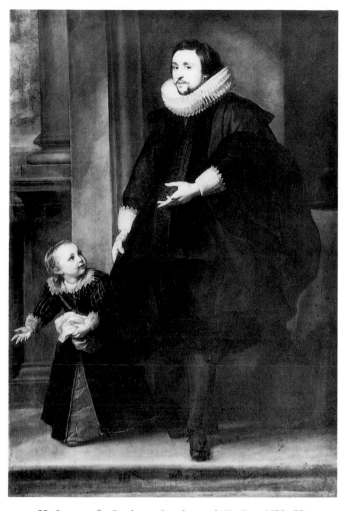

55. *Portrait of a Gentleman Standing with His Son.* 1628–29.
Oil on canvas, 79½ × 53½" (201.9 × 135.9 cm).
Musée du Louvre, Paris

ingfully, perhaps toward his wife. She is preoccupied and thoughtful. The children, in contrast, are animated, the little girl smiling as she looks openly but a little hesitatingly at us, the other child (a boy not yet in trousers) echoing the gesture of his father, to whom he looks up as if for guidance. Van Dyck has developed some individuality in the adults but not at the expense of their reserve, which is even beginning to affect the children. The effect is to establish their patrician status as their primary sense of themselves.

Whether for reasons of economy, or a sense of their less elevated status, or both, Van Dyck's double portrait of Jan de Wael and his wife, Gertrude de Jode (fig. 56), is not so imposing. It retains a formulaic background of a column and drapery, and the poses are as stiff and correct as their sons' are relaxed and casual (see fig. 38). Van Dyck, who painted this work forty-one years after the couple's marriage in 1588, must have been respectful of them not only because of their age and as the parents of his friends but also because of Jan de Wael's distinction as a painter and as a member of the militia organization denoted by the lozenge badge on his sleeve. Van Dyck knew them, of course, and his characterization is correspondingly specific. The husband seems as firm and unbending as the column behind him, and if he does not quite scowl, he is certainly stern. His wife seems to be looking inward; her lined face and the set of her lips suggest that her life has not been easy and that she has submitted and survived. Van Dyck has managed to identify them both as individuals and as a couple, long-married and accustomed to each other, for an effect that is arche-

painter) but without any warmth, as if his sense of the dignity and authority of his rank and the importance of his responsibility alienated him from any personal contact.

Many of Van Dyck's paintings in Antwerp of rulers and generals in Spanish army commands were similarly detached and remote, as if they were more icons than portraits. Sitters of less exalted rank, although similarly dignified by the Grand Manner formula, nonetheless emerge with more individuality, as in the pendant portraits of an unidentified couple with their children (figs. 54 and 55), once mistaken for Rubens and his family. They are clearly of the wealthy gentry, the adults dressed in rich understated black, the children with indulgent extravagance. The jeweled crosses at the woman's and child's necks mark them as Roman Catholic. Although the man is standing while his wife sits, they share the same source of light— from the right on her and the left on him—and they face each other. However, they seem to have no psychological contact with each other, and the man's cautious glance makes contact with us only, as he gestures not very mean-

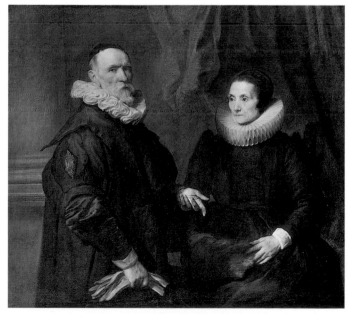

56. *Double Portrait of Jan de Wael (1558–1633)
and His Wife, Gertrude de Jode.* 1629.
Oil on canvas, 49¼ × 54¾" (125.1 × 139.1 cm).
Alte Pinakothek, Munich

57. *Portrait of the Antwerp Cathedral Organist Henricus Liberti (1600–1669)*. c. 1630–31. Oil on canvas, 43¾ × 34⅞" (111.1 × 88.6 cm). Museo del Prado, Madrid

58. *Portrait of an Unidentified Man with a Lute*. 1628–32. Oil on canvas, 50⅜ × 39⅜" (128 × 100 cm). Museo del Prado, Madrid

typal. Despite the somewhat pretentious setting, they can escape neither that identity nor their identity as good burgher citizens.

Most of Van Dyck's Antwerp portraits are involved to a greater or lesser degree in social status. In some portraits, of friends or at least of sitters who were his equals socially and professionally and in age, he concentrated on characterization rather than position in society. His portraits of two musicians are typical. One, Hendrick Liberti (fig. 57), the organist at Antwerp cathedral, who is remembered as a composer, was a friend; whether the other, an unidentified lute player (fig. 58), was or not is unknown. Both portraits are quite simple compositions, painted with hardly more color than the flesh tones and slightly warm neutrals. In neither did the painter introduce any props, apart from the skimpiest architectural setting, other than the indispensable lute and Liberti's sheet of his own music, a canon with the words "Ars longa, vita brevis." But two very different personalities are revealed: Liberti, pudgy, neurotic, and a little effeminate, a visionary dreamer, perhaps hearing secret choirs; the lutanist, spare, forthright, and masculine, a direct, challenging realist.

In March 1632, Van Dyck left Antwerp for London. Perhaps his visit to Frederick Henry's court in The Hague had heightened his awareness of the limitations of working in Antwerp rather than in a capital city. Brussels, the capital of the Spanish Netherlands, was not promising. The widowed Infanta Isabella had joined the Third Order of the Franciscans (the Poor Clares) in 1621 when her husband died, and the sobriety of the unadorned monastic habit that she wore for the rest of her life was characteristic of her court. The Stuart court in London, on the other hand, was lively, in a burgeoning city with a young, highly cultivated royal couple. King Charles I (fig. 59) and a few of the leading peers were enthusiastic and discerning patrons of art. The king, enchanted by the *Rinaldo and Armida* (plate 24), which he had acquired in 1629, probably was eager to acquire the painter as well. Judging from his support of Van Dyck from the moment of his arrival in London sometime before 1 April 1632, the king offered appealing incentives.

From Holbein's time onward, what the English had required of their artists, most of whom came from the Continent, was almost exclusively portraiture, and Van Dyck was able to satisfy both that demand and in the process to transform the by now antiquated Tudor portrait tradition into the latest Grand Manner. It was this gift of dignifying the sitters rather than his insight into personalities that brought his great success in England.

So, after some negotiations, Van Dyck went to London. Soon the king had him installed in a house at Blackfriars on the Thames, beyond the jurisdiction of

the English equivalent of the Continental guild, the Painter-Stainers Company. The house and studio were commodious. Van Dyck, according to Bellori, lived "ostentatiously," establishing a splendid salon, not only to receive his sitters but also to entertain friends and clients with lavish food, music, and other diversions. The king visited the house often enough so that in 1635 a special landing dock was built into the river for his convenience. Van Dyck's situation in London was quite different from what it had been in Italy, for now he belonged to the court circle, although he tactfully retained a respectful distance from such grandees as the duke of Lennox and Richmond. But in the Stuart court, he was appreciated as one of its great adornments. The marquess of Newcastle, for example, gushed with pleasure at the "blessings of [his] company." He responded to this appreciation; his English portraits are not only more colorful but he also seems more at ease with his sitters.

In July, Van Dyck was knighted and appointed principal royal painter, a privileged title rarely before conferred. Charles in 1633 doubled the pension of one hundred pounds that James I had awarded him in 1620 and supplemented it from August onward by payments for single paintings. Altogether, additional payments for paintings of over three thousand pounds are documented. He was kept busy not only by the royal family but by many others as well. According to the German international banker and collector Everhard Jabach (1618–1695), whom Van Dyck portrayed during 1636–37 with a background of the "Ypres" tower at Rye in England (the painting is now in the Hermitage, Saint Petersburg), his studio operated a kind of production line. Each sitter was scheduled a one-hour appointment during which the master sketched the face on the canvas and made a drawing of the pose in black and white chalk on a separate sheet of gray paper. (Many of these drawings survive.) Van Dyck's assistants then took charge of the canvas, laying in the figure's setting and painting the costume from clothing that the sitter left in the studio for that purpose. There is also an undocumented tradition that the typical long, narrow fingers in Van Dyck portraits were often not the sitter's own but the more elegant hands of a model. Finally, Van Dyck himself finished the head and touched up the rest of the portrait.

Apparently, the studio also had a flourishing business in copies of portraits, carried out by assistants with little or no supervision from the master. None of these assistants has been identified as working for Van Dyck at any specific time, but throughout his career he is recorded with "servants," who certainly included painters as well as personal attendants. Bellori wrote of Van Dyck's retinue of servants in Italy, and he is also recorded as accompanied by servants on his arrival in England in 1632, again in 1634, and on his return from France in 1641. Only one of

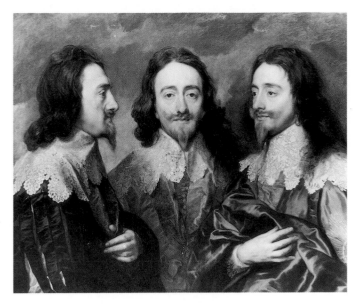

59. *Triple Portrait of Charles I.* 1635–36.
Oil on canvas, 33¼ × 39¼″ (84.5 × 99.7 cm).
Royal Collection, St. James's Palace

these servants, a certain Theodore (or Dierick) Hess, is specifically identified as a painter, in a document of 1649 where he is described as a "limner" about twenty-five years old. Because of his youth he can hardly have been more than an apprentice in the studio during the last years of Van Dyck's life. Van Dyck's staff unquestionably included more mature and experienced assistants, notably Leemput and de Reyn, who probably were with him for many years, both in the Netherlands and in England, and Cornelis Johnson's nephew, Theodore Roussel (or Roussell, 1614–1689), whose father, a native of Bruges, was the royal Stuart jeweler in London.

The London of 1632 was very different from today's city. Stretched along the Thames from the present City of London to Westminster, it had a population of a little over three hundred thousand and was growing rapidly. The king furthered its expansion and encouraged the consolidation of the peerage in town and the development of a predominant court culture. By midway in his reign, about two-thirds of the peers kept residences in London, centered along the Strand, where the Buckinghams and the earls of Arundel (see plate 36) and Pembroke (see plate 34) maintained their great houses. Numbers of the landed gentry followed, and many others seeking their fortunes in the capital. Its culture was cosmopolitan. The first English monarch since the Middle Ages who had spent any time on the Continent, in 1623 the king, as Prince of Wales, had visited Spain, where he saw the great royal collection and acquired a passion for collecting paintings, particularly by the great sixteenth-century Venetians. The queen, the daughter of Marie de Médicis of the Tuscan ducal family of art collectors, had been born and raised in the French court, and she brought with her

60. Wenceslaus Hollar. *Map of London: The Long View.* Parthey 1014a, 1014b. Engraving.
Royal Collection, St. James's Palace

to London her own cultural entourage. Many of the nobles were inveterate travelers (see plates 31, 32, and 36) and no less cultivated.

It was a small world. Although the number of peers had been doubled since Queen Elizabeth's death in 1603, by 1628 there were still only 126. There was much intermarriage. The duke of Buckingham's daughter, Lady Mary Villiers (fig. 61), for example, was the niece of the earl of Denbigh (see plate 32) and the marchioness (eventually the duchess) of Hamilton. She married the earl of Pembroke's heir (see plate 34) and, after his death, the duke of Lennox and Richmond (fig. 62 and plate 31), whose sister had married Lord Arundel's heir. The royal family and the leading nobles set an example by patronizing Van Dyck repeatedly. Lady Mary he portrayed in at least five different paintings. His success as a court portraitist was so great that he died a rich man, and his influence persisted in British portrait painting throughout the successive centuries, even into the twentieth.

Van Dyck's primary responsibility was to Charles I and his family. While specific numbers cannot be determined precisely, during the hundred months that he lived in London, he probably painted as many as fifty portraits of the royal family, for which he was paid somewhat less than he charged others not of royal rank. These royal portraits ranged from heads of individuals (see figs. 59 and 75) to full-length groups (fig. 63 and plates 28, 29, and 30). One of the problems confronting Van Dyck was that neither Charles nor Henrietta Maria was handsome or impressive physically. Both were small in stature and their rather commonplace physiognomies flawed. The king's narrow face resembled his father's, although without his crafty eyes; he had the long Stuart nose and prominent chin, softened by the goatee he grew after his return from Spain, and his forehead was too high, his mouth too small, and his eyes too big. The queen was slightly bucktoothed and her face a little crooked, although her eyes were very pretty.

Van Dyck solved the problem by utilizing all he had learned painting Grand Manner portraits on the Continent, and he devised new means to dignify the subjects. Very soon after his arrival, he began a series of large, official royal portraits, to satisfy both the king's discriminating taste and the need to create an impressive royal image. Among them were the so-called *Greate Peece* of the whole royal family in 1632 and two equestrians of the king. In the earlier equestrian, of 1633, Charles is accompanied by his lifelong riding master, the Seigneur de Saint-Antoine (fig. 63). For it, Van Dyck returned to the foreshortened composition he had used in Genoa (see fig. 34). Perhaps the king himself, remembering Rubens's portrait of the duke of Lerma in Spain (see fig. 35), suggested the motif. Van Dyck transformed the motif by adding a monumental arch through which the king, mounted on a magnificent white stallion, is passing, like an ancient Roman warrior-emperor returning triumphant to his capital city. The royal coat of arms, with the crown above, is stacked against the footing of the left column (which, incidentally, sits lower than the right footing). Displayed dramatically at the end of the Long Gallery in Saint James's Palace overlooking Titian's paintings of ancient Roman emperors (some of which Van Dyck had restored), the portrait asserted the king's supremacy peremptorily. In the second equestrian portrait, Van Dyck presented Charles as a reincarnation of Marcus Aurelius, as benign as the Roman emperor but no less absolute in power. Because Van Dyck's source, the famous bronze Marcus Aurelius equestrian in Rome, had once been thought to represent the first Christian emperor, Constantine, some hint of a Christ-like identity within the divine right of Charles's imperial persona may also be implied.

These two portraits, along with Van Dyck's other official images of Charles, have the effect of apotheoses of the king. Van Dyck's contemporary portraits of such leading courtiers as Lord Denbigh (see plate 32) and the earl of Warwick (see plate 33) are not so glorifying in characterization, while conferring hardly less pomp on Denbigh or self-assurance on Warwick.

In both equestrian portraits of the king, the insignia of the Order of the Garter are displayed. The king cherished the order, founded in the fourteenth century by Edward III and the English equivalent of the Spanish Golden Fleece (see fig. 53). Only rarely, in such relatively informal portraits as the *Portrait of Charles I Hunting* (plate 29), does the king appear without it. Correspondingly, those peers honored by inclusion in the order unfailingly make their appearances in Van Dyck's formal portraits wearing the insignia (see fig. 24 and plates 34 and 36)—understandably, when we see the full glory of its gold and silver star on the cape of James Stuart, the king's distant cousin (fig. 62). Awarded the honor in 1633, which was probably the occasion for this portrait, he also

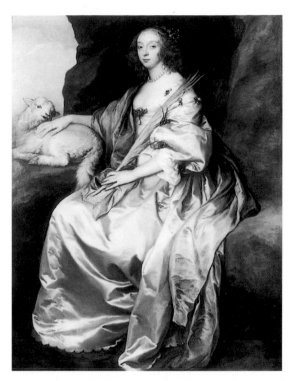

61. *Portrait of Lady Mary Villiers as Saint Agnes.* 1637.
Oil on canvas, 73½ × 54″ (186.7 × 137.2 cm).
Royal Collection, St. James's Palace

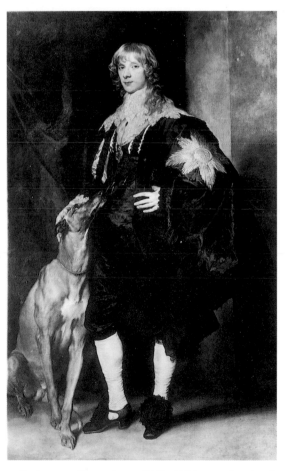

62. *Portrait of James Stuart (1612–1655), Fourth Duke of
Lennox and First Duke of Richmond.* 1633.
Oil on canvas, 85 × 50¼″ (215.9 × 127.6 cm).
The Metropolitan Museum of Art, New York.
Gift of Henry G. Marquand, 1889, Marquand Collection

wears the Lesser George medal suspended around his neck and the actual garter just below his left knee. Despite the duke's youth (he was twenty-one), his reported sweet nature, and his rather ordinary face, his rank and calling are clearly no less exalted than the star that he (and his portraitist) are so careful to display. The adoring noble greyhound that he strokes absentmindedly may even be taken as suggestive of the attitude suitable for lesser humans toward the duke.

Although this branch of the Stuart family, unlike the earl of Pembroke (see plate 34), did not commission a single family group portrait, perhaps because the duke was too young yet to pretend to the earl's dynastic presence, Van Dyck portrayed three of the duke's four brothers, two of his sisters, his sister-in-law, and his wife during the

following years. The most imposing of these Stuart portraits is of the third and fourth sons (fig. 64), Lord John (on the left) and Lord Bernard—so imposing that Van Dyck's greatest successor, Thomas Gainsborough himself, copied it. The family likeness is so evident that Van Dyck seems to have made little or no effort to idealize the faces. Nonetheless, he presented them as the ultimate haughty young courtiers. In fact, despite their extravagant costumes and the apparent arrogance of Bernard's swaggering, even insolent pose, they were brave and loyal adherents to the king, and both died in battle serving his cause.

The second son, Lord George, in a shepherd's Arcadian costume (fig. 65), appears no more bellicose than his younger brothers, but he, too, fell courageously, serving

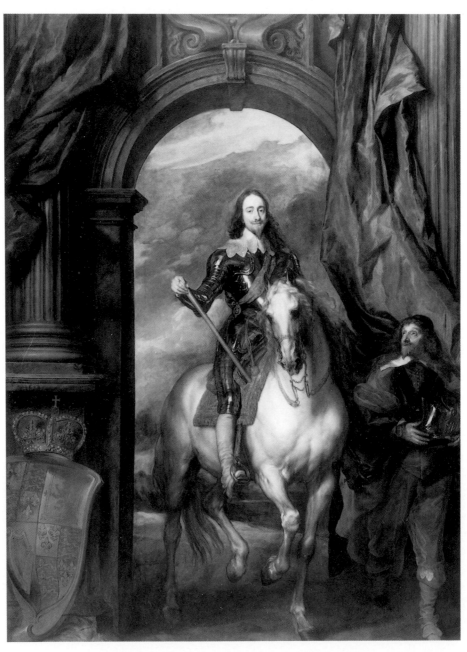

63. *Portrait of Charles I with the Sieur de Saint Antoine.* 1633.
Oil on canvas, 145 × 106⅜″ (368.3 × 270.2 cm). Royal Collection, St. James's Palace

36

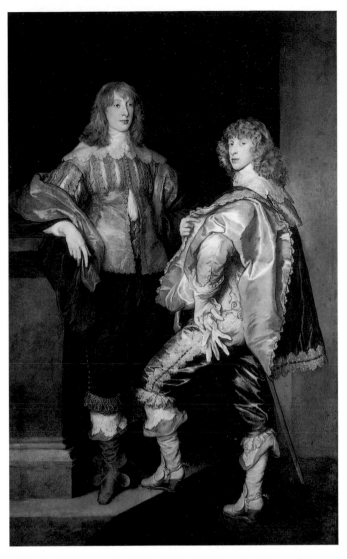

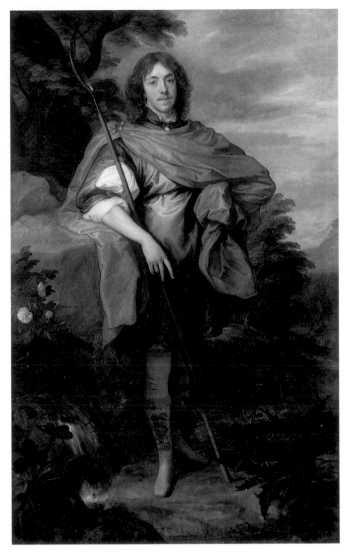

64. *Double Portrait of Lord John (1621–1644) and Lord Bernard Stuart (1622–1645).* c. 1638–39. Oil on canvas, 93½ × 57½" (237.5 × 146.1 cm). The National Gallery, London

65. *Portrait of Lord George Stuart (1618–1642), Seigneur d'Aubigny.* c. 1638. Oil on canvas, 86 × 52½" (218.4 × 133.4 cm). The National Gallery, London

in the royal cavalry. His pastoral costume and the motto on the rock, "Me firmior Amor" (Love is stronger than I am), may commemorate one of the masques performed at court several times each year, with such amateur actors as the Stuarts and even the royal couple themselves.

The fourth Stuart portrait (fig. 61), of James Stuart's wife, Lady Mary Villiers, appears to be more consistent with the sitter's personal history, although it is probably no less authentic a manifestation of the Stuart Cavalier ethos. It was probably painted on the occasion of her wedding to the duke in 1637. Her life had been so unsettled as to be notable even in early Stuart England. The only daughter of the duke of Buckingham, she and her brothers had been brought up in the royal nursery after his assassination in 1628. The king gave her away at her first marriage, to the Pembroke heir (see plate 34), and at her second, to James Stuart, but did not survive to perform the same service at her third, in 1664, to the Earl of Carlisle's younger brother, Colonel Thomas Howard. She

is portrayed here in white as Saint Agnes, the patron of brides, with her symbolic lamb and a martyr's palm, in an Arcadian grotto.

The Stuarts were not alone in taking advantage of Van Dyck's skills: other noble families, notably the Buckinghams, the Pembrokes, and the Arundels, also commissioned as many portraits of their individual members.

Van Dyck went home to Flanders in the winter of 1634, perhaps to tend to family affairs or perhaps by invitation of the City Council of Brussels, which might explain his being housed just behind the City Hall. For the City Hall, he painted two giant pictures of the twenty-three assembled aldermen, both destroyed by French bombardment of Brussels in 1695. All that remains are a grisaille sketch for one of the paintings (fig. 66) and studies of two of the aldermen (fig. 67), one of whom resemble Justus Van Meerstraeten, whom Van Dyck portrayed in a portrait now in the Staatliche Gemäldegalerie in Kassel, Ger-

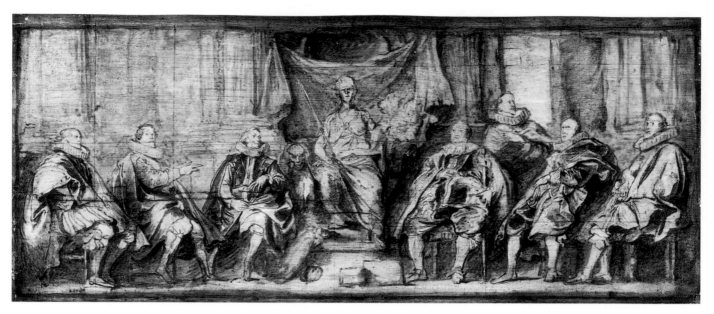

66. Study for *Aldermen of Brussels*. 1635. Grisaille on panel, 10¼ × 22⅞″ (26 × 58.1 cm).
Ecole Nationale Supérieure des Beaux-Arts, Paris

many. Van Dyck did not exercise as much inventiveness in arranging the aldermen as Frans Hals had in comparable paintings of two decades before. An allegory of Justice is enthroned in front of an apse in the center, with aldermen on either side of her, all backed by a wall dignified by columns and pilasters on head-high bases. Summary as the sketch is, the concept is nonetheless quite fully developed, with even the light effect indicated, probably so

that Van Dyck could leave much if not all of the execution of the paintings to assistants. The preparatory portraits of individual aldermen, presumably of all of them, he sketched with his own hand, effortlessly but with convincing structure and acute, if quick, characterization.

Van Dyck's return to Flanders was opportune, preceding by six months or so the arrival of the new governor, the Cardinal-Infante Ferdinand (fig. 68), the younger

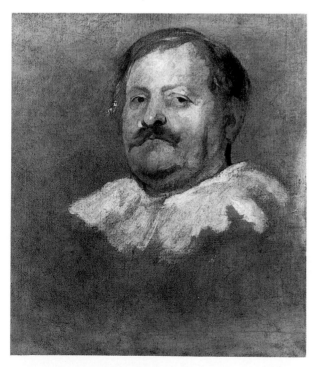

67. Study for *Aldermen of Brussels, Perhaps a Portrait of Justus van Meerstraeten (Portrait of a Bearded Man Wearing a Wheel Ruff)*. 1635. Oil on canvas, 20¾ × 18⅛″ (32.7 × 46 cm). Ashmolean Museum, Oxford

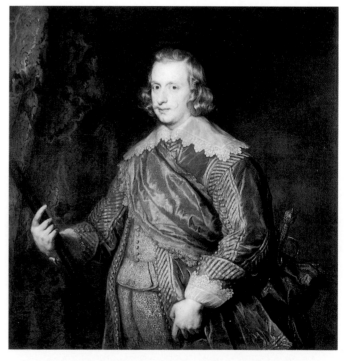

68. *Portrait of the Cardinal-Infante Ferdinand (1609–1641)*. 1634. Oil on canvas, 42⅛ × 41¾″ (107 × 106.1 cm). Museo del Prado, Madrid

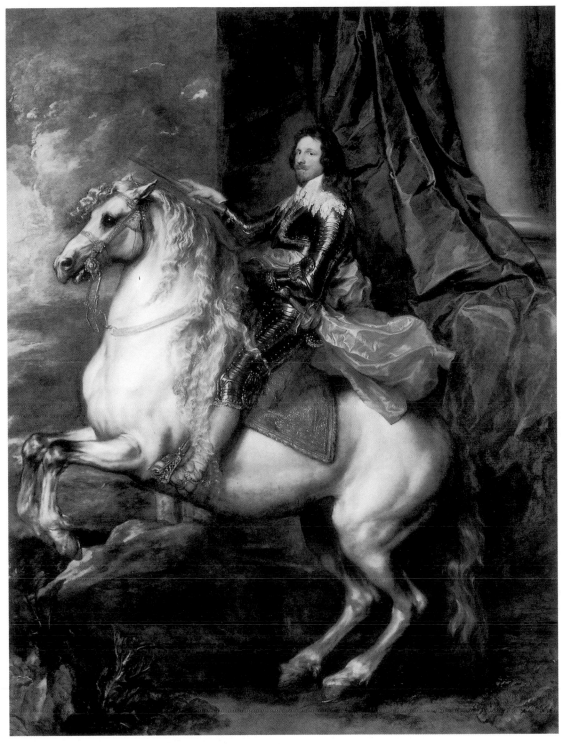

69. *Equestrian Portrait of Prince Thomas of Savoy-Carignon (1596–1656).* 1634.
Oil on canvas, 122⅞ × 92″ (312.1 × 233.7 cm). Galleria Sabauda, Turin

brother of Philip IV, whom Van Dyck portrayed as a matter of course. Although Ferdinand was fresh from the Hapsburg victory in the Battle of Nördlingen and is holding a field marshal's baton, he is not wearing armor. He carries the sword of his great-grandfather, Charles V, and wears the bizarre costume of his Triumphal Entry into Antwerp (see fig. 3). The neutrality with which Van Dyck characterized him conveys an alert self-possession that must have satisfied him, because he permitted the portrait

to be sent home to his royal brother in 1636. Philip IV must also have been satisfied: he allowed Velázquez to base his *Fraga* portrait (in the Frick Collection in New York) on it.

Ferdinand's cousin and second-in-command, Prince Thomas of Savoy-Carignon, fared even better. For him, Van Dyck painted his greatest equestrian portrait (fig. 69). This work, situated stylistically between Titian's *Charles V at Mühlberg* of ninety years earlier and Bernini's

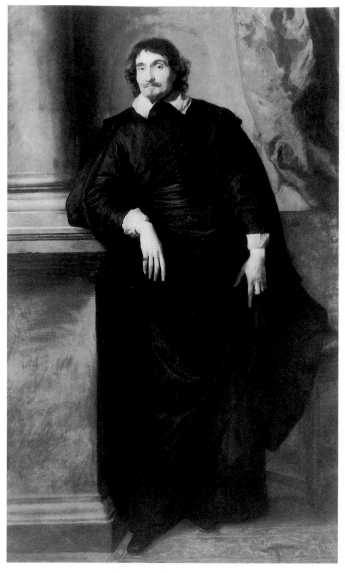

70. *Portrait of the Abbé Scaglia (1592–1641)*. 1634.
Oil on canvas, 80½ × 49″ (204.5 × 124.5 cm).
Collection of the Viscount Camrose

of which the portrait was carried out: following his usual procedure, the head probably from life by Van Dyck himself, and the rest in the studio without the model, much or all of it by the hands of assistants. It was sold by the Franciscans very soon after Scaglia's death in 1641 and replaced by a copy over his tomb in the chapel.

It served another purpose, as the model for Paul Pontius's engraving (fig. 71) in the series of prints after Van Dyck portraits, titled the *Iconography*. Unquestionably originated by Van Dyck, who himself etched the first fourteen or fifteen and perhaps the first eighteen plates, the *Iconography* included portraits of artists, rulers, statesmen, generals, and a very few women, including Van Dyck's wife (see fig. 81) and mistress (see fig. 80). He also made many preparatory drawings, like the van Balen study (see fig. 4), for the engravers. First published during the 1630s by Martin van den Enden in a suite of eighty prints, the *Iconography* was given its definitive form in 1645–46 by Gilles Hendricx in a publication of one hundred plates called the *Century* edition. It was immediately successful, attracting participation of the leading engravers in Antwerp and almost taking on a life of its own. Published again and again by different printers, augmented eventually by almost one hundred more plates, it was given its final full edition only in 1759.

Scaglia was responsible for two of Van Dyck's few religious paintings during the last nine years of his life,

marble *Constantine the Great* in Saint Peter's of thirty years later, recreates the pose of Rubens's equestrian portrait of Buckingham (now destroyed). Its spectacular effect derives no less from the resplendent colors—the luminous silver-gray horse with a golden mane contrasting with the extravagant green drapery and tempestuous sky—than from the impassive authority Van Dyck conferred on the prince.

In Brussels, Van Dyck was also in touch with the Abbé Cesare Scaglia (fig. 70), an Italian diplomat and connoisseur of painting. Van Dyck painted him full-length leaning against the base of a column, perhaps as a kinesthetic expression of his world-weary, too-knowing face. The setting is relatively subdued, as is his plain, black silk clerical dress, giving the effect of a wise and statesmanly eminence. The aureole around his head appears in Van Dyck's contemporary portraits (Prince Thomas's for one) as a sign not of sanctity but rather of the process by means

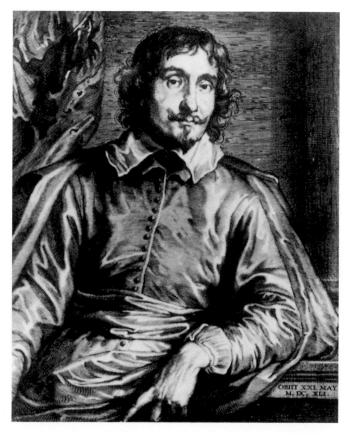

71. Paulus Pontius, after Anthony Van Dyck. *Portrait of the Abbé Scaglia*. Engraving, third state, 10 × 7¼″ (25.4 × 18.4 cm)

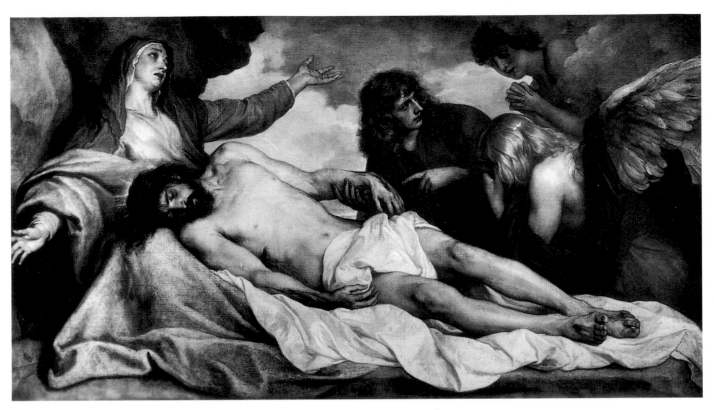

72. *The Lamentation.* 1636. Oil on canvas, 44½ × 80¾" (113 × 205.1 cm).
Koninklijk Museum voor Schone Kunsten, Antwerp

the votive *Madonna and Child with the Abbé Scaglia* (see plate 38) and *The Lamentation* (fig. 72) intended for a chapel in the Franciscan Church of the Recollets in Antwerp (see fig. 3k), to which he was to retire in 1639. Compared with the near-brutal early *Lamentation* (see plate 1), Scaglia's seems very suave. Van Dyck emphasized sorrow rather than the faith of the Beguinage version (see fig. 44), as if less concerned with doctrine than with the pathos of tragic human experience.

This *Lamentation* may have been completed in England and shipped across the channel in time for the dedication of the chapel in 1637, although the altar was not prepared for it until 1641. It is Van Dyck's last known religious painting. According to Bellori, he painted several others in England, which seems likely. They included a *Deposition* for Sir Kenelm Digby, and because the queen, despite the ardent Protestantism of the English public, was a devoted Roman Catholic, probably works for her and for the many members of her circle, like Mrs. Endymion Porter (see fig. 79) and Lady Arundel, who were also Roman Catholic. But none survives or is documented elsewhere.

Instead, on his return to London by June 1635, Van Dyck took up again his primary activity as portraitist to the court. He brought back with him from Antwerp his collection of paintings, which would seem to indicate an intention to stay in London, as would his denization in

1638. However, such less than inventive compositions as the *Portrait of the Earl and Countess of Derby and Their Daughter* (see plate 35) and the stiff, expressionless Lady Mary Villiers (see fig. 61) suggest that the process of painting many of his portraits had become rather routine and even burdensome, and that his assistants increasingly took a large role in carrying them out. Political men like Arundel, Pembroke, and Warwick (see plates 36, 34, and 33) clearly inspired Van Dyck's respect and admiration. But a number of his portraits of aristocratic women give little evidence of much sympathy with, or insight into, their personalities. Some women he treated simply as models of dazzling satins (see plate 35) or emblematically (see fig. 61)—and not always to their satisfaction, as the letters of the countess of Sussex in 1639 make clear. One *grande dame* with whom he did establish rapport was the Huguenot countess of Southampton (1603–1640), whom a contemporary described as "very merrie and very discreet." Long believed to represent a skeptical and flirtatious Fortuna (fig. 73), she sits in the clouds with a scepter and a transparent, frangible globe in her hands, apparently ruling capriciously over the world. In fact, she represents her virtue's victory over the death symbolized by the skull under her foot. The portrait was deemed worthy not only of description by Bellori but also of a copy by Sir Peter Lely.

Some other court commissions were as stimulating, particularly the series of the royal children as they grew

73. *Portrait of the Countess of Southampton (1603–1640)*
as Virtue Triumphant over Death. c. 1638.
Oil on canvas, 86⅝ × 52⅜" (220 × 133 cm).
Fitzwilliam Museum, Cambridge

self, who hoped it and similar presents would entice the king into the Roman Catholic church. Unfortunately, the bust was destroyed when Whitehall Palace burned in 1698; its shadow may survive in an eighteenth-century marble supposedly carved after a cast of the original (fig. 74). The legend that Bernini had a tragic presentiment of doom in Charles's face is untrue, part of the mythology of the martyr-king fostered after his execution. Van Dyck, as usual, improved the appearance of his features, and gave him a pensive sobriety fitting to a ruler. But the king is reported at this time to have described himself as the happiest king in Christendom.

Henrietta Maria was so pleased with the bust that she wanted Bernini to make one of her, too. So Van Dyck painted three views of her face as well, although on three separate canvases rather than on one (fig. 75). However, despite the valuable diamond and the thousand Roman crowns he had received for the bust of the king, Bernini balked and refused to carve another portrait from paintings. So the three portraits remained in England, this one presented to Lord Denbigh.

The *Cupid and Psyche* (see plate 39) must have been painted soon after, perhaps also for the queen. Why Van Dyck's English patrons did not commission more of these exquisite mythologies is as puzzling as it is disappointing. Bellori listed four others carried out for the king, but no

up (see plate 30), troublesome models as they may have been. And it is inconceivable that Van Dyck was not delighted, soon after his return from Flanders, to paint the triple portrait of the king (see fig. 59) to be sent to the great Cavaliere Giovanni Lorenzo Bernini in Rome for transformation into a marble bust. Van Dyck provided Bernini not only with three views of the king's head and shoulders but also with three different jackets (although only one lace collar), as well as a glimpse of the Star of the Garter and the George medal. He also showed the distinctive royal hairstyle, with much longer locks over the left shoulder than the right.

The painting was sent to Rome in spring 1636, and work on the bust began that summer. When it was delivered to England in mid-1637, both the king and the queen were delighted. Well they might have been: it was Bernini's first portrait of any ruler except a pope, and carving it had required the permission of Urban VIII him-

74. Thomas Adye (?), after Bernini (?). *Bust of Charles I.*
18th century. Marble. Royal Collection, St. James's Palace

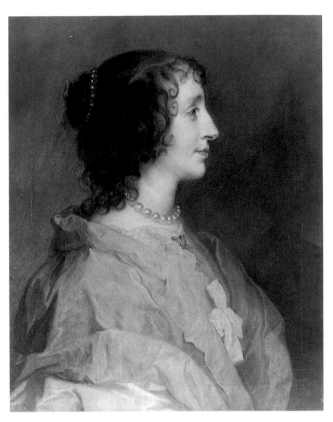

75. *Portrait of Queen Henrietta Maria (1609–1669).* 1637.
Oil on canvas, 25¼ × 29¾″ (64.1 × 75.6 cm).
Memphis Brooks Museum of Art, Memphis, Tennessee.
Memphis Park Commission, Purchase

more trace of them remains than of the religious paintings he also reported. Almost as disappointing is the very limited number of Van Dyck's studies of nature that survive: several remarkably fresh landscapes in watercolor (see plate 40) and two—too few—drawings of plants. Unquestionably done on the spot in the countryside and almost surely in the fragrant English air, these nature studies sometimes served as details in portraits; for example, the prickly *Sonchus arvensis* in the center of the study of plants in the British Museum (fig. 76) appears in the portrait of the Derbys (see plate 35). Van Dyck's interest in nature was sufficiently scientific that he wrote the names of the plants across the top of the sheet. Primarily, however, these studies seem to have been his spontaneous response to the pleasure he felt in nature.

In England as in Antwerp, Van Dyck's oeuvre was not limited to the ostentation of court portraiture. At the onset of his career at Charles's court, he carried out a commission unique in his oeuvre although not uncommon in the seventeenth century. It was for one of his English intimates and advisers, Sir Kenelm Digby, Bellori's informant; the commission was a portrait of his beloved wife, Venetia Stanley, in her deathbed two days after she had died (fig. 77). She is laid out not as a corpse but as a gently sleeping beauty, rose petals strewn across her lap.

Van Dyck was a social being and a man of much

76. *Study of Plants.* Pen and brown ink and wash, 8⅜ × 12⅞″ (21.3 × 32.7 cm). British Museum, London

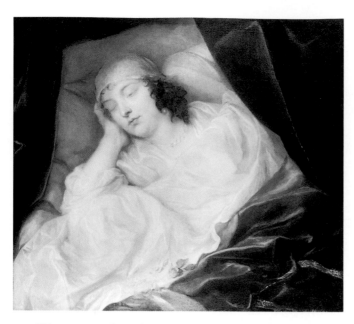

77. *Venetia Stanley, Lady Kenelm Digby on Her Deathbed.* 1633.
Oil on canvas, 29¼ × 32¼" (74.3 × 81.9 cm). By permission of
the Governors of Dulwich Picture Gallery, London

charm. He must have had many friends like the gentleman-courtier Thomas Killigrew (see plate 37) who did not require the pomp of a full-length portrait, even if they had the standard fifty to sixty pounds to pay for it (a half-length was thirty to forty pounds) and a suitable place to display it. Double portraits, of members of the same family (see fig. 38) or of husband and wife (see fig. 56), he had been painting during most of his career. In England he devised a variation, a double portrait of friends, the first one of which (fig. 78) is a self-portrait with Endymion Porter, whom he had known since his first visit to London in 1620. Porter served the king, at court and abroad, as a confidential agent in diplomatic and other matters and as an art dealer and agent. He occupies the superior position on the left and is larger and more robust than Van Dyck, his snowy white doublet demanding attention, his pose open and frontal. Van Dyck seems almost frail in comparison; dressed with elegant restraint in black silk, he portrayed himself in profile, his arms close to his body, his head turned only slightly toward the viewer. He sees himself not only as older than in his earlier portraits (see figs. 1 and 26) but as more introspective and discreet. He is a little reticent and has become subtle; Porter unquestionably is shrewd, but he is also good-natured, flamboyant, and aggressive. Although the painting is a testimonial to the friendship of the two men, as enduring as the rock on which they place their hands, it contrasts their personalities at least as much as it affirms their community of spirit.

Porter made a good marriage, to Buckingham's favorite half-sister's daughter, Olivia Boteler (fig. 79), who was close to the queen. The match, politically advan-

tageous, was also a happy marriage. They were both Roman Catholics and had many children, and she was capable both of running their household and of taking a hand in her husband's business affairs. Van Dyck could not convey all of her virtues in her portrait, particularly in an Arcadian setting and perhaps in the costume for a masque. But he did evoke her rather florid personality overflowing with life and revealed in her a largeness of both body and spirit equal to her husband's.

Gossip linked Van Dyck and Porter also through Margaret Lemon (fig. 80), the painter's mistress, whom he is said to have shared with his friend. She was also described as a demon of jealousy who tried to disable Van Dyck by biting off the tip of his thumb for receiving lady sitters without a chaperon. Portraying her as Andromeda chained to a rock and menaced by a dragon may have been her lover's witty response. This woman's body, however, is much more generous than Psyche's, for which Margaret is supposed to have posed (see plate 39). Perhaps Van Dyck intended the painting as his own version of the great *Andromeda* by Titian that he owned, although this composition owes more to the Cavaliere d'Arpino. Despite the beautiful background with Perseus and the dragon, as well as the floating drapery, this large, solid, and inarticulate body and the prosaic composition disappointingly lack the grace of the *Cupid and Psyche.*

Judging from Van Dyck's portrait of his wife, Mary Ruthven (fig. 81), in her the terrifying Lemon might well have met her match. The fortuneless granddaughter of the disgraced Scottish first earl of Gowrie, a distant kinsman of the royal Stuarts through his mother, she was one of Henrietta Maria's ladies-in-waiting and is certified a Roman Catholic by the rosary in her hand. The king and queen, concerned about Van Dyck's well-being, had put pressure on him to marry. He presents his wife as a pert, charming woman whose sidelong glance betrays a clever personality. The portrait is less than perfectly clean, so it has sometimes been ascribed to assistants rather than Van Dyck himself. However, the delicate but firm touch, particularly in the subtle gradations in skin tones, surely is Van Dyck's own.

They were married 27 February 1640. It was not a propitious year, as the political situation of England was disintegrating, at great and disappointing cost to Van Dyck: it brought the cancellation of his scheme to design (at prohibitive expense) four large tapestries of the procession of the Knights of the Garter for the Banqueting Hall in the royal palace of Whitehall. Van Dyck may have recognized the imminence of disaster for the king, or perhaps he hoped to take advantage of Rubens's death during May 1640. That autumn, he returned to Antwerp with his wife. Completing Rubens's unfinished paintings was not his intention, and he refused Cardinal-Infante Ferdinand's invitation to do so. He was, however, pre-

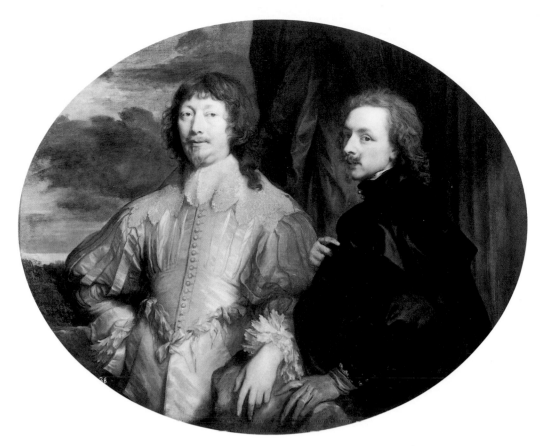

78. *Double Portrait of the Artist and Endymion Porter (1587–1649).*
c. 1635. Oil on canvas, 46⅜ × 56⅛″ (117.8 × 142.6 cm).
Museo del Prado, Madrid

pared to undertake independent commissions. When the Spanish offered him none, in December he went to Paris, hoping to be asked to decorate the Grande Galerie of the Louvre. Unsuccessful, he returned to London, where the political situation had worsened.

Time was also running out for Van Dyck, who was seriously ill, probably with tuberculosis. In October, he was enough improved to return to Antwerp without Lady Van Dyck, who was expectant. He soon went on to Paris, in great style with a four-horse coach and five servants, to paint a portrait of Cardinal Richelieu. By mid-November, however, he was mortally ill, and he went home to London, the portrait unaccomplished. The king offered the royal physician three hundred pounds if he could effect a cure of Van Dyck, but to no avail. Lady Van Dyck gave birth to a daughter, Justina or Justiniana, on 1 December 1641. Van Dyck made his will on the fourth, and five days later he died, leaving a very large estate, which was still being contested in 1704. The king had him buried in Saint Paul's Cathedral and an impressive monument raised to his memory. Both were destroyed without trace when the cathedral burned down in the great fire of 1666.

Lady Van Dyck remarried, to a Welsh baronet, Sir Richard Price (or Pryce) in 1642, who may have been a fortune hunter; she died three years later, and he in 1651.

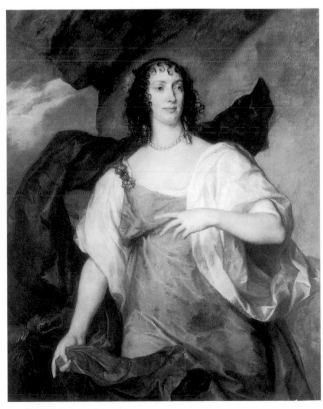

79. *Portrait of Olivia Boteler (died 1633), Wife of Endymion Porter.*
1637–38. Oil on canvas, 53½ × 42½″ (135.9 × 108 cm).
Collection of the Duke of Northumberland, Syon House, London

45

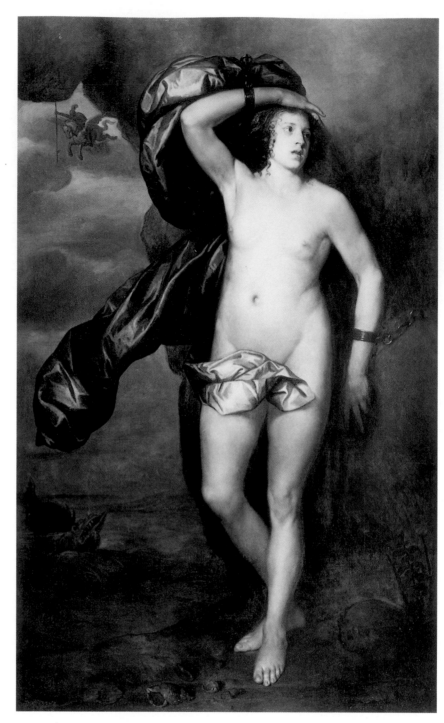

80. *Portrait of Margaret Lemon, Van Dyck's Mistress, as Andromeda Chained to the Rock.*
c. 1636–37. 84¾ × 52″ (215.3 × 132.1 cm).
Los Angeles County Museum of Art, Los Angeles. Gift of the Ahmanson Foundation

Justiniana lived to marry twice: first in 1653 to a baronet, Sir John Stephney, who was also very young, and, after his death, to Martin Carbonell. She died in 1688. She herself was a painter who achieved some recognition. In 1660 she and her husband visited her Aunt Susanna, who had been appointed her guardian in Van Dyck's will, and converted to Catholicism. She was survived by four children.

Van Dyck also had an illegitimate daughter, Maria Theresa, in Antwerp, of whom the first notice is in her father's will. Her birthdate is not known but she was old enough in 1641 to marry. She had seven children before her death in 1697. Justiniana and Maria Theresa shared in their Aunt Susanna's estate as well as their father's.

Although life expectancy in the seventeenth century was much lower than it is in the twentieth, Van Dyck's death at forty-two was premature. If he had lived much longer, however, he would have been overwhelmed by problems not of his own making. The convening of the Long Parliament in November 1640 and the passage of the Grand Remonstrance, detailing parliamentary demands,

a year later, just a few days before Van Dyck's death, marked the beginning of the collapse of the king's authority and the disruption of the court circle on which Van Dyck's career in England depended. The outbreak of the Civil War in 1642 would have compromised much of his patronage, and he might well have been forced into exile abroad. His trips to the Netherlands and Paris during the last year or so of his life may indicate that, aware of the progressive disintegration of the royal power, he was prepared to reestablish himself on the Continent, although his refusal to complete Rubens's unfinished paintings for Philip IV seems the sign of a man more proud than desperate. Like many members of the Stuart circle, he certainly could have settled in Antwerp, where he would presumably have shared with Jacob Jordaens the inheritance of Rubens's patronage, if he did not monopolize it. But to recreate his success in London, he needed a lively court and a stylish aristocracy, which neither the burghers of Antwerp nor the provincial government in Brussels could provide.

As Van Dyck lay dying in the gray days of a London December, the birth of his daughter Justiniana could have provided him the consolation of a sense of natural human fulfillment. But it came too late, and it must also have inspired profound sorrow, even remorse, that his life was ending as hers began. He could look back on the successes of his career with satisfaction, but he might also have regretted the elusiveness of complete fulfillment of his genius. During that last year, to look up to Rubens's three splendid canvases adorning the ceiling of the Banqueting Hall at Whitehall with the knowledge that they would never be complemented by the tapestries he had designed for the walls of that great Stuart audience chamber must have been a bitter disappointment. Hardly less disappointing must have been his failure to win the commission to decorate the Grande Galerie of the Louvre and his knowledge that he had completed only one major cycle of paintings—of the City Council of Brussels (see figs. 66 and 67)—independently in his own name rather than under Rubens's aegis. Destiny at least spared him the bitter knowledge that neither these Brussels paintings nor those in collaboration with Rubens in the Jesuit church in Antwerp would survive as long as a century.

If Van Dyck was by no means Rubens's equal in devising vast religious machines and was not granted the opportunity of carrying out many decorative cycles, the tenderness and intimacy of his images of the Virgin Mary, the Christ Child, and individual saints were unsurpassed during his lifetime and subsequently. The failure of his English patrons to take more advantage of his genius for poesies like the *Cupid and Psyche* (see plate 39) must have been frustrating; the recognition of their incomparable elegance and charm by one of the greatest of connoisseurs, Sir Peter Lely, and by Watteau and others of the

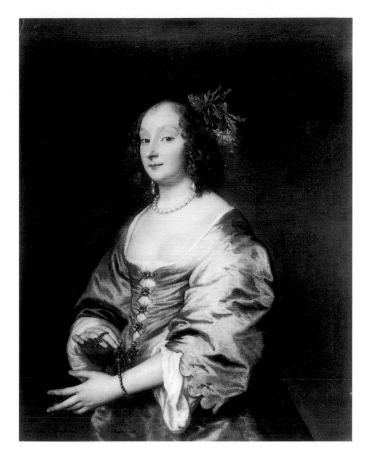

81. *Portrait of Mary Ruthven, Lady Van Dyck (died 1645)*. 1639. Oil on canvas, 41 × 31⅞″ (104.1 × 81 cm). Museo del Prado, Madrid

Rococo came too late for their maker's satisfaction. He could rest secure, however, in the knowledge that his inimitable skill as a portraitist was recognized and appreciated. The plethora of copies (and of copies of copies) of Van Dyck's portraits, particularly of British patricians, testifies to the veneration accorded them, carried to Gainsborough's extreme of even portraying many of his female sitters clothed in costumes recreating those worn by their predecessors for Van Dyck.

His greatest artistic legacy was rendering the Grand Manner portrait, which he had derived from his idol Titian and then perfected, capable, astonishingly, of such constant renewal as to remain vital for three hundred years, until well into the twentieth century, through the hands of Reynolds, Gainsborough, Sir Thomas Lawrence, and ultimately of John Singer Sargent. Historically, the world on Van Dyck's canvases, although international, is limited: to persons rather than events, to the proud rather than the humble, with portraits of triumphant generals the only hint of the misery inflicted on much of the population of Western Europe during the Thirty Years' War. Yet, however selectively, he celebrated his era and its dominant personalities with a conviction and an insight that few other chroniclers, in images or words, have been able to achieve.

THE LAMENTATION

1616?
Oil on canvas, 81½ × 54" (207 × 137 cm)
Ashmolean Museum, Oxford

Christ has just been taken down from the cross, his wounds still bleeding and his fingers taut in anguish. A muscular giant, his body is limp and contorted rather than heroic, the ungainliness of his pose poignant. Below him are the brutal hammer and nails of his crucifixion and the cruelly mocking crown of thorns and placard proclaiming him Jesus of Nazareth King of the Jews.

As if the pathos of Christ's corpse were insufficient in itself to command attention, Van Dyck has centered the composition on it. It is framed by the white shroud and the colorful costumes of the heavy, rather plain Virgin, the gloriously auburn-maned Mary Magdalene, and the handsome Saint John the Beloved, all compressed in the shallow space. If the mourners' gestures and facial expressions are somewhat rhetorical, and the decorative brilliance of their costumes' intense and varied hues seems contrary to the painful subject, the image is nonetheless heartrending, and all the more powerful for its being a little unwieldy.

There are several other versions of this composition, notably one in the Alte Pinakothek in Munich and another, which is slightly different, in the Prado, Madrid. The Prado painting belonged to Philip IV, who displayed it with *The Mocking of Christ* (see plate 2) in a prominent room in El Escorial, his vast country palace. The provenance of this painting before it was presented to the Ashmolean in 1869 is unknown. The different versions of this composition have been dated as early in Van Dyck's career as 1616 and as late as 1630. Probably he repeated the composition over a period of several years, as was his habit, before he went to Italy in October 1621; this is the original version.

The color, some of the physiognomies, and the relatively smooth handling of the mourners' costumes indicate that Van Dyck was already responsive to Rubens. The shallow compositional spiral, which originates in Christ's head and runs through his body into Saint John's cloak and through the arch of his and the Magdalene's poses into the Virgin's upturned face, is similar to that in the two versions of Van Dyck's *Mocking of Christ* (see plate 2 and figure 15). The heavy, loose, but controlled impasto of Christ's hair and loincloth is characteristic of Van Dyck's *fattura*.

Both paintings demonstrate the sensibility of the artist who throughout his career gave every indication of being a convinced and faithful son of the Roman Catholic Church. The raw power of Christ's twisted, bleeding, and tortured body is far from the grace that would be typical of much of Van Dyck's later work (see, for example, fig. 44). If his manner is not yet suave, such paintings as this compensate for their slight awkwardness with their youthful emotional intensity.

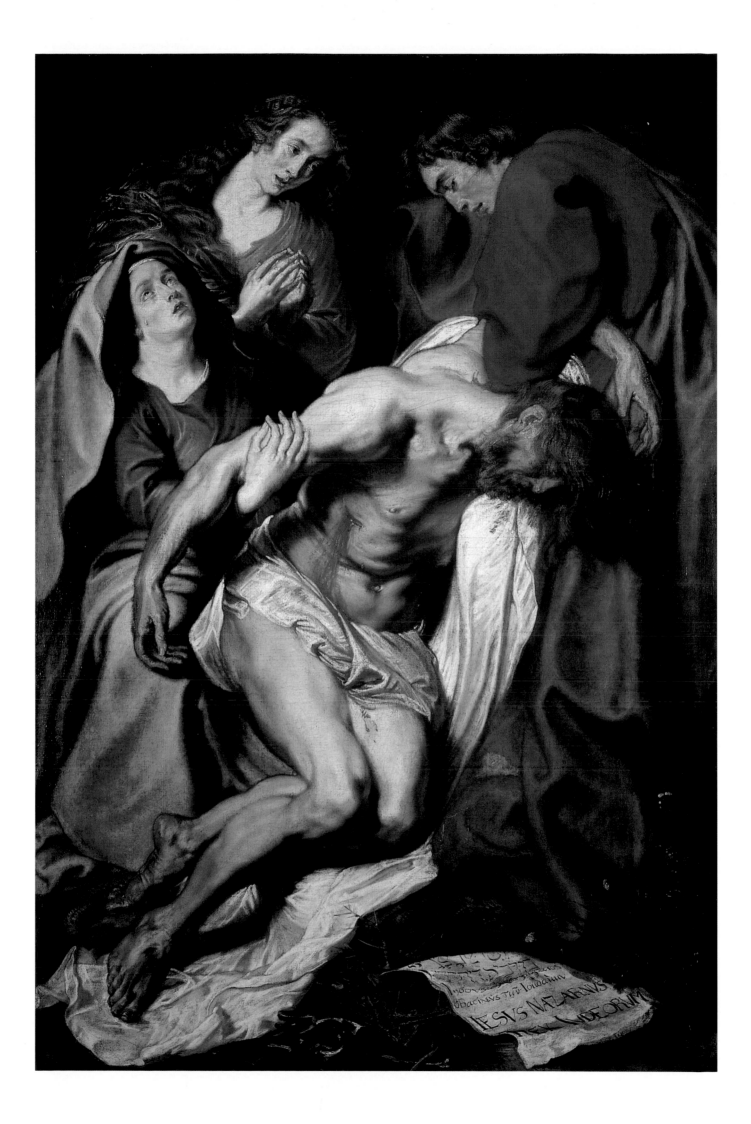

COLORPLATE 2

THE MOCKING OF CHRIST

c. 1618–20
Oil on canvas, 87¾ × 77¼" (223 × 196.2 cm)
Museo del Prado, Madrid

The painting was acquired during the 1640s for one thousand florins from Rubens's estate by Philip IV of Spain, who installed it with two other Van Dycks, *The Lamentation* (now also in the Prado) and a *Saint Sebastian* (which has not yet been identified), in the Chapter Room of the Prior at El Escorial. In this room Velázquez arranged some of the most important works in the king's magnificent collection; the Van Dycks shared its walls with paintings by Titian, Tintoretto, and Rubens.

Van Dyck owed the origin of this composition and some of the details to a painting of the subject that Rubens carried out in 1602 for the church of Santa Croce in Gerusalemme in Rome (now in the Grasse cathedral). Before his trip to Italy, Van Dyck could have known Rubens's painting only through the older master's studies for it or through copies, and his debt to it is no greater than Rubens's debt to Titian's great late canvas of *The Mocking of Christ* in the Louvre. The snarling dog was taken from Rubens's first great success in Antwerp, the *Elevation of the Cross* (originally in Saint Walpurgis Church and now in the cathedral). The armored man placing the crown of thorns on Christ's head appears to be adapted from Dürer's engraving *The Knight, Death, and the Devil*. Several of the other faces, notably of two of the bearded men—on the far right and looking over Christ's right shoulder—are identifiable in Van Dyck's oil studies of his models (see, for example, plate 4 and fig. 6). These men reappear in several other paintings: for instance, the man behind Christ as Eleazar in the *Moses and the Brazen Serpent* (plate 4).

Van Dyck's composition is less tense and constrained than that of Rubens; the men's physiques are more generously proportioned and are articulated more easily. Van Dyck eliminated the lantern included by Rubens at the top of his painting, achieving a velvety atmosphere in which the figures merge together rather than a sharp division between lighted areas and shadows.

In contrast to *The Lamentation* (plate 1) of several years earlier, everything in this painting seems more concrete, with more differentiated textures—the palpable woolen robe across Christ's knees, the firm flesh of his torso, the warrior's hard, bright armor. Although this composition is also frontal, the figures now find themselves in an adequate three-dimensional space, embodied in light from the left and wrapped in dark shadow.

It is a more dignified image, if perhaps somewhat less compelling. Christ is mocked, the crown held over his head; he is ashamed of his tormentors and saddened by their inhumanity. But a certain detachment has replaced Van Dyck's passionate engagement in *The Lamentation*.

The sources are John 19:2–3: "And the soldiers platted a crown of thorns and put it on his head. . . . And said, Hail King of the Jews! and they smote him with their hands," and Mark 15:17–20: "and did spit upon him, and bowing their knees worshipped him."

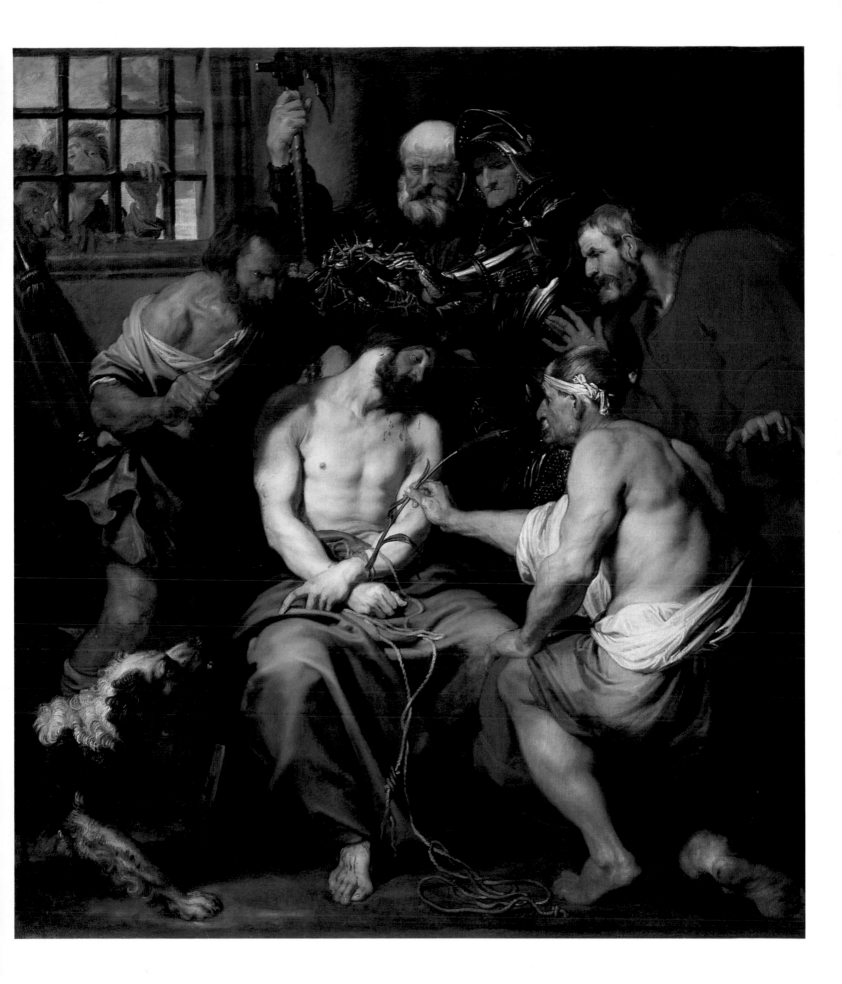

HEAD OF A YOUNG WOMAN

1620?
Oil on paper, mounted on panel, 19¼ × 16⅞" (49 × 45.7 cm)
Kunsthistorisches Museum, Vienna

This oil sketch is akin to the studies from live male models that Van Dyck transformed by the addition of appropriate attributes into his series of paintings of individual apostles (see fig. 6) and that he kept in his studio to serve in multifigural compositions. Whether or not intended specifically for the *Moses and the Brazen Serpent* (see plate 4), this head developed into its central female figure. The face and pose are evidently the same. Van Dyck may have chosen to portray her in this oil sketch simply because of her fresh and innocent beauty. Because he posed her looking up into a brilliant light, it seems likely that he intended to use the sketch for a religious painting—some inspired virgin martyr, or perhaps Mary Magdalene, as her reddish hair might suggest. He painted the same model in a different pose as the penitent Magdalene (formerly in a private collection in Los Angeles), looking down at a skull in contemplation of the transitory vanity of earthly life.

This brightly illuminated face was painted quickly, direct from the model, and as fluently as possible with rather thick, sticky pigment on a heavily loaded brush. The result is a rich, creamy surface comparable to that of the van der Geest portrait (see fig. 21) but without the effect of variation imparted by the older man's wrinkled skin. Her skin areas are opaque and warm in tone, turning cool in half-tones and warmish gray in the glazed shadows. Only in the periphery is the ground even faintly visible, and the only drawn lines are in the contours of the neck and forehead, which have been reinforced with the tip of the brush. Spontaneous as the sketch appears to be and dense as the impasto pigment, the anatomy of the head from skull to skin is flawlessly constructed.

Van Dyck's insight into the young woman's personality is so acute and sympathetic, even affectionate, as to intimate a personal, even familial relation with the model. He had three sisters in holy orders and, according to Bellori, he portrayed one of them as Mary Magdalene in the *Lamentation* he painted for her convent church (see fig. 44). The likeness between this woman's face and his own in the first self-portrait (see fig. 1) is just sufficient to give plausibility to the conjecture that he portrayed one of his sisters in this study as well.

The painting was in the vast collection of the Archduke Leopold William in Brussels. On his death in 1662, it passed to the imperial Austrian collections and thence eventually to the Kunsthistorisches Museum.

MOSES AND THE BRAZEN SERPENT

1620?
Oil on canvas, 80 × 91⅜" (205 × 355 cm)
Museo del Prado, Madrid

The source in the Old Testament is Numbers 21:4–9, relating how the Children of Israel grumbled in the desert wilderness on the exodus from Egypt because of the lack of food and water: "And the Lord sent fiery serpents among the people and they bit the people; and much people . . . died." So they approached Moses and asked him to pray the Lord to forgive them for complaining. "And the Lord said unto Moses, make thee a fiery serpent, and set it upon a pole . . . and it came to pass, that if the serpent had bitten any man, when he beheld the serpent of brass, he lived." In the New Testament this event is cited as a prefiguration of the Crucifixion: "And as Moses lifted up the serpent in the wilderness, even so must the Son of Man be lifted up" (John 3:14).

Van Dyck interpreted the story as a dramatic confrontation, on either side of a deep recessive space, between the calm, stalwart Moses, backed by Eleazar, the son of Aaron, and the writhing mass of the Israelites surging desperately toward the pole of salvation. The young woman portrayed so sympathetically in the Vienna oil sketch (see plate 3) has become a victim, rolling her eyes, her arms contorted, unable to kneel unsupported. Were not the life force seeping out of her, she might be the sister of the possessed woman exorcised by Saint Ignatius Loyola in Rubens's great painting of 1617 for the Jesuit church in Antwerp. The Israelite group is complex and dense, rich in color and incident—one man thrusts his arms toward the brazen serpent, another kisses the base of the pole in the hope of liberating himself from the serpent coiled around his nude body (which, incidentally, bridges the two groups), an old man makes a prayerful gesture, and a solitary hand in the upper right clasps a squirming tail. A few snakes are still falling from the sky.

This sky, a beautiful Titian blue and gold at the horizon, turns dark and menacing overhead. It provides a background foil for the mosaic of action and color in the figure groups. If Moses' two-color robe is Rubensian, the variety of hues in the other figures exceeds the customary range of Rubens's palette in the late 1610s. And throughout the painting evidence of Van Dyck developing his characteristic silvery tonality can be seen, not only in the praying old man's white goatee and the suffering young woman but also in many highlights and in the sky.

Van Dyck has taken a low viewpoint, perhaps planning on the installation of the painting high on a wall. Such a placement is indicated by the staging of the event on a stone ledge. The inscription painted on the ledge, "P.P. Rubens F.ct.," does not appear in a seventeenth-century copy that was probably made in Flanders, but the first documentation of the painting—in the 1666 inventory of the Alcazar in Madrid—attributes it to Rubens.

The origin of the composition can in fact be traced to a Rubens of about 1609–10, now in the Courtauld Galleries in London. Van Dyck's eleven surviving preparatory drawings allow us to follow his evolution of the theme. He preserved some of Rubens's conception and a few specific details, but he reformed them so thoroughly as to extricate them completely from the older master's hand. A key is the transformation of Rubens's commanding Moses into Van Dyck's passive observer. Another sign of Van Dyck's emergence from Rubens's shadow is that some of these models' figures show a tendency toward the extreme of elegant attenuation that would become one of Van Dyck's hallmarks.

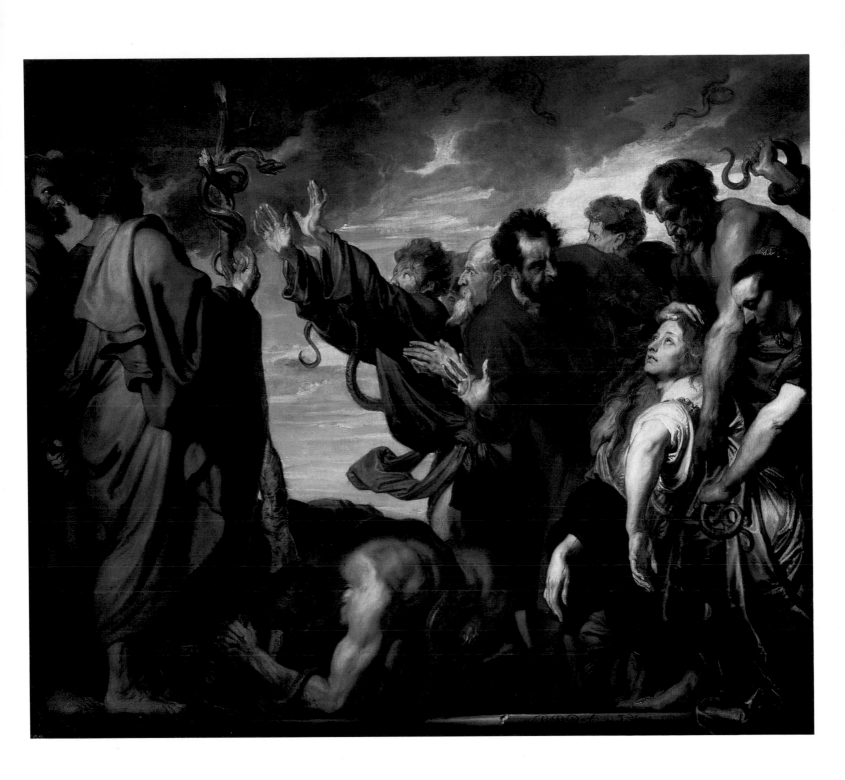

THE BETRAYAL OF CHRIST

1620–21
Oil on linen, 55⅞ × 44½" (142 × 113 cm)
The Minneapolis Institute of Arts. The William Hood Dunwoody,
Ethel Morrison Van Derlip, and John R. Van Derlip Funds

The betrayal and the taking of Christ prisoner are described in all four Gospels. Following tradition, Van Dyck combined them, adding the armored man and lantern from John 18:3 to the basic account in Matthew 26:47–50: "Judas, one of the twelve [apostles] came, and with him a great multitude with swords and stones. . . . Now he . . . gave them a sign, saying, whomsoever I shall kiss, that same is he: hold him fast. And forthwith he came to Jesus, and said, Hail, Master: and kissed him. . . . Then came they, and laid hands on Jesus, and took him." In this version and the one in the Prado (see fig. 16), Van Dyck also included the episode of Saint Peter cutting off the ear of Malchus, the high priest's servant, which Jesus then restored. A third version, in the City of Bristol Museum and Art Gallery, lacks this episode.

The painting demonstrates again Van Dyck's skill in dramatic staging. The introduction of the Malchus episode in the lower left of the painting establishes a space sufficiently deep for the explosive action. Despite the vertical format, the action sweeps from left to right in a wave of frenzied men, cresting in Judas's great cloak. It carries up to a dead stop in the commanding figure of Christ, the one immobile participant. His sad, tranquil face belies the violence swirling around him, his silence the antithesis of the noisy commotion of the rabble. The painting is full of telling details: the contrast of faces—Christ's fully lighted face with Judas's profiled in shadow; the helmeted man laying his right hand on Christ's shoulder and his left on the wrist while staring up apprehensively at his face; the almost disembodied hands lifting the binding cord over Christ's head; the torchbearer dancing with excitement; the struggle between Saint Peter and Malchus and their expressionistically distorted legs; and the giant lantern tumbling out of the bottom of the picture. Even the foliage is turbulent, under the serene silver of the moon.

The tumult of the men's actions is reinforced by the color, the light effects, and the handling. Van Dyck used a wide palette, ranging from such white highlights as the impasto touches in Malchus's eyes, the garment of the torchbearer, and the torch itself through the intense scarlet highlights on Christ's crimson cloak and the brilliant deep blue of Saint Peter's robe (worthy of Titian's latest paintings) to the dark neutral landscape background and the glittering black armor. The light is intense, flickering over the figures and the foliage, making a hot spot on the torchbearer's chest, and setting off the action by casting deep shadow behind it. The whole painting is bound together by the very loose handling, which would seem careless if the artist's touch were not as fluent and sure as it was spontaneous.

This painting seems too large to have been simply a preparatory study for the Prado and Bristol versions, although they are more than twice as big and much more conventionally finished. Furthermore, the excessively attenuated proportions of the figures in the drawing in the Kunsthalle, Hamburg (fig. 18), have been corrected here. Yet, despite all the preliminary drawings, it is so fresh that it seems almost extemporaneous. So it probably should be recognized as a step in Van Dyck's development of the theme rather than the conclusion. At the time of its making, however, it must have been recognized as a significant work of art; Jacob Jordaens made a copy of it and then used it as a source for his later painting of the betrayal (in the Cleveland Museum of Art).

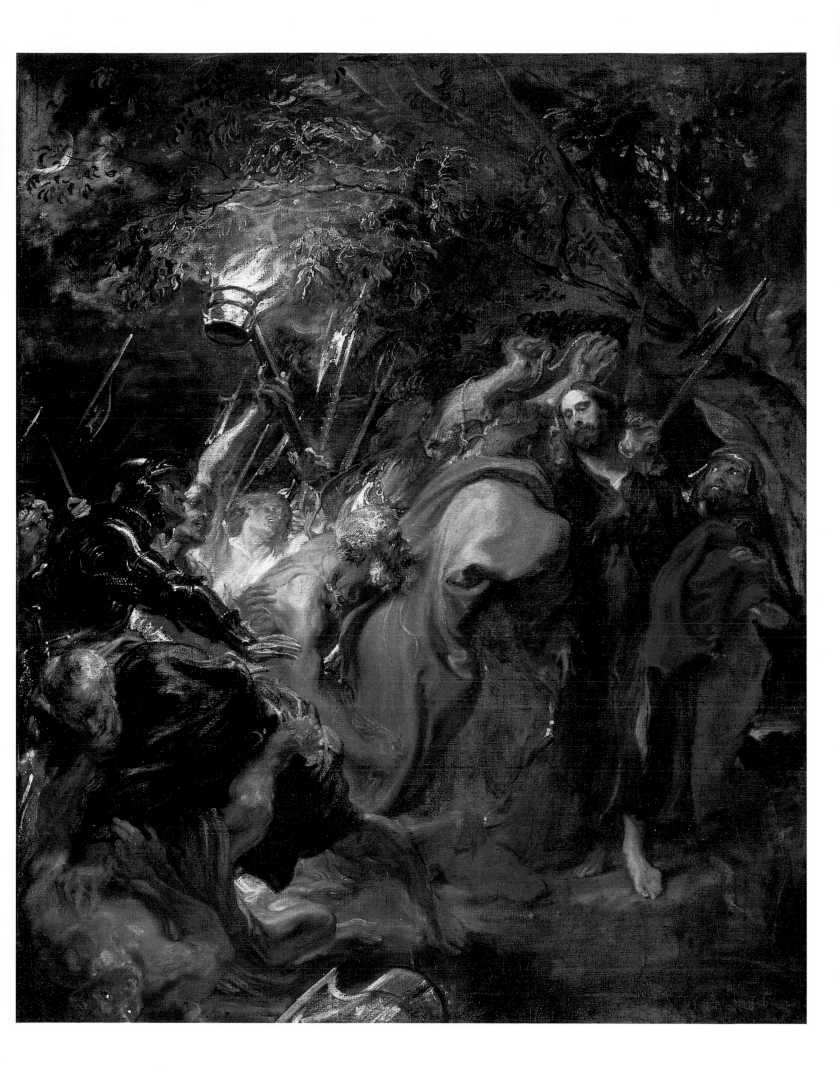

THE EXPULSION OF ADAM AND EVE
FROM THE GARDEN OF EDEN

1621
Oil on buff paper, laid down, 7 × 6¾" (178 × 172 mm)
National Gallery of Canada, Ottawa

This nearly monochromatic oil sketch is a rarity in Van Dyck's oeuvre. Usually he sketched in pen and ink and wash, and most of his relatively few oil compositional sketches are more deliberate and detailed and (with a few exceptions) on wood panels or on canvas rather than on paper (see figs. 52 and 66). In fact, he made a pen and ink drawing for this composition (in the Stedelijk Museum, Antwerp) with individual studies of Adam and Eve on the verso.

The existence of both a drawing and oil sketch might be taken as another (if abbreviated) instance of the process by means of which Van Dyck prepared himself to carry out large, finished paintings. However, there is no evidence of his having developed this subject any further or of any commission for it. One of the canvases on the ceiling of the Jesuit church in Antwerp represents the Expulsion, but Rubens, of course, rather than Van Dyck made the preparatory oil sketch for it. Perhaps Van Dyck was given the task of translating Rubens's sketch into the finished ceiling painting. It is tempting to imagine that having carried out this assignment, Van Dyck indulged himself by making this little painting and the preparatory drawing as an alternative to Rubens's design.

Van Dyck borrowed his conception of the subject from a woodcut of 1526 by Hans Holbein. The fact that he reversed Holbein's composition has led to some speculation that he may have been planning an engraving. But no print exists, and the few oil studies Van Dyck made for his engravers were invariably much more detailed, as they would have had to be to serve their purpose effectively.

The preparatory drawing has been considered Van Dyck's earliest that survives, which would date it about 1616. Alternatively, this oil sketch has been proposed as being contemporary with *Cupid and Psyche* of 1639–40 (see plate 39). It seems, instead, so close in form and spirit to *The Betrayal of Christ* in Minneapolis (see plate 5) as to be contemporaneous with it. Limited as it is in hue, it, too, uses the light effect to contrast the radiance of the angel with the gloomy world into which he is driving Adam and Eve. The broad diagonal stripe of light across the sheet from upper right to lower left between the dark triangular corners reinforces the powerful thrust of his action. Van Dyck manipulated his brush, loaded with rather dry but malleable pigment, with the same easy, quick assurance as in *The Betrayal of Christ,* and with comparable effect; the adroit movement of his hand imparted its energy to the whole scene, particularly to the angel's driving force and the wiry muscularity of Adam's legs.

This little painting has evidently been appreciated throughout its history. The collectors' marks show that it belonged to the great eighteenth-century connoisseur-collectors of drawings Jonathan Richardson, Thomas Hudson, and Sir Joshua Reynolds.

Recently, the attribution to Van Dyck has been seriously questioned and an alternative proposed, to Jan van Boeckhorst (1605–1668), the "Lange Jan" often mentioned as Van Dyck's friend, copyist of his paintings, and perhaps member of his atelier.

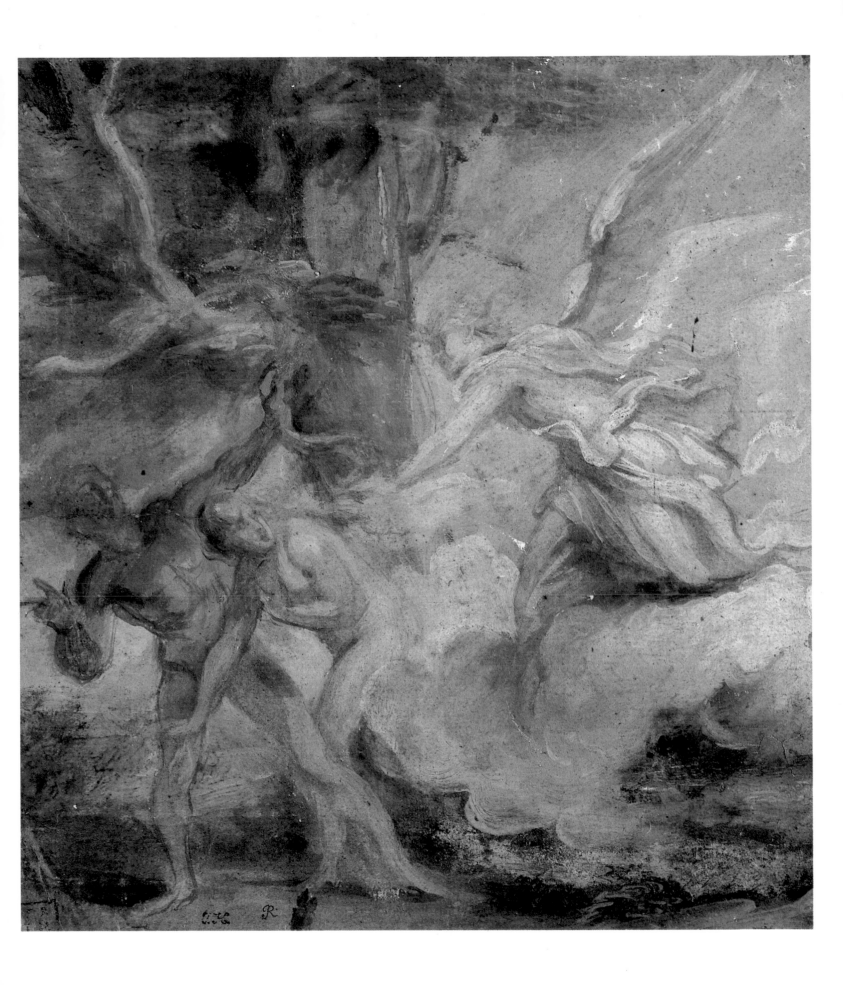

THE DRUNKEN SILENUS

1618–20
Oil on canvas, 41¾ × 35⅝" (107 × 90.5 cm)
Gemäldegalerie Alte Meister, Staatliche Kunstsammlungen, Dresden

This is one of the few paintings of Van Dyck's youth that he signed—very cleverly, with the initials AVD, like a potter's mark fired into the bottom of the jug. Perhaps he felt it necessary to assert his independence both from Rubens's *Silenus* of a few years earlier (in the Alte Pinakothek in Munich), which was later enlarged, and from the *Triumph of Silenus* (in the National Gallery, London), which was certainly a collaborative effort of both painters, with Frans Snyders lending a hand for the fruit and perhaps Jordaens for a head or two.

This *Silenus* is Van Dyck's second version of the subject. The first, in the Alte Pinakothek, Munich, is of a similar disorderly drunk but with only two other figures, both of whom have been replaced here. It is one of his relatively few paintings of classical subjects. He used the ancient legend as a means of conveying a moralistic comment on human sensuality and excess.

The legend, from Ovid's *Metamorphoses,* tells how the old satyr Silenus, who was the teacher of the Greek god of wine, Dionysus, became so drunk that he got lost. Found by some peasants, he was taken by them to their king, Midas. Dionysus rewarded Midas for looking after Silenus by granting the king the near-fatal wish that everything he touched turn to gold.

The models for this cast of characters play very different roles in other works by the young Van Dyck: the woman as Mary Magdalene, the young man as Saint John the Evangelist, and Silenus himself as Saint Jerome (see fig. 20). While at first glance their boisterousness here seems to celebrate drunkenness, neither the flabby old man nor his attendants are the joyously heedless revelers of the London *Triumph of Silenus.* Quite the contrary: Silenus has almost passed out, and, except for the scarcely visible man drinking from the jug, the others are alert, the woman glancing amorously across Silenus's back at the black man, who is licking his lips with erotic desire, and only the young man on the right showing any solicitousness for Silenus.

The composition is a diagonal, with the massive central figure of Silenus staggering compellingly close to the picture plane. The palette is mostly warm earth tones but with Van Dyck's characteristic touches of white highlights and his rich impasto surface. The contrast between the relatively smooth surface of the robe across Christ's knees in *The Mocking of Christ* (see plate 2) and the looser surface of the young man's scarlet cloak demonstrates the evolution of Van Dyck's style. Notable also are the black man's long fingers, anticipating one of the mannerisms of Van Dyck's aristocratic portraits (for example, see figs. 64 and 70).

The painting was engraved by Schelte à Bollswert (1586–1659) (Hollstein no. 69), a skilled and prolific craftsman who served both Rubens and Van Dyck. It was also etched by Franciscus van der Steen for the *Theatrum Pictorum,* the visual record of the Archduke Leopold William's collection. In the eighteenth century, it was acquired by Antoine Pesne for another great collector, the Elector Frederick Augustus II of Saxony (King Augustus III of Poland), and eventually entered the Dresden public collection.

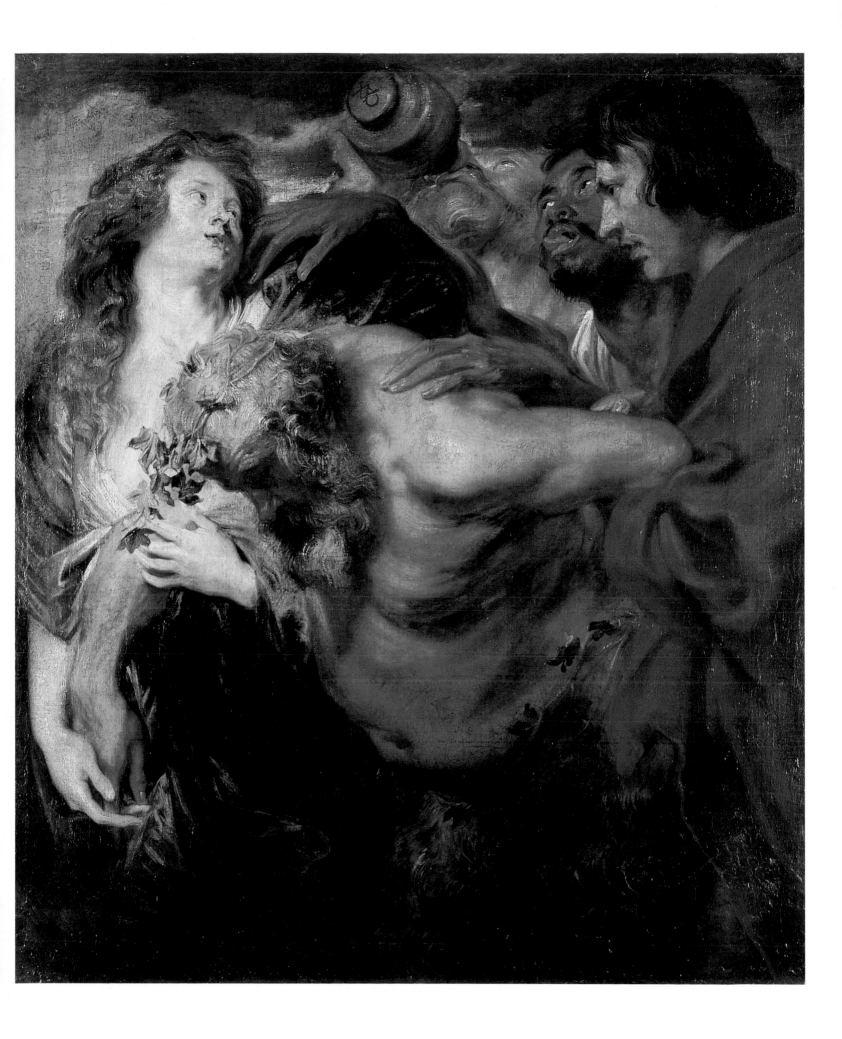

PORTRAIT OF A MAN AND BOY,
PERHAPS GUILLAUME RICHARDOT AND HIS SON

1618–20
Oil on panel, 43¼ × 31½" (110 × 80 cm)
Musée du Louvre, Paris

This well-groomed gentleman and his son are presented so sympathetically as to suggest a personal relation with Van Dyck. Van Dyck might have known the man in Antwerp, either in Rubens's circle of intellectual friends or among the Neo-Stoic scholar-administrators who served in the city government. Attempts have been made to identify him as Jan Wouverius (1576–1635), who was with Guillaume Richardot and Philip Rubens (and perhaps Peter Paul Rubens) in north Italy in 1602. Alternatively, it has been suggested that he was Rubens's wealthy friend and patron Nicholas Rockox (1560–1640), who served as a public official in Antwerp for many years and whose portrait Van Dyck slipped into his copy of Rubens's *Meeting of Saint Ambrose and the Emperor Theodosius*. But Van Dyck's portraits of the two men do not resemble this sitter sufficiently, despite the characterization of each of them as a sober humanist. Both Wouverius and Rockox appear in engravings in the *Iconography* series based on Van Dyck portraits, and neither had so noble a visage or such a fine Roman nose.

The portrait is more likely to represent one of the sons of M. le Président Richardot, Jean or Guillaume, who was born in 1579. Jean was the archduke's ambassador in Rome while Rubens was there in 1602, and Guillaume was an intimate of Rubens's beloved older brother Philip, with whom he had been a student of the influential Neo-Stoic philosopher Justus Lipsius. At some point, a strip of canvas about two inches high with the inscription "M. le Président Richardot" was added along the top of the painting.

A Van Dyck portrait of a woman and a girl (in the Gemäldegalerie, Dresden), who are presumably mother and child, has been proposed as a companion painting. It, too, is on wood, has similar dimensions, and is comparable in format and composition, although the female models sit a little higher than the males and are posed more rigidly. It bears the Wouverius coat of arms, and the woman has been identified as Jan Wouverius's wife, Marie Clarisse. Although the children in both portraits seem to resemble each other, the similarity in the two portraits is probably generic, as Van Dyck was still in the process of working out the form of the double portrait of parent and child, to be fully developed a little later in Genoa. The arrangement of son, father, and landscape in three recessive steps is suggestively analogous to that in the *Saint Jerome* in Rotterdam (see fig. 20).

The characterization of the father and son is brilliant, individuating each personality and simultaneously relating them to each other. The man's experience contrasts with the innocence of the boy, who stands like a little man, proud to be with his father. Both son and father convey a sense of security: the boy under his father's protective hand, and the man less from his evident prosperity than in his calm, philosophic assurance. He holds a book in his left hand, as if he had been interrupted in his reading; perhaps it is a Neo-Stoic tract.

The actual handling is exemplary of Van Dyck's virtuosity with the brush and pigment, ranging effortlessly from the rich impasto of the boy's ruff through the smooth opaque glazing of the man's face to the fluent spontaneity of the undisguised brushstrokes forming the landscape. The boy's right hand was left unfinished, but everything else in the painting appears to be carried to completion; even the very summary sketching of the fur seems intentional, to produce an almost tactile illusion of its textures.

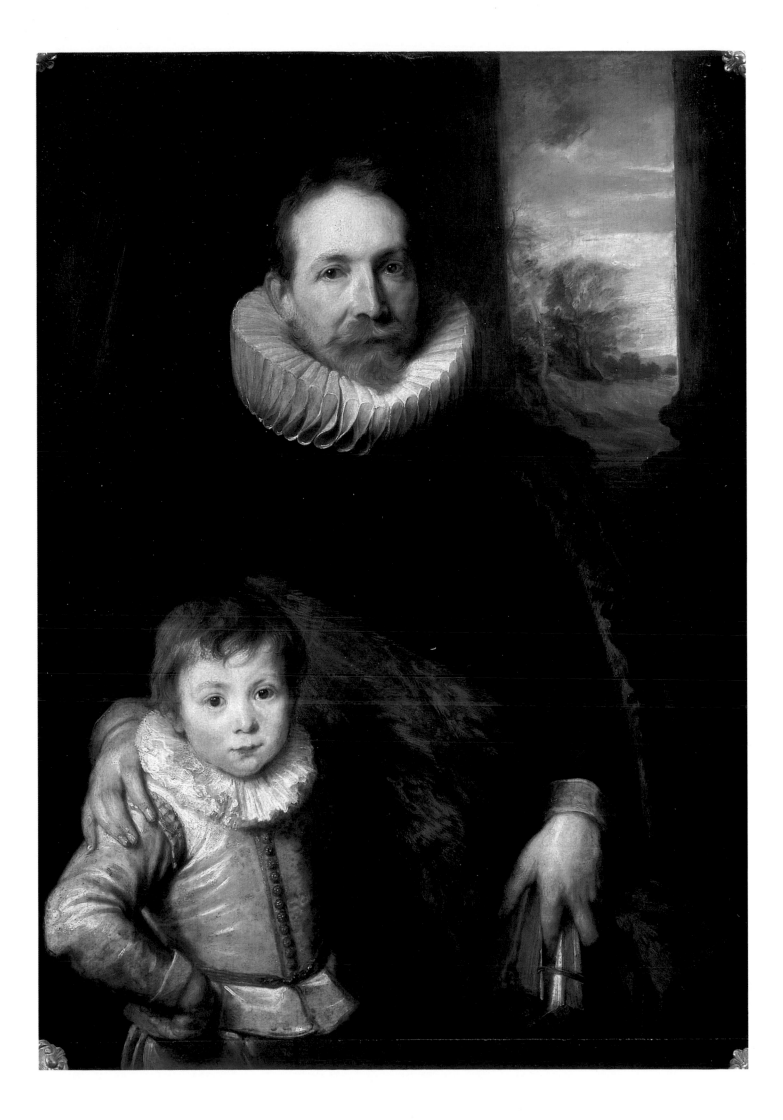

PORTRAIT OF SUSANNA FOURMENT
AND HER DAUGHTER CLARA

1620–21
Oil on canvas, 68 × 46¼" (172.7 × 117.5 cm)
National Gallery of Art, Washington, D.C. Andrew W. Mellon Collection

The sitters have been identified without complete certainty. If they are in fact Susanna Fourment (1599–1628) and her daughter, they belonged to Rubens's extended family, and are typical of the close relations and intermarriage within the tight-knit artistic and burgher community in the relatively small city of Antwerp. Susanna's brother Daniel was related to Rubens by marriage, and her younger sister, Helena, became his second wife in 1640. Her daughter, who was born in 1618, married Rubens's eldest son, Albert, in 1641. The painting would have been done before 1621, when Susanna Fourment's first husband, Raimond del Monte, died. She did not remarry, to the merchant and collector Arnold Lunden, until after Van Dyck had left for Italy. Judging from the daughter's age, the portrait cannot have been painted much earlier than 1621.

Although the formula of the well-dressed young matron facing to the left and seated in front of an impressive architectural and landscape background was by this time standard in Van Dyck's repertoire (see fig. 23), few if any of his previous portraits of comparable sitters were full-length. A matching male portrait is easily imagined, but Susanna and Clara form so self-sufficient a composition as to need no male companion. This apparent self-sufficiency need not rule out the possibility that they once had one, because the history of the painting before the eighteenth century is not known. Eventually a Russian prince presented it to Catherine the Great for the Hermitage, from which it was sold in 1937 to Andrew Mellon (as a Rubens) for the National Gallery in Washington, D.C.

The identification of Susanna is based, somewhat questionably, on the likeness of this face with that in two works of art by Rubens: a drawing (in the Albertina, Vienna) that bears an inscription identifying the woman as "Rubens' sister" and an irresistible Rubens painting traditionally called *Le Chapeau de Paille* (in the National Gallery, London), representing Susanna after her second marriage. Clearly, this woman markedly resembles the Susanna in both the drawing and the painting: she has a rather small head, a deeply elongated oval in shape, large eyes, high cheekbones, a small pointed nose, and a narrow chin. Most striking, however, in all three portraits is her characterization as a rather volatile, alert personality with a lightly challenging, mischievous facial expression. The little girl is lively and sweet-natured but clearly adoring of and dependent on her mother. Although the gesture of the mother's right hand, the firm set of her lips, and the direct intensity of her eyes all show great protectiveness, she seems to be more at home in the palatial background than she would be with daily maternal chores and housekeeping. Certainly she is dressed as a grande dame, and her daughter to match.

They both look at us unwaveringly, Susanna's evident strength of character reinforced by the spotlight on her and the pyramidal composition of her pose. Perhaps also the dark stormy sky and the billowing drapery can be read as hints of a less than placid temperament.

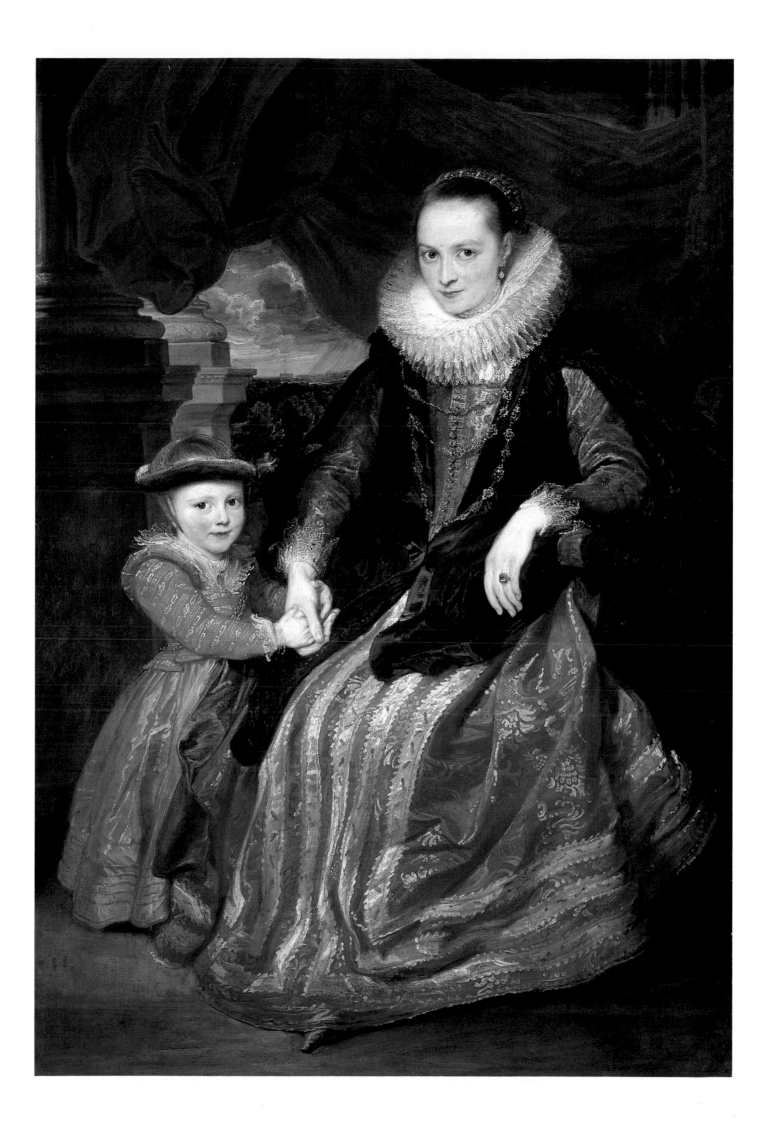

PORTRAIT OF ISABELLA BRANT

1621
Oil on canvas, 60¼ × 47¼" (153 × 120 cm)
National Gallery of Art, Washington, D.C.
Andrew W. Mellon Collection

According to the French art historian André Félibien in 1688, Van Dyck painted this portrait of Rubens's first wife (1591–1626) just before his departure for Italy, as a farewell present to the older painter. Unsurprisingly, it has a distinguished history: presumably inherited by the sitter's children, it then belonged to the great French collector Pierre Crozat (who attributed it to Rubens), from whose heirs the encyclopedist and art critic Denis Diderot acquired it for Catherine the Great of Russia. Andrew Mellon bought it from the Hermitage (still attributed to Rubens) for the National Gallery in 1937.

Recent scholarship has debunked Félibien's account of its origin as "romantic" fantasy. But the gift of the painting would have been the kind of gracious gesture to be expected of the young sophisticate we see in Van Dyck's contemporary self-portraits (see fig. 26), and one that Rubens would certainly have appreciated. For Rubens was devoted to Isabella, the mother of his three eldest children. When she died in 1626, presumably of the plague, he was almost inconsolable.

Judging from Rubens's own drawings and paintings of her, this is a good likeness. Van Dyck has depicted her as a little older and more matronly and a little less vivacious than Rubens did, perhaps out of respect for his patron's wife, who was eight years older than he. Often Van Dyck placed comparable sitters against pretentious imaginary architectural settings (see plate 9, figs. 22, 23). Instead, Isabella is seated at home, clearly at ease within the garden of her own magnificent establishment, and dressed in splendor appropriate to the wife of a man whose income was princely. She was not aristocratic; in an often quoted letter of 1634, Rubens explained that he had no desire "to make a Court marriage" lest his wife belittle his profession as a painter. Her father and brother were scholarly city officials, members of the professional burgher class like Rubens and Van Dyck. From his years of collaboration with her husband, Van Dyck must have known her well. He has presented her with the "goodness and honesty" mourned by her husband after her death. Her gaze is no less direct, forthright, and confident than Susanna Fourment's (see plate 9), but she is more thoughtful, and so secure in her position as mistress of the grand household as to be quite benign. Van Dyck has moved the statue of Minerva, the ancient Roman goddess of wisdom and the liberal arts, from its actual position in the garden so that it peers over her shoulder, as if to confirm his characterization of her. Isabella also holds one of Van Dyck's favorite flowers, the rose, symbolic of love.

The subtly exaggerated scale of her body in relation to her head suggests her stability. But the recessive diagonal composition, the agitated drapery, and the restlessly shifting clouds all serve to animate the image. The range of hue and value is wide and opulent, as is the vigorous impasto surface. The effect of a spotlight on Isabella's face brings out the warmth of her coloring, particularly in contrast to the blue of the sky behind her, and by implication the warmth of her personality as well.

If Rubens were pleased with the portrait, it may not have been for reasons of personal sentiment only: he may well also have recognized it as the young Van Dyck's guarantee of his ability to relieve him of the chore of painting portraits, which he found burdensome. This portrait is a milestone in Van Dyck's career, its splendor the sign of his newly established independence and the warrant of his complete mastery of the métier in which he was to achieve his greatest fame.

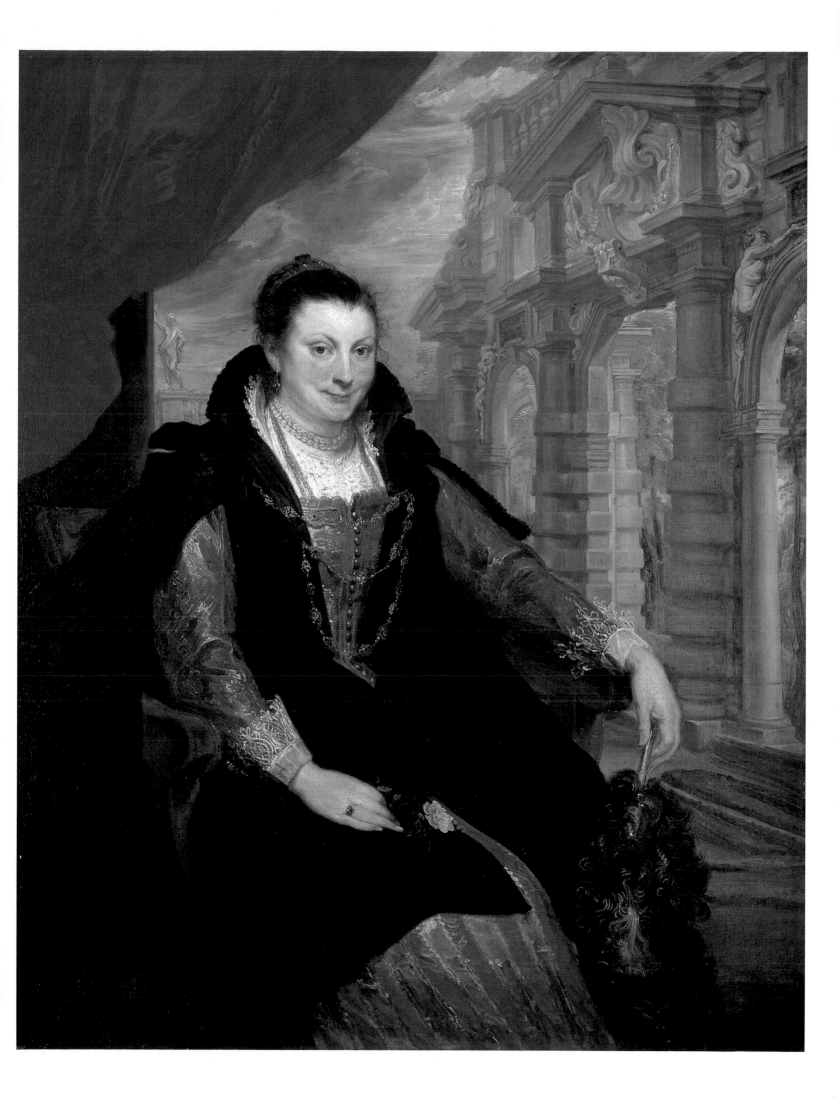

SUSANNA AND THE ELDERS

c. 1620–22
Oil on canvas, 76⅜ × 56¾" (194 × 144.2 cm)
Alte Pinakothek, Munich

Probably from early in Van Dyck's Italian trip, this painting belongs with the *Martyr-dom of Saint Sebastian* (see fig. 33), the *Portrait of Lucas van Uffel* (see fig. 31), and a few other works. They all share thick impasto, rich red and subdued earth colors, a dark periphery surrounding a lighted central figure, and a rather shallow space. They also correspond in some details: for instance, the same leering graybeard that clutches Sebastian's hair touches Susanna's shoulder; and there is a peephole to a distant golden sky in both pictures, just behind the arms of the brute tying Sebastian's legs and just above Susanna's right hand. The Venetian origin of the van Uffel portrait and such details as the similarity of the *fattura* of Susanna's robe and the tunic of Elena Grimaldi's servant (see plate 14) also argue for an Italian origin.

The composition seems to have been derived from a lost painting by Annibale Carracci, known through a print. Otherwise, this *Susanna* is the product of the almost overwhelming impact on Van Dyck of Venetian painting. The inspiration is less Titian's than Tintoretto's, but of his later colors and handling rather than his famous *Susanna* in Vienna. Tintoretto conceived his Susanna innocently drying her leg rather than terrified by the menace of her two molesters. Van Dyck's Susanna is already caught in the dark web of their lust and extortion, and like Sebastian with his captors, is at their mercy. Van Dyck's manipulation of the language of hands is masterful: Susanna, shrinking from the men, attempts to cover herself, while the older man caresses her flesh and the craftier younger man tugs at her robe with his right hand and emphasizes their threats with his left.

The story of Susanna is from the Apocrypha. It relates the misadventures of a virtuous Hebrew matron who was propositioned by two older men who spied on her while she was bathing. She refused them, so they accused her falsely of having committed adultery with a younger man, a crime punishable by death. When the accusation was disproved (either by Daniel's clever questioning or, according to another source, by divine intervention), the two lechers, rather than Susanna, were put to death.

Although the legend has acquired symbolic meaning in Christianity as referring to the salvation of pure souls or as the Church preserved from persecution (Susanna the lamb between two wolves), its popularity in the seventeenth century seems largely the result of its providing artists with the opportunity to represent a beautiful female nude in a compromising situation.

The suggestion has been made that the picture belonged to Gaspar Roomer, the great Flemish merchant and collector in Naples, during the mid-1600s. The first documented provenance is with the Elector-Palatine Johann Wilhelm at the end of the century.

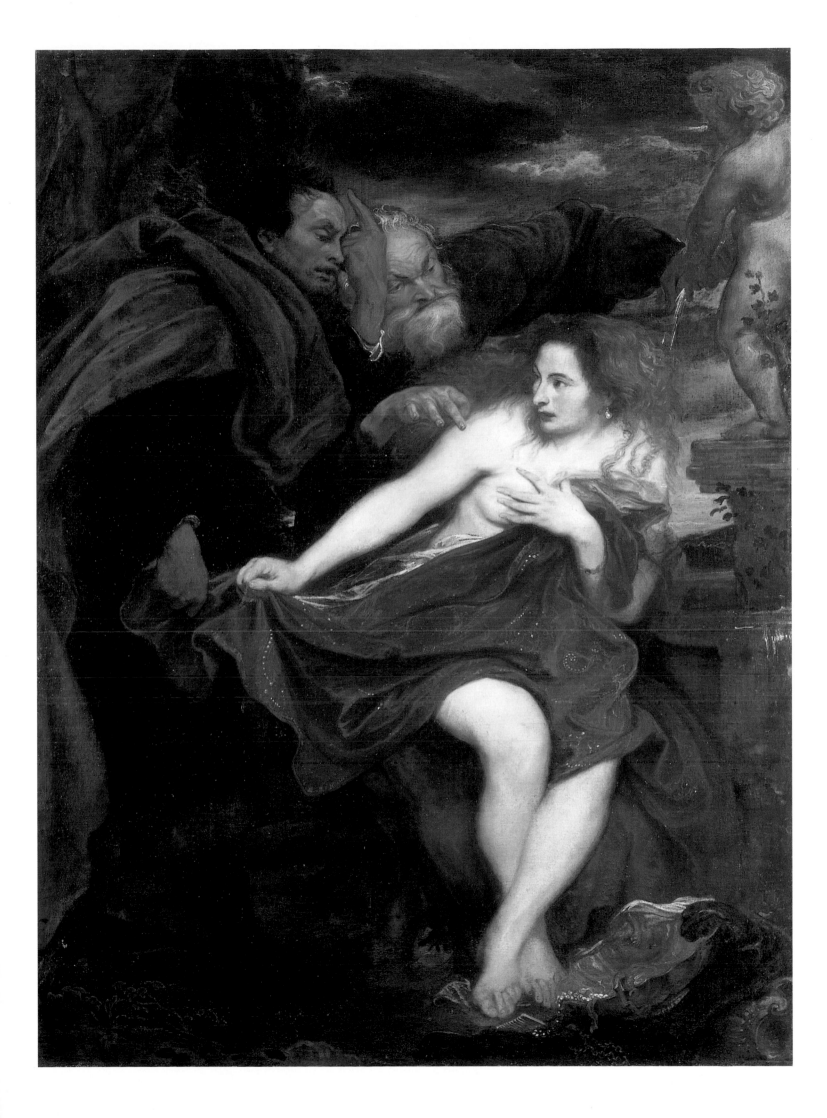

PORTRAIT OF AN UNKNOWN GENOESE LADY
(TRADITIONALLY IDENTIFIED AS A MARCHESA BALBI)

1621–22
Oil on canvas, 72 × 48" (183 × 122 cm)
National Gallery of Art, Washington, D.C.
Andrew W. Mellon Collection

Although the painting belonged to the Balbi family in 1819, when it was sold to the British consul in Genoa, the traditional identification of the sitter as one of the Balbi ladies has recently been disproved; none of them is known to have been of an appropriate age in the early 1620s. One of them, born Lucrezia Santfort in Antwerp, would be a likely candidate, but by 1615 she already had a grown son.

Van Dyck's sympathetic depiction of this radiant young woman succeeds in bringing what might have been a very somber, stiffly formal portrait to charming life. The composition is a reprise of Rubens's *Portrait of Veronica Spinola-Doria* (in the Kunsthalle, Karlsruhe), one of a number he did in Genoa during his visit there in 1606–7. Van Dyck eliminated Rubens's architectural setting (and his detail of a colorful parrot at the back of the throne-like chair) and managed to put his sitter at ease. So what in Rubens's hands was tense and almost iconic in Van Dyck's comes through as an appealing contrast of the solemn setting, the splendor of the costume and the Oriental rug underfoot, with the gentle youth of the sitter.

Van Dyck manipulated his very limited palette brilliantly. The drapery behind the head is almost totally neutral black. Otherwise, even the heavy black velvet skirt glows with an underlying warmth and is animated by the lightly scumbled highlights floating over its surface. No less a tour de force is his control of the brush and pigment to characterize the varied appearance of the gold brocade—its whole pattern glittering in the light on the cape and only whispering at the bottom of the skirt. The effect is so convincing as to camouflage the elongation of the sitter's body below the waist, a distortion indispensable to the patrician bearing with which Van Dyck endowed her.

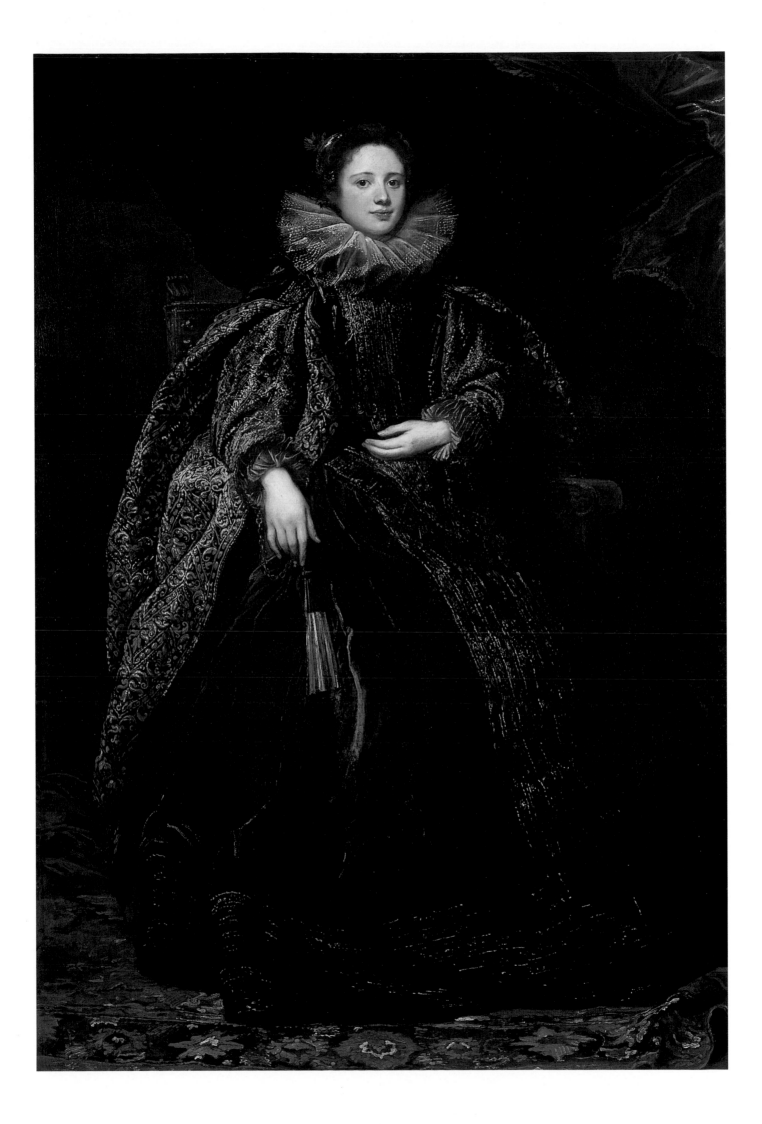

COLORPLATE 13

PORTRAIT OF THREE CHILDREN
(TRADITIONALLY IDENTIFIED AS OF THE BALBI FAMILY)

1622–23
Oil on canvas, 86¼ × 59½" (219 × 151 cm)
The National Gallery, London

Like Goya almost two centuries later, Van Dyck had a particular sympathy for children, as was already evident in Antwerp (see plates 8, 9). This portrait may be the first in which he depicted a child without an adult; it is certainly his first unaccompanied group of children.

They are posed like adults, and their elaborate costumes and the grand architectural setting establish their privileged status. The self-confident, slightly swaggering pose of the eldest shows him to be already aware of it. The youngest is still a baby, and looks out at us with an innocence quite different from the knowing brother.

The painting was recorded in 1780 in the Palazzo Giacomo Balbi of Genoa and has therefore been assumed to represent children of the family, although as a cadet member of the family, Giacomo was not in a direct line of inheritance. However, Van Dyck's contemporaries in the family were fairly numerous, and they had Antwerp connections and were among his best patrons in Genoa. So quite possibly these children were theirs, perhaps grandchildren of Nicolo, whose five sons were about Van Dyck's age.

The painting is more colorful than the *Portrait of Lucas van Uffel* (see fig. 31) and the paintings associated with it or the putative Marchesa Balbi (see plate 12). To some extent, this palette may have been dictated by the children's more colorful clothing. It seems indicative primarily of Van Dyck's evolving response to Venetian painting, specifically to Titian's *Portrait of Ranuccio Farnese* in the National Gallery of Art, Washington, D.C.

The crows on the steps in the foreground may convey some esoteric symbolic message that has been forgotten. If so, Van Dyck has disguised the secret meaning playfully. The fact that they are unafraid to feed so close emphasizes the children's harmlessness. Perhaps it can be interpreted as implying that underneath the formality of their poses and costumes, the children share the birds' unaffected nature.

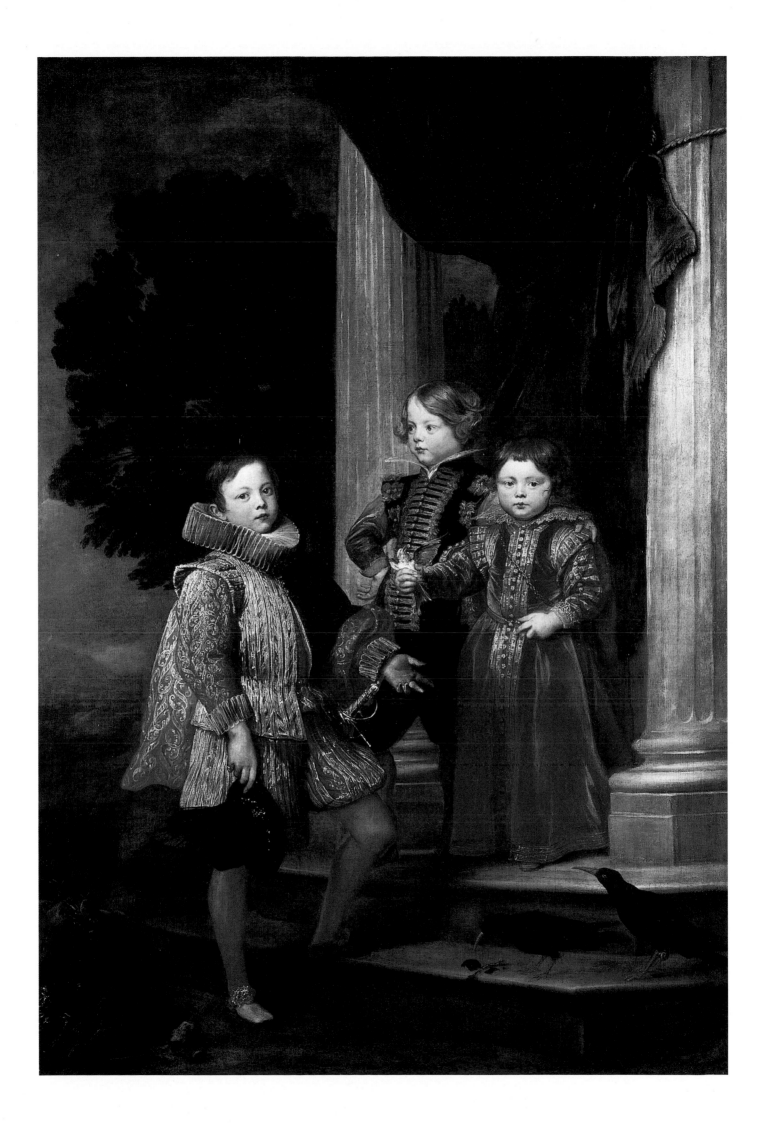

PORTRAIT OF ELENA GRIMALDI, MARCHESA CATTANEO

1623
Oil on canvas, 97 × 68" (246 × 173 cm)
National Gallery of Art, Washington, D.C. Widener Collection

The recent cleaning and conservation of this painting have restored its original colors and reduced it to its original dimensions by the removal of two strips on the left and right. As a result, the Marchesa seems physically closer to us, but, with her icy pallor and haughty demeanor, psychologically more distant. Van Dyck has dignified her not only by his usual devices and her exaggerated height but also by introducing the servant so solicitously following her. She shows no more awareness of him than of the umbrella shading her, as if he were another accessory, without human identity. In fact, he was one of the Moorish slaves that Genoese traders imported from North Africa.

The composition is owing to another Genoese portrait by Rubens, of Brigida Spinola-Doria (also in the National Gallery), of 1606. Originally full-length, it was cut down to three-quarter-length sometime after 1848, when the original format was illustrated in a lithograph. Van Dyck added the servant and reduced the breadth of Rubens's architecture to allow for the luxuriant landscape, indicative of great wealth in its vast emptiness. And he set his model in gentle motion, apparently inspired by a drawing of a Roman woman almost floating on a page in his Italian album (folio 112 verso), whom he probably sketched in midsummer of 1622. The influence of Venetian painting appears in the stateliness of the composition, echoing some of Titian's court portraits, and in such details as the blue and gold sky and the Veronese architecture.

The identification of the marchesa dates from 1780, when the painting was in the Palazzo Cattaneo in Genoa. The daughter of a Genoese Senator Grimaldi, she married Giacomo Cattaneo. Of their four children, two survive in Van Dyck portraits (also in the National Gallery). Both families took advantage of Van Dyck's presence in Genoa to perpetuate themselves.

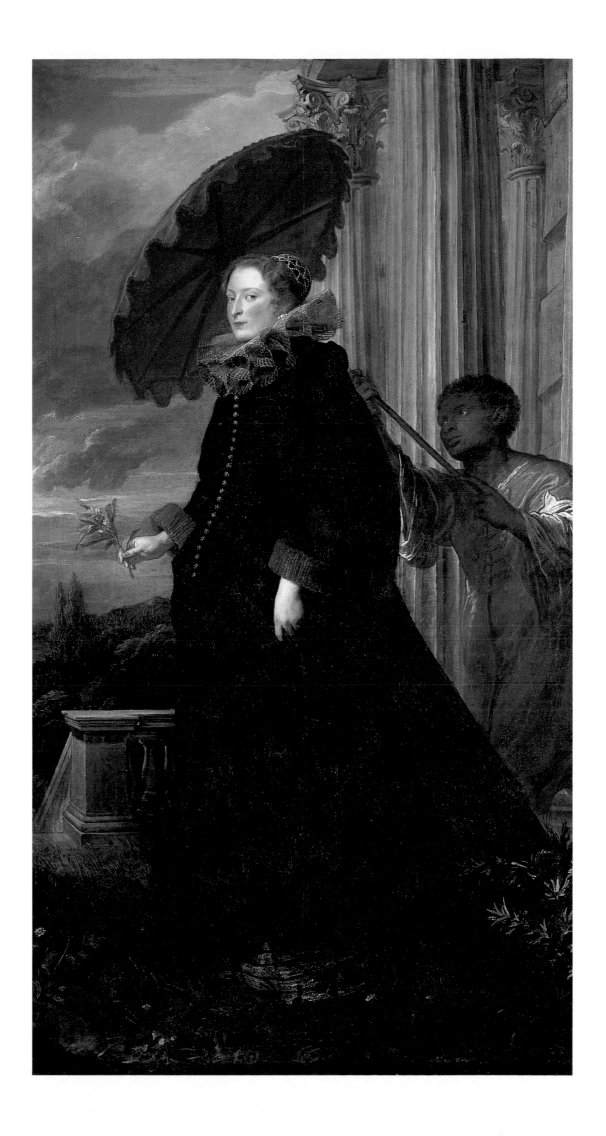

PORTRAIT OF A GENOESE NOBLEWOMAN
(FORMERLY THOUGHT TO BE PAOLA ADORNO, MARCHESA BRIGNOLE-SALE)

1623–25
Oil on canvas, 90⅞ × 61⅜" (230.8 × 156.5 cm)
The Frick Collection, New York

The composition of this standing portrait Van Dyck often repeated in Genoa, but the color scheme is exceptional. The palette is surprisingly light in tone and with a broader range of hues, apparently keyed to the white satin and gold braid and embroidery on the costume. The yellowish ground shows clearly through the white satin and has the effect of uniting the reds of the chair, the drapery, and the Oriental rug. The general tonality and details of the rest of the painting are, however, slightly muffled. Except for the figure itself and the brilliant illusionism of the satin and gold, the paint is laid on very loosely, and the setting is sketchy. The blue-gray neck ruff and the black outer edges of the cuffs give daring color accents. Altogether, this light-toned painting is a worthy companion of the dark so-called Balbi portrait (see plate 12).

The identification of the model as Paola Adorno, the first wife of Anton Giulio Brignole-Sale (see fig. 34), whom she married in 1625, has recently been rejected because she is not the same woman portrayed in Van Dyck's documented painting of Paola Adorno (in the Palazzo Rosso, Genoa). This young woman appears, at the same age and in the same dress, three-quarter-length in another portrait by Van Dyck (also in the Frick Collection), with an early nineteenth-century provenance from the Cattaneo collection. She toys with a gold chain across her chest, which has been interpreted very speculatively as a pun on the Italian word *catena* (chain) and the Cattaneo family name, which might also explain the "C" embroidery on her sleeve. So she has been identified hypothetically as Giovanna Battista Cattaneo.

Van Dyck has played with the perspective: we look down on the floor and the seat and right arm of the chair; the top of the chair back is about at the level of our eyes; and we look up at the tip of the woman's nose—making her seem about seven feet tall.

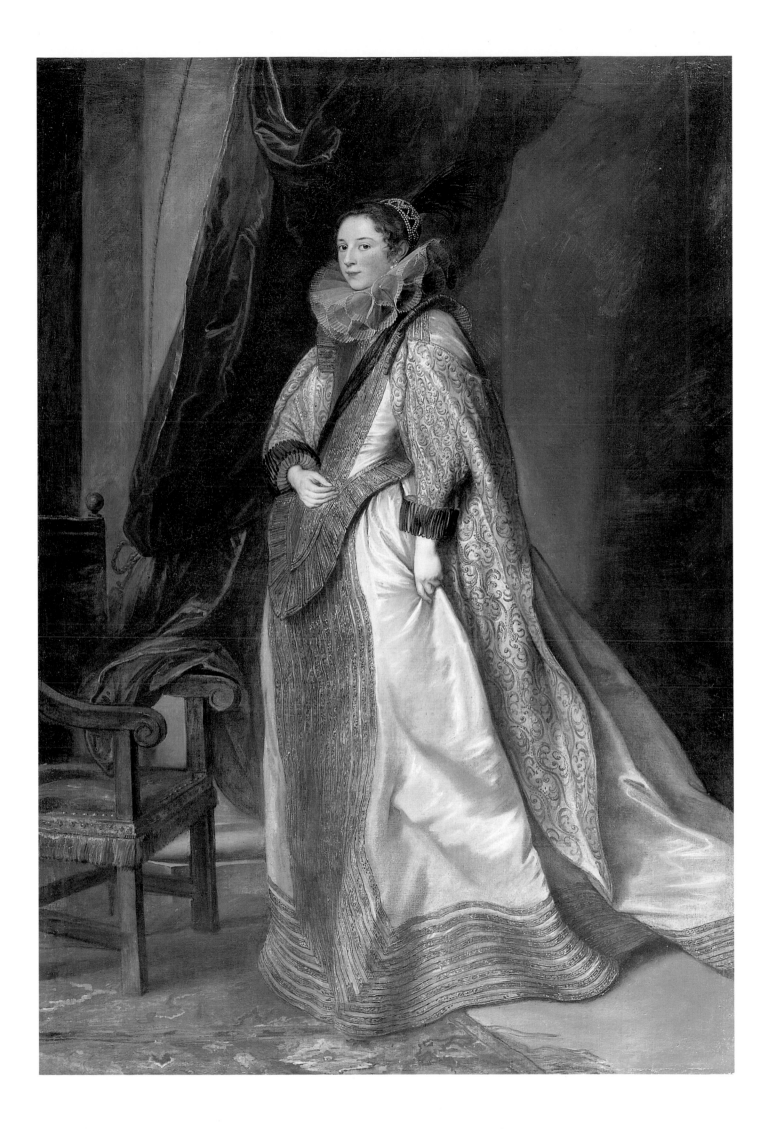

PORTRAIT OF CARDINAL GUIDO BENTIVOGLIO

1623
Oil on canvas, 77⅛ × 57⅛" (196 × 145 cm)
Palazzo Pitti, Florence

Guido Bentivoglio (1579–1644), a native of Ferrara, was a member of a leading Emilian family. He went to Rome in 1600 and had a successful career as a church bureaucrat. After serving as papal nuncio to James I of England and in Paris and the Spanish Netherlands, he was elevated to the cardinalate. He served as artistic advisor to the great collector Cardinal Scipione Borghese, the nephew of Pope Paul V, and oversaw the decoration of the family palaces of Pope Gregory XV. The climax of his influence was achieved under Urban VIII Barberini, who appointed him head of the Congregation of the Holy Office. He and his brother Enzo, themselves discriminating patrons and collectors, were intimates of the pope's family.

Van Dyck was a member of the cardinal's circle in Rome. The cardinal may have introduced him to Maffeo Barberini, soon to be elected pope, whose portrait (now lost) Van Dyck painted for Cardinal Bentivoglio. Van Dyck painted a *Crucifixion with Two Thieves,* about ten feet high, which has not been identified, and this portrait, probably in 1623 during his second visit to Rome. This date, which appears on a reproductive print of 1643, seems confirmed by the maturity of the style.

The Bentivoglio brothers lived in the magnificent Palazzo Borghese on the Quirinal Hill, and the opulent setting of the portrait might well recreate his study in the palace, appropriate for a prince of the church. The eagles on the chair back and in the carpet represent the Bentivoglio family emblem. The cardinal is depicted in his splendid scarlet satin cape and robes, turning as if his attention had just been distracted from the letter held in his hands. This active pose is consistent with the energy animating the picture in such details as the billowing drapery and in Van Dyck's rather thin and summary handling of the pigment. It is also consonant with the characterization of the cardinal as a lively personality. No less an authority than Cardinal Mazarin described him as "a man of angelic morals, a sweet nature, notable thoughts, prudent, wise . . . witty and ingenious." But Van Dyck recognized also the acute intellectual power within his vigorous, fine-boned body and the perceptiveness that qualified him as a connoisseur.

The painting was already in the Medici collection in the Palazzo Pitti by 1672, admired by Bellori as a good likeness that captured the "moderation of his spirit."

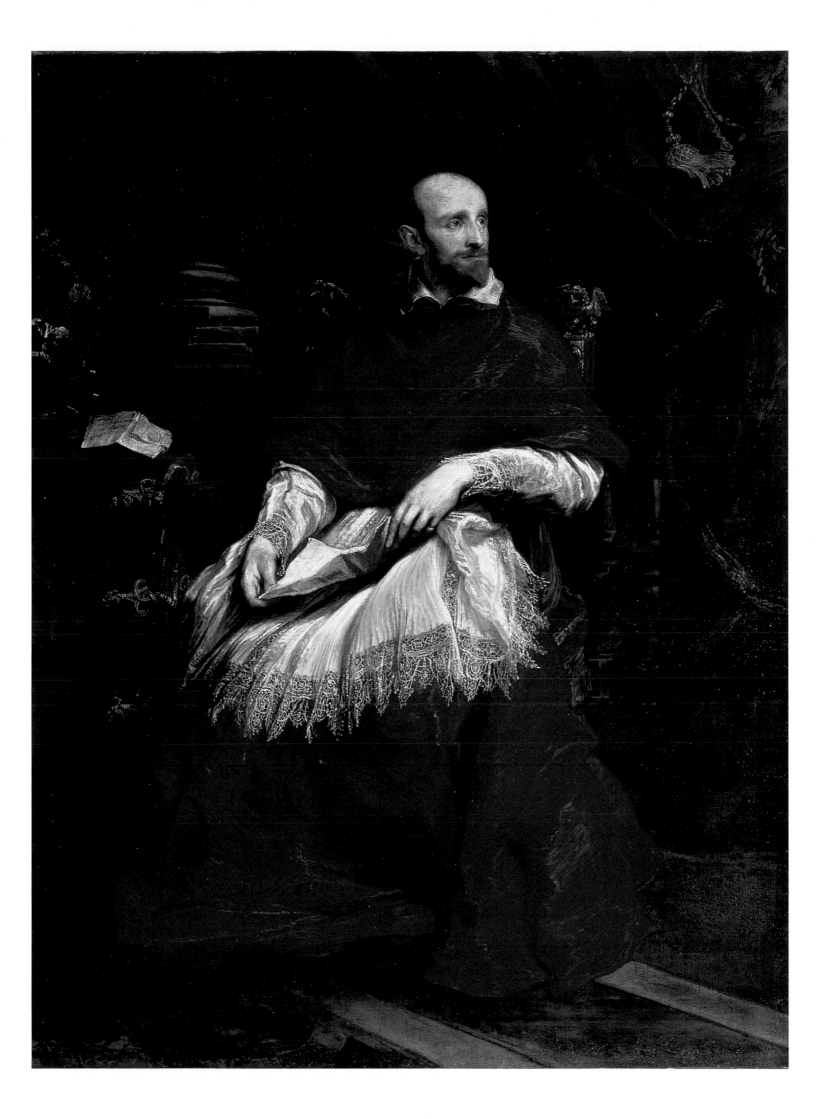

SAINT ROSALIA INTERCEDING FOR THE PLAGUE-STRICKEN OF PALERMO

1624
Oil on canvas, 39⅜ × 29¹⁵⁄₁₆" (100 × 74 cm)
The Metropolitan Museum of Art, New York. Purchase

Saint Rosalia was an aristocratic anchorite of the twelfth century who was one of the patron saints of Palermo. She had been generally forgotten until July 1624, when the city was in the throes of the plague. Then, providentially, her remains were discovered in the grotto in the Monte Pellegrino overlooking the city, where she had retired five centuries previously to live the life of a hermit. The discovery inspired her immediate rehabilitation, in the hope that she might intercede to lift the plague from the city. (She continues to be invoked against the plague today, and is thought to be effective against earthquakes as well.)

Van Dyck included Saint Rosalia among the five virgin martyrs in his *Madonna of the Rosary* (see fig. 40) and painted a number of pictures of her alone. Because she had been so neglected, she lacked any iconological tradition. So he invented one, presumably with the learned guidance and assistance of the Jesuits, who adopted the saint and sponsored her cult. Evidently, he associated this image with the Assumption of the Virgin, as was appropriate for a virgin saint. He represented Saint Rosalia as floating, supported by a cloud of putti, who crown her with the roses of her name and of divine love. The skull in the lower left corner may refer to the discovery of the relics and is also an allusion to the plague. Rosalia herself looks imploringly heavenward and pleads for mercy, gesturing toward the city of Palermo below her, as a beam of divine light breaks through the dark clouds.

Van Dyck painted this image over a self-portrait, sketched but not completed. The canvas has suffered from the ravages of time—the city has all but disappeared—but is clean and very colorful, with such surprises as the saint's green dress, the little swatch of scarlet drapery under the bottom central putto, and his brilliant blue wing.

As the picture was acquired between 1646 and 1649 by Antonio Ruffo, the great Sicilian collector, it may have been painted before Van Dyck returned from Palermo to Genoa in September 1624. It later belonged to Jérôme Bonaparte and was acquired by the Metropolitan Museum early in 1871.

Van Dyck also illustrated a pamphlet on the life of the saint, probably in 1629, the year of his altarpieces for the Confraternity of the Bachelors (see plate 21). Three of his preparatory drawings in pen and wash for the illustrations are in the British Museum, one of them indented for transfer; a fourth Saint Rosalia drawing in the British Museum is indented but there is no corresponding print. The only known copy of the pamphlet is in the Bodleian Library, Oxford.

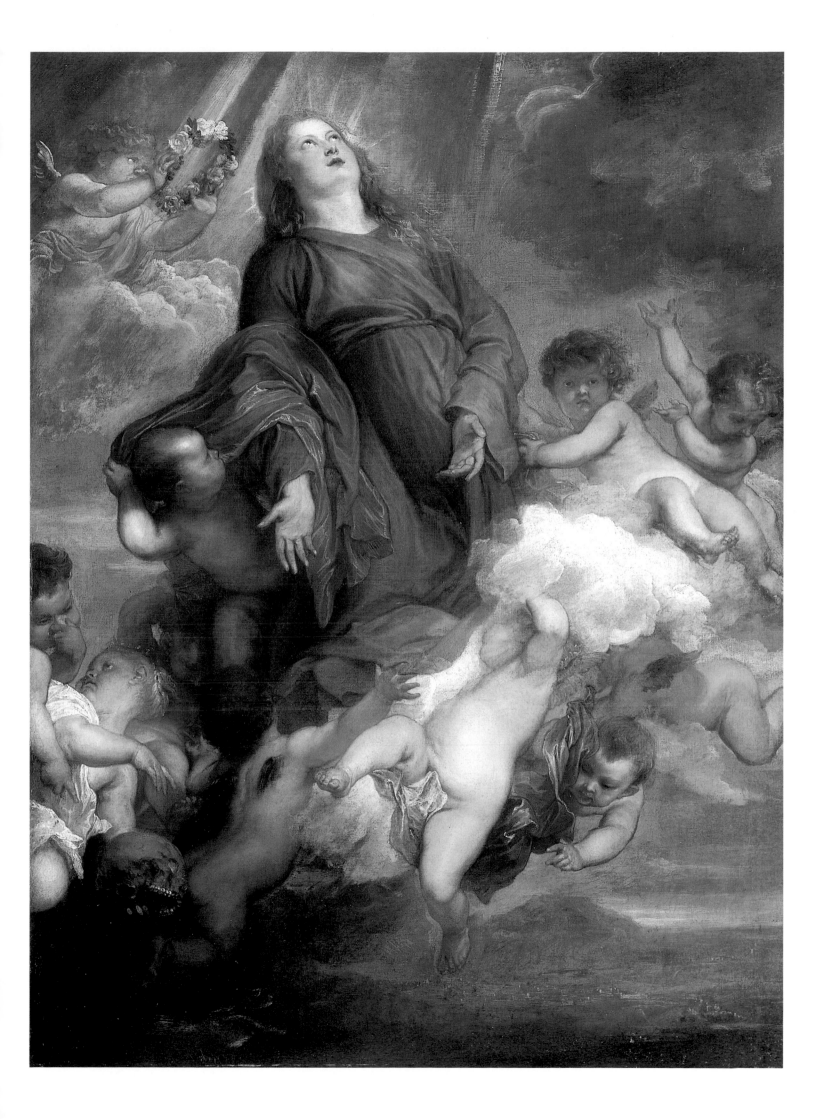

MADONNA AND CHILD (DETAIL OF FIG. 29)

1621–22
Oil on panel, 25⅜ × 19½" (64.5 × 49.5 cm)
The Metropolitan Museum of Art, New York. Fletcher Fund, 1951

One of at least seven versions of this composition, this painting is probably entirely auto-graph. It shows both the process and the virtuosity of Van Dyck's manipulation of the pig-ment. Incised contours indicate that he started with a full-scale drawing of the figures, which he then transferred to the still-damp ground, which is a relatively light, slightly warm neutral. He then applied the pigment thinly over the ground, the Madonna's exquis-ite, rosy hand contrasting with the baby's creamy flesh. The handling of the pigment is sen-sitive but rapid, fluid and assured, with most traces of the brush suppressed. Enough trace of the brush remains, however, to create a visual play between the actual texture of the semitranslucent pigment and the illusion of delicate flesh. Van Dyck's touch reflects his ten-der sentiment for the Madonna and Child.

Amusingly, the model for the Virgin had a dirty fingernail, even on so slender and patrician a hand. The seventeenth century was less fastidious about such personal details than the twentieth.

This painting, until 1917 in the collection of the Earl of Harrington, was, according to a family tradition, acquired by a seventeenth-century ancestor from Van Dyck himself.

THE THREE AGES OF MAN

1625?
Oil on canvas, 46½ × 64½" (120 × 165 cm)
Museo Civico, Vicenza

Bright as he was, Van Dyck was not an intellectual, and this allegory is the only instance of a philosophical subject in his Italian oeuvre. It is of a type, rare enough at any time in his oeuvre, to suggest that it was done at the request of someone more inclined to speculative thought. Whether intended to fulfill the wishes of a patron or not, the work has ample precedent in Venetian painting for its form and content.

Both Giorgione and Titian treated the subject of man's ages, the former in *The Three Philosophers* (Kunsthistorisches Museum, Vienna), the latter in *The Three Ages of Man* (on loan from the Duke of Sutherland to the National Gallery of Scotland in Edinburgh). Although neither of these paintings provided Van Dyck with this crowded, relieflike arrangement, the composition of the Giorgionesque *Musical* (in the Palazzo Pitti, Florence) comes close. The pose of the sleeping putto closely resembles that of the baby in *The Three Ages of Man* and belongs with a number of sketches of comparable infants in the Italian album. The soldier is reminiscent of Giorgione's warriors.

The dominant theme is the three ages of man viewed, as indicated by the presence of the woman, in terms of erotic love: the baby sleeps unaware of it, or unawakened; the old man turns his back to the woman, rejecting it; only the soldier is responsive. The centrality of his figure introduces a third theme, of duty, of resisting love's distractions, symbolized by the young woman and the roses that she proffers. The flower, evidently favored by Van Dyck, appears again and again in his oeuvre as the symbol of love, of one sort or another.

The first record of the painting is in the 1665 inventory of the collection of Carlo II, duke of Mantua. Presumably, therefore, it had been acquired by the Mantuan ruling family only after 1628, when Charles I bought the collection of the then-duke, Francesco I, who was bankrupt. The painting was acquired for the collection in Vicenza by inheritance in 1826.

THE VIRGIN MARY AS INTERCESSOR

1628–29
Oil on canvas, 46½ × 40¼" (118 × 102 cm)
National Gallery of Art, Washington, D.C. Widener Collection

With the exception of the palette, which is much lighter, the painting is closely related to the *Saint Rosalia Interceding for the Plague-stricken of Palermo* (see plate 17), both in conception and in the message of hope for humanity through the intercession of the women. The subject was formerly misinterpreted as the Assumption of the Virgin, understandably. Not only is the composition reminiscent of Titian's famous *Assumption* (then and now in the church of the Frari in Venice, where Van Dyck certainly studied it), but also many of the objects carried by the chubby little angels are appropriate to either subject. They are, in fact, the symbols of the Passion of Christ. The crown of thorns is borne by the putto on the top left; opposite, on the top right, a square of white material that might be Saint Veronica's veil is shown instead by its weight—it requires the putto to support it with both hands—to be a cloth holding something heavy, perhaps the nails of the Crucifixion; just below, another little angel is wrapping his head and shoulders playfully, if rather sacrilegiously, in the shroud; his companion, just to the left, lays the bloody scourge onto his back; the crucifix in the lower left corner with the orb signifies the world. Mary, instead of rising triumphant into heaven as in an Assumption, is kneeling, arms spread supplicatingly, in the beam of light cast down from above.

The symbols of the Passion identify the Virgin Mary spiritually with her son's suffering and death on the cross. Her spiritual death provides her, in Roman Catholic belief, the power not only to mediate for sinful humanity but also to offer, with her son and second only to him, the hope of redemption.

Another putto fluttering just above and to the left of Mary's head offers a crown of roses like Saint Rosalia's. The light tonality of the painting seems to have been determined by her dress, virginally white with pale yellow highlights reflecting the golden divine light. Her figure is set off by the yellow and blue-gray sky behind her.

Altogether, with even the reminders of Christ's agony on the cross relieved of their grim reality by the lively cherubs, it is a genial painting, optimistically hopeful that the Virgin Mother will prevail to gain salvation for humanity.

The canvas, too small for an ordinary church altarpiece, was probably painted for a private patron's chapel or gallery. It appears as a centerpiece in a painting of about 1670 by Hieronymus Janssens (in the Musée Anne-Louis Girodet in his native town of Montargis in central France) of just such a gallery, which probably existed, however, only in Janssens's imagination.

THE MADONNA AND CHILD ENTHRONED WITH
SAINTS ROSALIA, PETER AND PAUL

1629
Oil on canvas, 108¼ × 83⅜" (275 × 210 cm)
Kunsthistorisches Museum, Vienna

In 1628 Van Dyck joined the Confraternity of the Bachelors, a lay organization in Antwerp sponsored by the Jesuits. The following year he painted this altarpiece, for which he was paid three hundred guilders, and the similar *Vision of the Blessed Hermann Joseph* (also in the Kunsthistorisches Museum) for the Confraternity (see fig. 3j).

The antecedents of the painting are Italian. Titian's *Madonna of the Pesaro Family* (in the church of the Frari, Venice), which Van Dyck sketched in the Italian album (folio 28 verso), is the most obvious model, although Van Dyck reversed its composition. It is also modified, perhaps on the basis of his recollection of Lodovico Carracci's famous *Holy Family with Saint Francis* of 1591 (then and now in the Emilian town of Cento). To Veronese are owing the courtliness, the bright hues, the silvery atmosphere, and the brilliant illusionism of the fabrics. Although the sketches after Titian dominate in the Italian album, his were not the only paintings that Van Dyck documented. He recorded details from Lodovico Carracci (folio 9 verso) and Veronese (folio 2 verso) as well, although infrequently.

This kind of hieratic devotional altarpiece, with the Madonna and Child regally enthroned among adoring saints, was a popular variation of the Italian *sacra conversazione,* the seventeenth-century religious painting equivalent of the Grand Manner portrait. This Christ, another of Van Dyck's lively babies, greatly resembles Titian's Pesaro Jesus. He is extending a crown of roses to Saint Rosalia, who kneels before him with her other attributes of the lily and the skull. Her presence in the picture is owing to the acquisition of some of her relics by the Confraternity and the Jesuits' sponsorship of her cult. Saints Peter with his keys and Paul with his sword and books stand on either side of the throne, like the Queen of Heaven's ministers—Saint Peter the first Vicar of Christ on earth and Saint Paul his greatest missionary. Why the frowning Paul is so pensive and gloomy, with his hand on the sword, is uncertain; perhaps he is contemplating his martyrdom and death, or he may be distressed by the Protestant heresies in the northern provinces.

The Jesuits transferred the altarpiece to their own confraternity in the early eighteenth century only to lose it themselves to the Empress Maria Theresa in 1776, when their order was suppressed. She paid 3,500 guilders for it and moved it to Vienna.

COLORPLATE 22

REST ON THE FLIGHT TO EGYPT

c. 1630
Oil on canvas, 53 × 45¼" (134.7 × 114.9 cm); with
an addition at the top, 7⅞" (20 cm)
Alte Pinakothek, Munich

Van Dyck remained a bachelor until less than three years before his death. But he clearly had strong feeling for mothers and children (see, for example, plates 9, 21, 27, 35, and 38; figs. 29, 36, and 54). Apparently, he also had strong family feeling, not only for royal or patrician dynasties (see plate 34 and fig. 36) but also for his own kin. He dedicated pictures (or prints of them) to his father and his sisters (fig. 44). This painting may have been done for his younger brother, Theodoor (1605–1668), a canon of Saint Michael's Church in Antwerp. The engraving of the picture is dedicated to Theodoor, and an inventory made between 1640 and 1668 lists a *Rest on the Flight to Egypt* by Van Dyck in the brother's possession.

It is an intimate scene, showing the holy family in a natural landscape. The child is asleep, sprawled on his seated mother's lap, as in one of the Titians in the Italian album (folio 9 verso). She is watchful and protective as she caresses his shoulder. The elderly Saint Joseph, standing behind her, is pointing to his right with some anxiety, as if urging her to get under way again. Without his gesture, the serenity of the scene would be complete; because of it, we are reminded that the holy family is in desperate flight from Herod's soldiers.

This luxuriant landscape is only the physical background; the subtle suggestion of the historical background, of the flight to escape the fate of the massacred innocents, confers depth and poignancy on what would otherwise be simply a tender image of the holy family.

Van Dyck's conception of the Virgin may hint of a response to Michelangelo's *Pietà* (in Saint Peter's in Rome). Her costume is similar, with a veil over her head and loose voluminous draperies covering her body. Her body is exceptionally monumental and matronly; in comparison, her head is small and her face still very young. Her expression is sober; perhaps as she holds the warm body of her child she has a premonition of the cold corpse that she will support another time.

Van Dyck conceived of the subject as gently as Correggio, and with an understatement that permits tender sentiment without sentimentality.

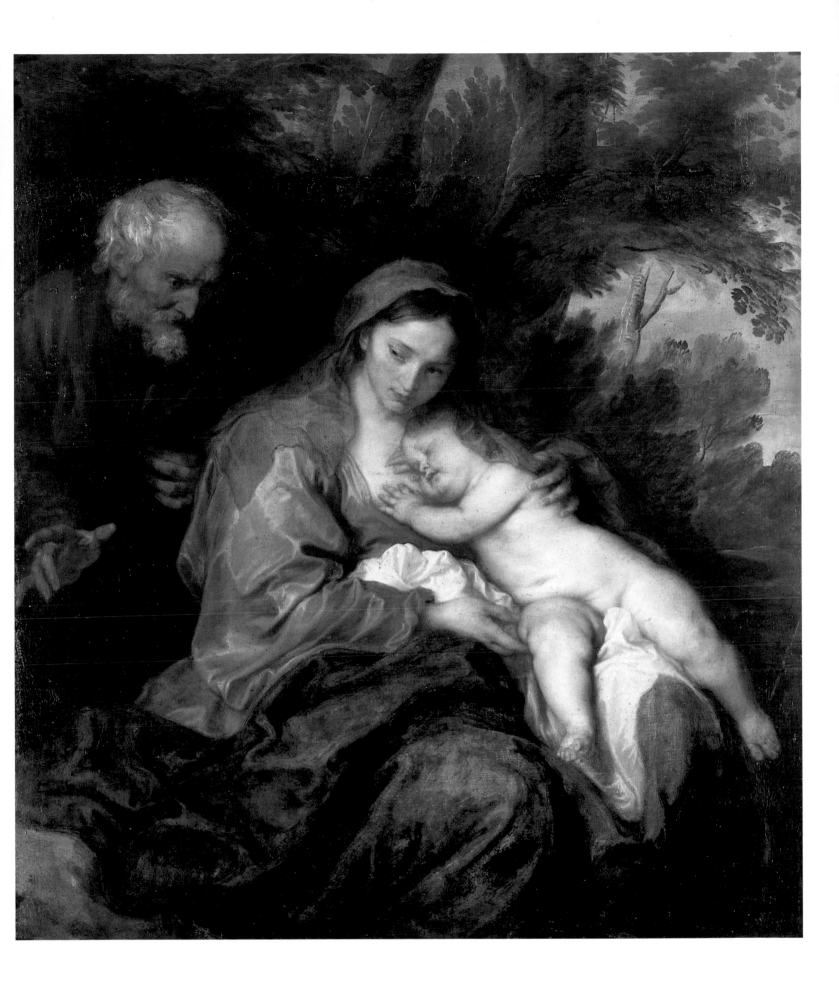

THE RESURRECTION OF CHRIST

c. 1631–32
Oil on canvas, 44⅞ × 37⅛" (114 × 94.3 cm)
Wadsworth Atheneum, Hartford, Connecticut.
Ella Gallup Sumner and Mary Catlin Sumner Collection

The composition is formed of two separate elements: the group of soldiers compressed into a dark wedge on the ground in front of the cave/tomb and the radiant ascending Christ. The source of the composition must have been the engraved illustration of the *Resurrection* by Theodoor Galle after Rubens's design in the *Breviarum Romanum,* published in Antwerp during 1612–14.

Van Dyck's version of the composition is less suave than Rubens's and even a little clumsy. It has little depth, and the rupture between the two parts is disturbing. However, the contrast between the solid agitated mass of soldiers and the convincing levitation of the weightless volume of Christ's body seems to substantiate the miracle of the resurrection, giving form to the two states of being, the confused emotions of the corporeal and the incorporeal bliss. Christ's right foot almost touches the small of the sleeping soldier's back, with an effect of spatial ambiguity that removes Christ from the three-dimensional world into another realm.

The composition is asymmetrical and a little lopsided, as if the painting were intended to be the right wing of a diptych or a triptych, with the Crucifixion to the left. Despite the relatively large size of the canvas, the loose but very assured handling and the lack of finish in details suggest that it may have been an autograph preparatory study, although neither any commission nor a larger more finished version is known. The similarities of the color scheme in the upper section to *The Virgin Mary as Intercessor* (see plate 20) and of some of the soldiers to Van Dyck's *Elevation of the Cross* of 1631 in Courtrai place the painting chronologically in the early 1630s.

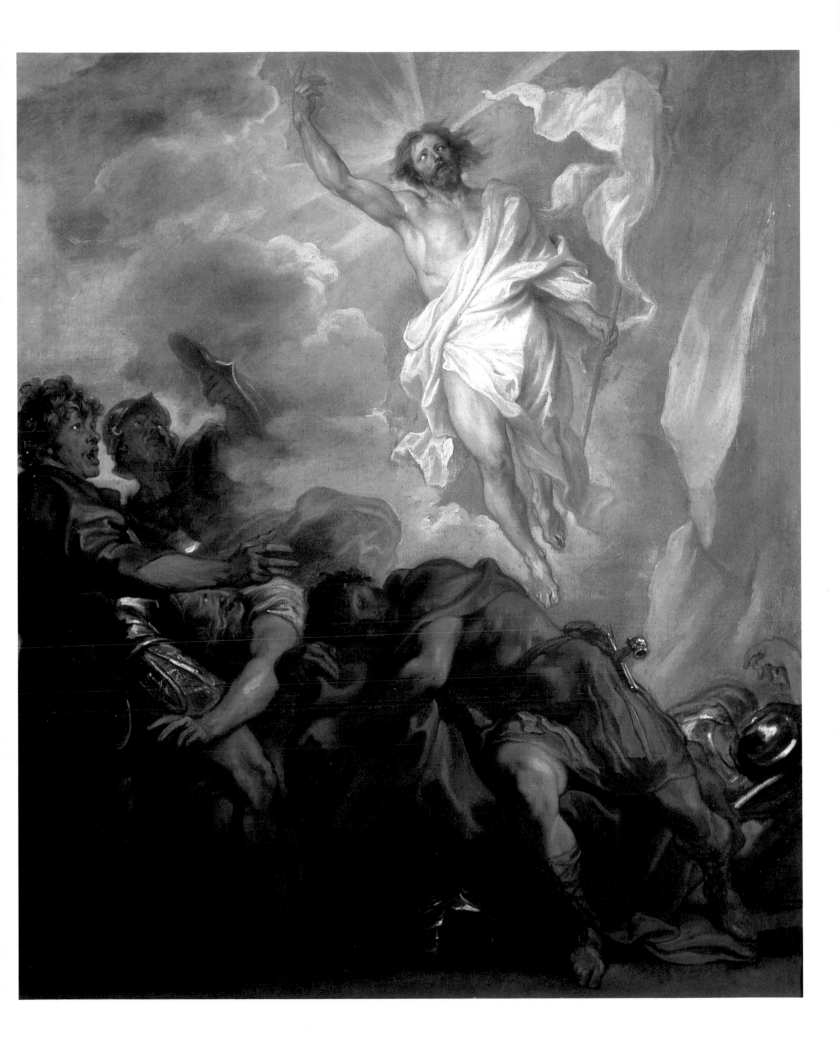

RINALDO AND ARMIDA

1629
Oil on canvas, 93 × 90" (236.2 × 228.6 cm)
The Baltimore Museum of Art.
The Jacob Epstein Collection

This painting was commissioned of Van Dyck by his friend Endymion Porter (see fig. 78) acting as an agent for Charles I of England. Van Dyck was paid seventy-two pounds for it and delivered it in December 1629.

The subject is from cantos 14–16 of the epic poem *Gerusalemme Liberata* by the Italian Torquato Tasso (1544–1595). The enchantress Armida has fallen victim to love at first sight of the Christian crusader Rinaldo, whom she had intended to kill. Instead, she binds him with a chain of flowers to hold him prisoner on her enchanted island, a fate he initially accepts willingly. Eventually, however, he comes to his senses and ends this happy interlude with her to return to his Christian duty of rescuing Jerusalem from the infidels.

The poem became universally popular and was translated into English in 1600 with a dedication to Queen Elizabeth. An analogy was made between Armida's island and the England of Queen Elizabeth and the early Stuarts, as both fortunate and blessed. Another analogy, equating Tasso to Virgil and *Gerusalemme Liberata* to the *Aeneid,* appealed to the court's liking for classical erudition and for amateur theatricals derived from classical themes. Charles himself, as Prince of Wales, had performed in 1625 as an ancient hero in a masque by Ben Jonson, *The Fortunate Isles and Their Union.* Soon after his accession to the throne and throughout his reign, similar masques were staged by members of the court.

By 1629, four years into his reign, Charles had become a practiced connoisseur and avid collector of paintings. He is very likely to have recognized the *Rinaldo and Armida* as a masterpiece, rivaled ultimately in Van Dyck's oeuvre of literary subjects only by the *Cupid and Psyche* (plate 39) of the end of his career.

The composition forms a kind of a whirlpool swirling through the peripheral landscape, locking the lovers together, and reaching its apogee centripetally in Armida's head. Van Dyck was at his most inventive in bestowing on the lovers a profligate richness of detail: the pearls of love entwined in Armida's hair; the sheet of music, perhaps from Monteverdi's lost opera *Armida,* in the seductive mermaid's hand; the playful putti hovering in the sky and beside Rinaldo; and the baby peeking coyly from behind Armida. This child originates in Titian's *Worship of Venus* (in the Prado, Madrid), and many other details, like the drapery billowing out behind Armida, are owing to his example, as are the color and the poetic spirit. However, whatever the lineage of Van Dyck's dreams, they were his own, inspired but not haunted by his artistic progenitors. The poetic conception, the wit and graceful style of this painting are as unmistakably from his magical imagination as the pyrotechnics of the execution are from his hand.

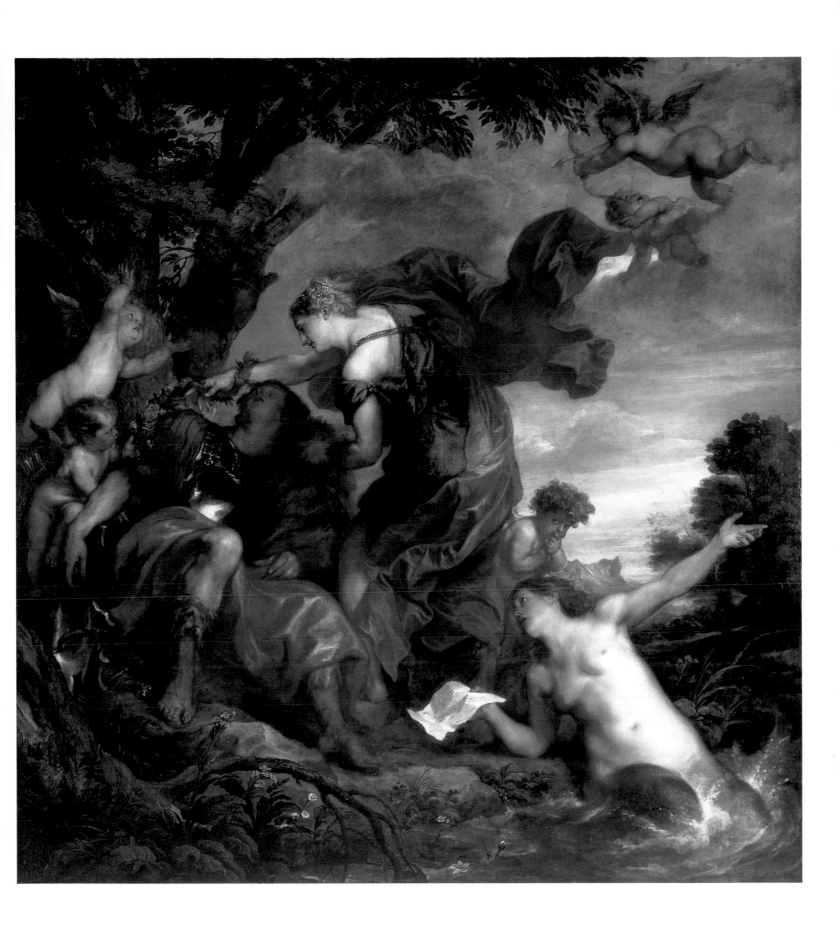

PORTRAIT OF PRINCE RUPERT STANDING

1631–32
Oil on canvas, 68⅞ × 37⅝" (175 × 95.6 cm)
Kunsthistorisches Museum, Vienna

When Van Dyck was visiting the court of Prince Frederick Henry in the Netherlands, he painted this portrait and a pendant of Rupert's older brother, Prince Charles Louis (1617–1680) (also in the Kunsthistorisches Museum). They were the sons of the unfortunate Elector-Palatine Frederick V and his wife Elizabeth, the sister of Charles I of England, often called the Winter King and Queen because of their very brief tenure as rulers of Bohemia. Caught up in the crossfire of the Thirty Years' War, they had lost not only Bohemia but also Frederick's inherited domain, the Palatinate in the Rhineland, and had taken refuge in Holland.

As a younger son, and one without a country, Rupert was at loose ends much of his life. But he was a man of great personal resourcefulness, and he made a remarkable career for himself. Throughout his life, he was in and out of the English court, serving both his uncle Charles I and then his cousin Charles II with distinction in their armed services, at different times as a general and an admiral. And, perhaps most remarkably, he achieved near-professional ability as a printmaker, particularly of mezzotints.

Unsurprisingly, none of this adventuresome future is evident or forecast in this superb portrait. The composition is based on a painting that Van Dyck owned, thought to be a Titian of the young duke of Milan. (It is actually by Sophonisba Anguissola and of another young aristocrat, the nine-year-old Marchese di Soncino; the best version of several is in the Walters Art Gallery, Baltimore). Prince Rupert (1619–1682) was a little older, but no more than thirteen, and Van Dyck has acknowledged some boyishness, particularly in the young dog looking adoringly up at him. He is a handsome boy, obviously to the manor born. Both the setting and the costume bespeak wealth, and his proud but relaxed pose and the directness with which he looks at us convey the self-assurance of his princely birth. How much of the awareness of rank was Rupert's own and how much Van Dyck contributed can only be guessed. But there is no hint that this elegant youth and his family were in fact refugees and relatively poor.

The color and texture contrasts are particularly ingenious: of the black doublet's mat velvet with the glittering black satin sleeves; of the whole suit with the gold chain across the chest; and of the neutral costume against the green satin drapery and the windblown violet and green landscape.

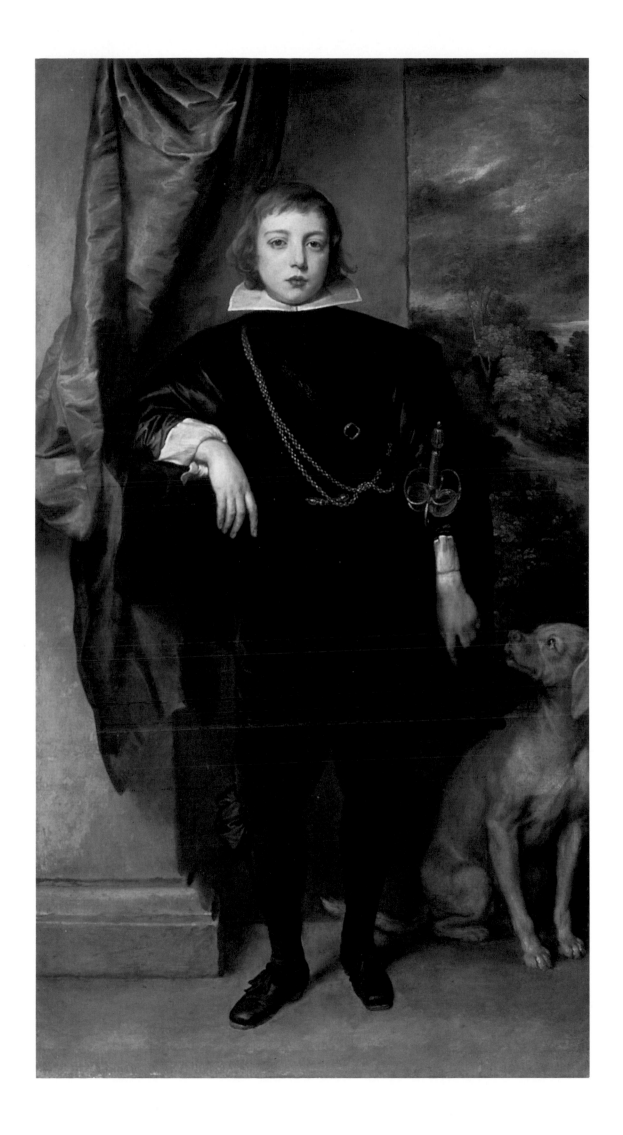

PORTRAIT OF THE PAINTER MARTIN VAN RYCKAERT

1630
Oil on panel, 58¼ × 44½" (148 × 113 cm)
Museo del Prado, Madrid

Martin Van Ryckaert (1587–1631) was famous as a painter of small, imaginary landscapes. He was also memorable as a one-armed painter, a handicap that Van Dyck has artfully concealed by exposing the right arm and covering the left with the coat. Careful scrutiny discloses his left sleeve to be empty.

The portrait is one of the very few on this large scale after 1621 that is on a panel rather than on canvas. In the Spanish royal collection by 1686, evidently it has been and was much admired: several copies exist, and it served as the model for Jacques Neeffs's engraving in the *Iconography*. Ryckaerts is seated on a broad, leather-backed wood chair, his pose almost symmetrical and uncompromisingly frontal. He is elaborately and colorfully dressed, in a white shirt under a scarlet satin smock belted by a light green satin sash and partly covered by a very heavy fur-trimmed coat with half-sleeves. The costume is topped by a floppy cap also trimmed in fur. The combination of the solidity of the pose, the bulky costume, and the direct focus of his eyes characterizes his personality compellingly. In surprising antithesis to the exquisite detail and small dimensions typical of his own paintings, he seems a powerful, determined, and forthright man. The sketchy spontaneity of the handling, the liveliness of the glittering satin highlights, and the twisting of the trim and the folds of the coat animate the image. If he were less preoccupied, it would nearly be a speaking likeness. The painting is a brilliant demonstration not only of the virtuosity of Van Dyck's brush but also of his insight into his friend's personality and of his ability to translate it into a visual image that conveys it convincingly.

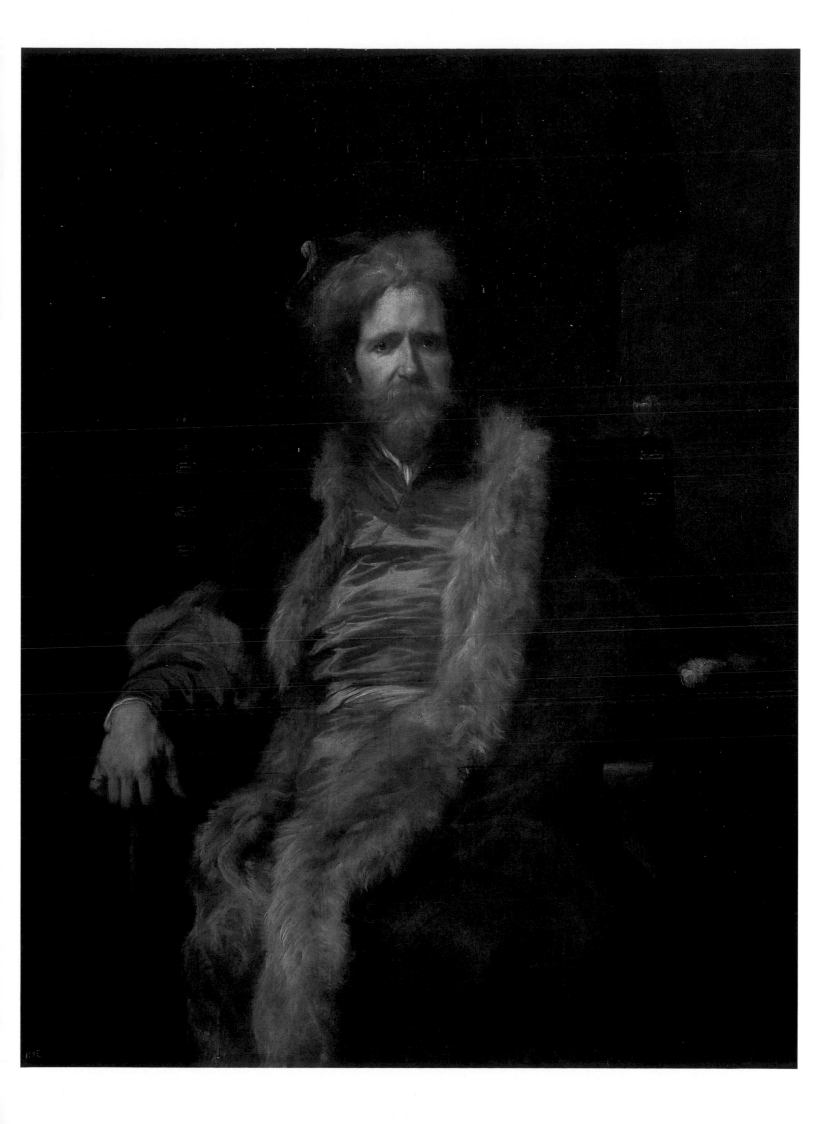

PORTRAIT OF A MOTHER AND HER DAUGHTER, PROBABLY ANNA VAN THIELEN AND HER DAUGHTER ANNA MARIA

1632?
Oil on oak panel, 48⅜ × 35¾" (122.9 × 90.8 cm)
Alte Pinakothek, Munich

The painting has usually been dated about 1630 but seems technically more like those of about 1620. In the Munich museum, it hangs together with a portrait of a man (inv. no. 603), also on an oak panel, of nearly identical dimensions, and of the same provenance. Both are listed, already as pendants, in the 1698 inventory of the collection of the Kürfurst Max Emanuel, which eventually evolved into the Alte Pinakothek. The adults are portrayed three-quarter-length and would face each other as pendants. Their poses correspond, although Van Dyck painted enough portraits in this format to make a mismatch of identities quite possible.

The man was identified as the painter Theodoor Rombouts (1597–1637) in the 1698 inventory. In an inventory of 1761, he is listed as the Antwerp sculptor André Colyn de Nole (1590–1638), perhaps because of a sculptured head at his elbow. Portraits of both Rombouts and Colyn de Nole appear in the *Iconography* engravings (such as fig. 71). While neither engraved portrait is entirely contradictory of the appearance of this sitter, neither conforms to it very exactly, although Rombouts looks somewhat more like him.

Rombouts's wife, Anna van Thiele, married him in 1627, and their daughter, Anna Maria, was born during the following year. The child in this portrait appears to be no less than four, and more probably five, which would date a portrait of Vrauw Rombouts as 1632 at the earliest, just before Van Dyck went to England. This date would correspond with the election of Rombouts as dean of the Guild of St. Luke, an appropriate occasion for portraits of himself and his family.

The fact that the portrait is painted on a wood panel might point to an earlier date. Although Van Dyck continued to paint on panels during the later 1620s and early 1630s, they were ordinarily in grisaille on the small scale of the preparatory sketches he made for paintings (figs. 52 and 66) and for his engravers rather than for portraits. During his youth in Antwerp, on the other hand, he often, if not customarily, painted his commissioned portraits on panels, only toward 1620 beginning to favor canvas. Although the stiff gorget ruff (as in plate 8) was standard in Antwerp during the 1610s, by about 1620 it was already being replaced by the shallower lace collar worn by this woman, as well as by Isabella Brant (see plate 10) and Frans Snyders (see fig. 22).

This portrait is more conservative than the canvases of Isabella Brant and Susanna Fourment (see plates 9 and 10), both in the restrained characterization of the shy little girl and her mother, who is alert but as wary as many of his male sitters, and in the *fattura*. Most of the paint layer is thin and, except for the opaque black of the woman's dress, allows the neutral yellow ground to show through, as is characteristic of Van Dyck's portraits on wood. Only in the girl's costume did he build up the impasto substance, as he did in the Fourment and Brant portraits.

The preparatory drawing in the Morgan Library in New York (inv. no. I. 244), however, is characteristic of those Van Dyck did in the 1630s. Presumably this portrait, like that of the Antwerp painter Martin van Ryckaert (see plate 26), which is also on a panel, manifests a moment of technical retrospection in Van Dyck's career.

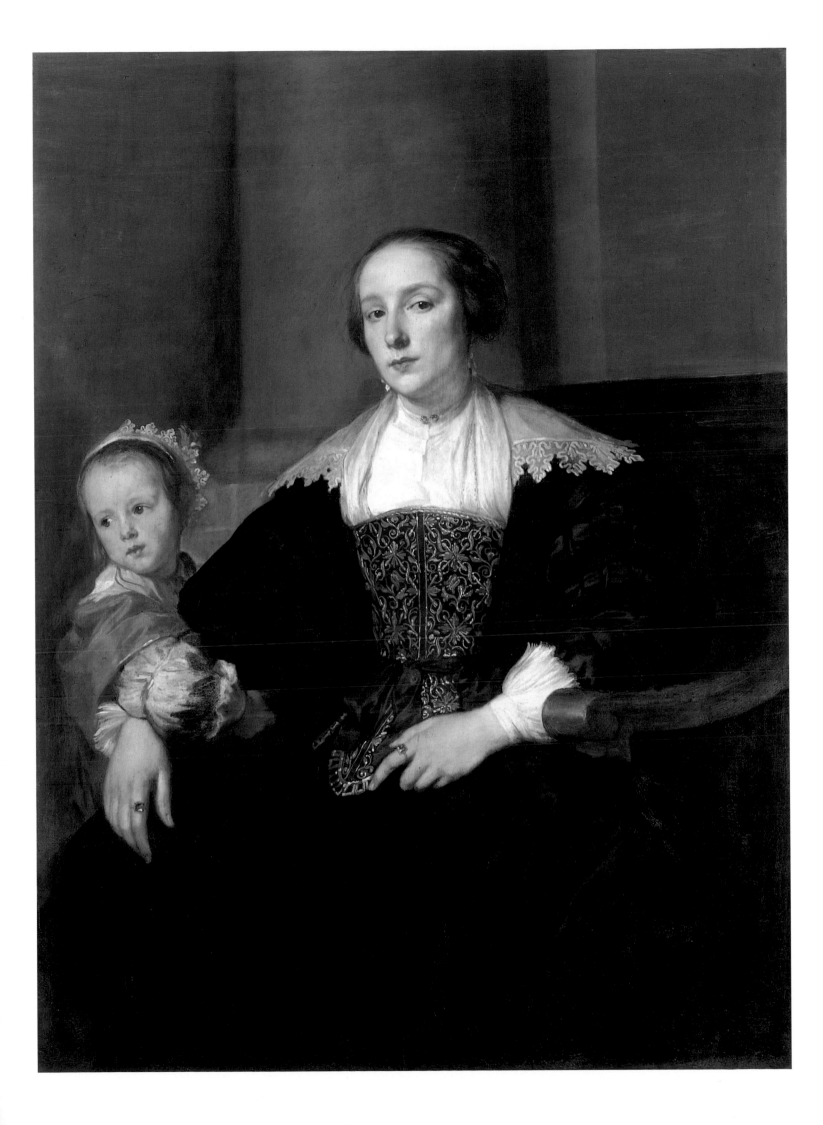

PORTRAIT OF QUEEN HENRIETTA MARIA
WITH SIR JEFFREY HUDSON

1633
Oil on canvas, 86¼ × 53⅛" (219.1 × 134.8 cm)
National Gallery of Art, Washington, D.C. Samuel H. Kress Collection

Henrietta Maria (1609–1669) was the youngest child of Henry of Navarre (Henri IV of France) and Marie de Médicis. She married Charles I in 1625, after his unsuccessful pursuit of a Spanish infanta for his wife. The marriage required a special papal dispensation and the bride's promise to attempt to convert Charles to Roman Catholicism and through him to return England to the church. Despite this less than auspicious beginning, after a few years together they became a devoted couple and she a loyal wife. In 1644, however, as Charles's political position deteriorated, she fled to France. She returned at the time of the Stuart restoration in 1660 but five years later went home to die in France.

Sir Jeffrey (1618–1682) was discovered about 1625 by the duke of Buckingham near his family home in Leicestershire. Then only eighteen inches tall, he was presented to the bride-to-be in a cold pie. He grew up to be forty-five inches tall, handsome and amusing. He was also loyal; he served as a captain in the royal forces during the Civil War, went into exile with the queen, and served her until her death. The presence of the monkey has been explained as possibly allegorical, referring to the soul bound by sensuality; the queen's gentle restraint of him would indicate that she had the passions under control. She had a liking for exotica and actually did own a monkey, which became Sir Jeffrey's pet and constant companion.

The queen, contrary to her appearance here, was diminutive, even shorter than her husband's five feet two inches. Clearly, Van Dyck put to good use the methods of flattering his exalted sitters that he had developed for his Genoese patrons (see plates 14 and 15). The formula is much the same: a tall, relatively narrow canvas, a low horizon line, and an opulent architectural and landscape setting. But this, like many other of his English portraits, has a quite different character.

Despite the crown at her elbow, Henrietta Maria never accepted coronation, refusing it from any but a Roman Catholic priest. She did not even attend her husband's coronation. Nonetheless, she was a legitimate queen and of ancient royal lineage. But she is much more approachable than Elena Grimaldi (see plate 14): she not only is aware of her servant but apparently is even solicitous of him and his pet; she looks at us directly with a kind of half-smile; and she wears a hunting costume rather than court dress. The colors of the picture are lavish. The total effect of the portrait, ostentatious as it may be, is engaging rather than intimidating.

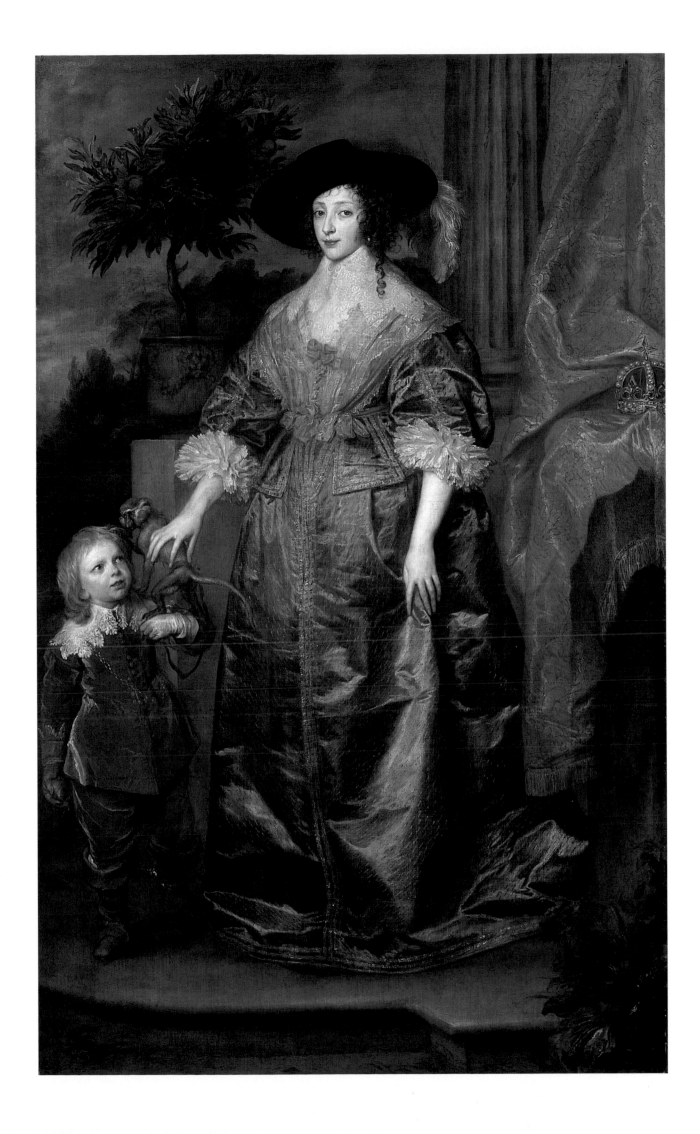

PORTRAIT OF CHARLES I HUNTING

1635
Oil on canvas, 107⅛ × 83½" (272.1 × 212.1 cm)
Musée du Louvre, Paris

The most famous of Van Dyck's portraits of the king, it was probably painted in 1635, for what specific purpose or place is unknown. Van Dyck asked two hundred pounds for it but was forced in 1638 to settle for half that. It is inscribed on the stone in the right foreground, "CAROLVS • I • REX/MAGNAE BRIT–/ANNIAE • &c" and signed "A.VAN DIICK • F."

Charles I (1600–1649), the second son of the first Stuart king of England, James I (James VI of Scotland), succeeded his father in 1625 and soon after married the French princess Henrietta Maria (see plate 28). They had nine children (see plate 30) and a happy family life. Charles was less successful as a monarch than as a father, and after a series of political and military catastrophes climaxed by civil war, he was tried by Parliament, condemned, and beheaded on 30 January 1649.

The king looks good-humored, as well he might be on so fine a day. He has dismounted to take a healthy stroll through the fresh air of the beautiful English wooded countryside overlooking the sea, with the Isle of Wight in the distance. He is dressed informally as a country gentleman, like Henrietta Maria for the hunt, but with a more casual elegance, in a white satin jacket over chamois or deerskin breeches and with a cavalier's broad-brimmed black hat. Armed with a rapier, he holds a walking stick in his right hand and carries leather gloves with full gauntlets in his left.

Van Dyck used several ingenious devices in addition to the customary low horizon line to center attention on the king. The hat sets off his face against the sky; he alone is fully illuminated; and he is depicted with more substance and more illusionistic detail than are his servants. The gentleman groom has been recognized as Endymion Porter (see fig. 78); the flaxen-haired adolescent page carrying the royal crimson cloak is unidentified.

Although this painting belongs to the well-established tradition of hunting portraits, it is exceptional in the complexity of meaning that has been imputed to it. The hunt was even given a moral value, as training the hunter in virtue and leading to the death of vice. The docile horse has been interpreted as symbolic of passion controlled by reason, as exemplified by the king. Particularly, however, the image has been burdened by the myth of Charles the sainted martyr-king that arose immediately after his execution. Legitimized in 1660 after the Stuart Restoration by Parliament's proclamation of his death date as a day of mourning, this fiction was dear to romantic historians of the nineteenth century and persists to some extent today.

Unquestionably, the portrait conveys a political message. In contemporary politics, it may refer to the king's control of the royal forests and of the ship tax, both important sources of the royal revenue and both resented and resisted by those taxed for them. The prominence given the walking stick may connote it as a symbol of royal authority. The king certainly displays it proudly. His commanding stance conveys his sense of himself as master by divine right of all this domain, where even the horse bows reverently to him (a motif from Titian recorded in the Italian album) and the very rocks proclaim him as king.

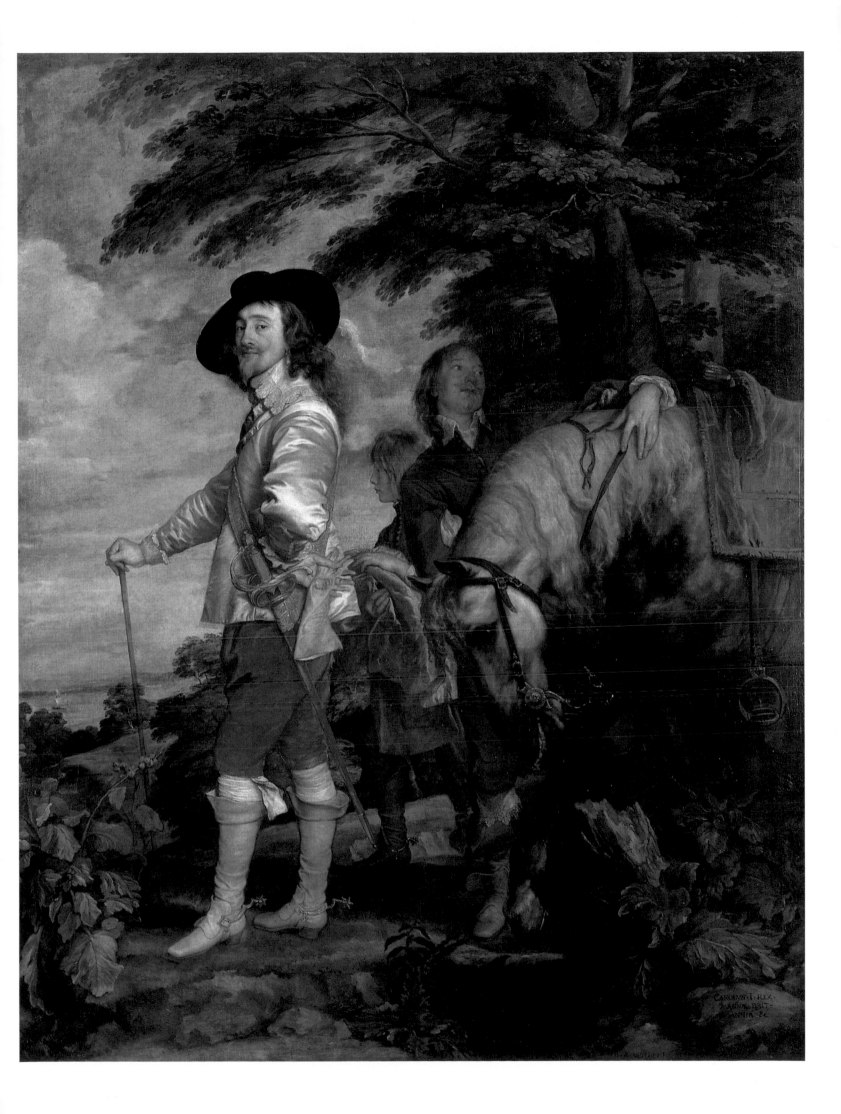

PORTRAIT OF THE FIVE ELDEST CHILDREN OF CHARLES I

1637
Oil on canvas, 52½ × 59¾" (133.4 × 151.8 cm)
Royal Collection, St. James's Palace

This picture provided Van Dyck the opportunity to combine three of his best sub-jects—children, dogs, and royals. Of his numerous portraits of the English royal chil-dren as they were born and grew up, this is the most elaborate in the sequence and portrays the most children. Only two who survived infancy are missing: the sixth, Prince Henry, duke of Gloucester (1639–1660), who was not born until two years lat-er, and the last child, Henrietta Anne (1644–1670), who became the duchess of Orleans.

The painting is inscribed with the names and birthdates of the children in Latin and signed "Antony van dyck Eques Fecit/1637." The surviving eldest, Charles, Prince of Wales (1630–1685), who was to reign as Charles II, occupies the center. The only one who is fully frontal, he already hints of his future power as his little hand dominates the placid giant mastiff. On the far left is the eldest daughter, Mary Princess Royal (1631–1660); in 1641 she was to marry Prince William II of Orange (1626–1650), who succeeded his father as stadtholder of Holland in 1647. With her, still in his baby dress, is the second son, James, duke of York (1633–1701), whose short reign as James II was brought to an end by the bloodless Glorious Revolution of 1688. The two children on the right are the Princess Elizabeth (1635–1650), who, although not yet two years old, is portrayed as her brother James's age and as taking responsibility for the baby Princess Anne. Anne was born in March 1637 and lived only until 1640. Perhaps fittingly, the second dog, a little King Charles spaniel, looks up at them a little tensely.

For this painting also, Van Dyck was paid only half of his asking price of two hun-dred pounds. But the king thought well enough of it to have it hung, in an elaborate-ly carved blue and gold frame, in the royal breakfast room in Whitehall Palace in London, where presumably he would have it before his eyes every morning that he was in residence. At the time of the Commonwealth it apparently was disposed of. Recovered at the time of the Restoration, it passed out of royal possession during the reign of James II. George III, who despite being a Hanoverian was generous to the Stuarts, bought it back in 1765.

The painting's kinship to the *Portrait of the Earl of Pembroke and His Family* (see plate 34) of a year or so earlier is evident. The scale is much smaller, the setting less osten-tatious, with a relatively modest still life of fruit (a rarity in Van Dyck's oeuvre) instead of a coat of arms and without a dais or the little angels. But the composition is comparable in format. The children are not holding court like Lord Pembroke, but they are not playing either. Instead, they are posed, on display in their finery. Engag-ing as they all are, at least the two eldest are very poised, without any trace of shy-ness, apparently aware of their privileged status and certainly accustomed to it. Van Dyck appears to have deliberately developed the contrast of their youth with the for-mality of the composition as a means of demonstrating his awareness of their royal destiny. Perhaps the older children are also aware. Only the baby acts entirely natu-rally and without self-consciousness.

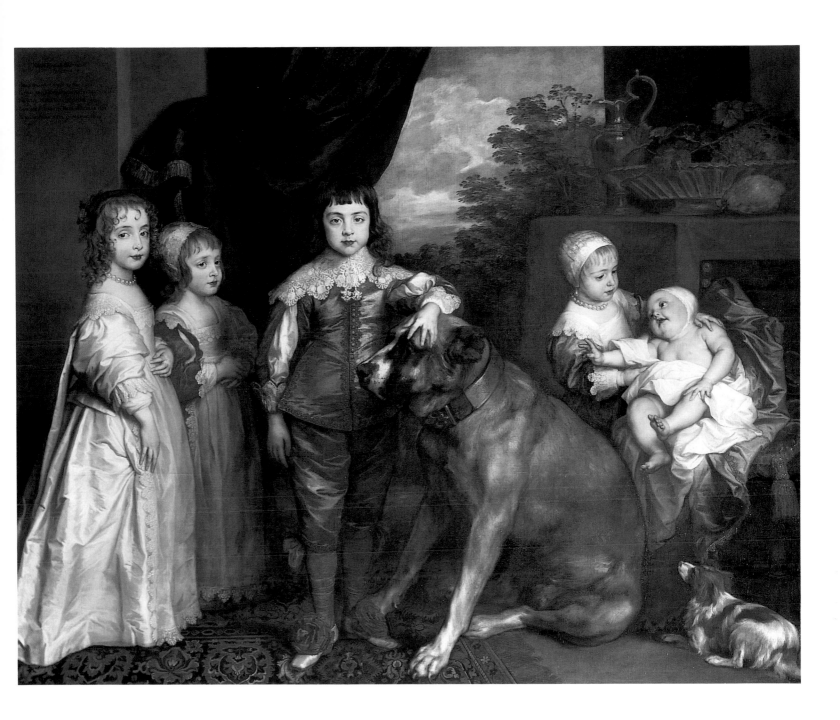

PORTRAIT OF JAMES STUART, DUKE OF LENNOX AND RICHMOND

1635–36
Oil on canvas, 39¼ × 63" (99.7 × 160 cm)
The Iveagh Bequest, Kenwood, London

James Stuart (1612–1655), who succeeded his father in the peerage of Scotland as fourth duke of Lennox in 1624, was universally admired as an amiable man. He was also one of the closest confidants and advisors of the king, his cousin by descent from the same great-great-grandfather. James Stuart was given his second dukedom, of Richmond in England, in August 1641 and shortly thereafter appointed Charles's Lord Steward. He and his brothers (see figs. 64 and 65) served the king faithfully throughout the Civil War. He survived his brothers and was one of the five peers who offered themselves to Parliament for punishment in lieu of the king. Their offer refused, it fell to him to perform a last, sad duty for his royal cousin: he arranged for Charles's burial in the Royal Chapel in Windsor Castle.

Van Dyck painted two other portraits of the duke: the ceremonious formal image as a Knight of the Garter (see fig. 62) and a half-length as Paris (in the Louvre), perhaps as a souvenir of some amateur theatrical performance at court. The face is distinctively the same in all three. This one seems the best and the most likely to have been painted from life. It is another hunting portrait, in this instance commemorating the duke's favorite dog, the giant greyhound, which according to tradition had saved his master's life in a boar hunt while the duke was traveling on the Continent from 1630 to 1633. The boar spear on the right probably refers to the incident.

Amiable the duke no doubt was, as Van Dyck has depicted him here, apparently without indulging in any more idealization of his rather plain features than emphasizing his rich head of chestnut hair. But Van Dyck has also conveyed the resoluteness of his character, particularly in the firm set of his mouth. Of all the portraits the painter carried out for the family (see figs. 62, 64, and 65), this is probably the most personal, despite the tactful reticence with which Van Dyck has observed the duke's personality. Young and relatively relaxed the duke may be, but he still commands the respect that Van Dyck discreetly provides him.

The painting is inscribed "L. Steward/Duke of Richmond."

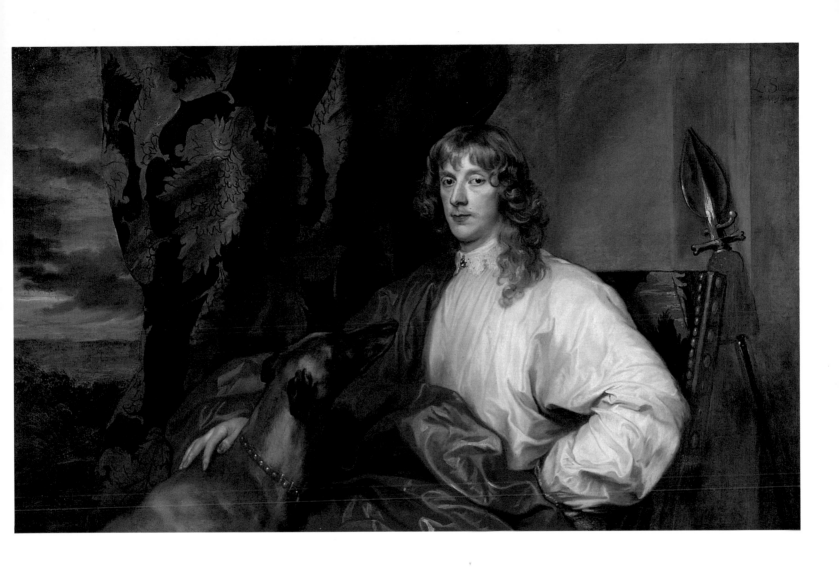

PORTRAIT OF THE EARL OF DENBIGH

1633–34
Oil on canvas, 97½ × 58½" (247.5 × 148.5 cm)
The National Gallery, London

William Feilding (c. 1582–1643), first earl of Denbigh, was very well-connected. In 1607 he married the sister of George Villiers, soon to become royal favorite and eventually duke of Buckingham; their daughter Mary was married (at age seven) to the king's distant cousin and close advisor the marquess (later the duke) of Hamilton, who was fourteen. In 1623 Denbigh accompanied Charles, then Prince of Wales, and Buckingham on their trip to Spain in search of a royal Spanish bride for the prince. He served Charles as Master of the Great Wardrobe and in 1636 was appointed English ambassador to Venice, acting on the king's behalf both conventionally as a diplomat and also as his agent in a relentless and sometimes ruthless pursuit of works of art worthy of the royal collection. Denbigh was not merely a royal sycophant: he died of wounds while serving in the cavalry during the Civil War under the command of Prince Rupert (see plate 25).

Denbigh was, in fact, an adventurous man; from 1631 to 1633 he traveled through Persia and India. The visit was private, although he carried letters from King Charles to the Shah of Persia and the Great Mogul in India. Such tours were expensive, very difficult and arduous, and sometimes dangerous. But they manifest already developing European interest in distant and exotic foreign lands. At just this time Rembrandt was making studies of Oriental costumes; Rubens had painted a portrait of a European dressed in Turkish costume; Frans Post (1612–1680) was visiting Brazil, documenting its colonization in paintings; and Lord Arundel (see plate 36) was contemplating exploitation of Madagascar and perhaps even migrating there.

In Rome during 1622, Van Dyck had already painted the shah's English ambassador to the pope, Sir Robert Shirley, and his Circassian wife in Persian costumes (both portraits now in Petworth House in Sussex). The Shirleys are simply posing; Denbigh is shown walking, accompanied by a small Indian servant, Jacko, who is pointing in the opposite direction or perhaps to the parrot. A story credited to Lady Denbigh is told about the painting: that her husband had lost his way and was led to safety by the native boy. Despite the costumes, Denbigh hardly seems to be in any very great peril in this tranquil landscape, which, except for the palm tree (apparently bearing large pears) and the parrot, could be the ordinary English countryside.

Denbigh's loose pink silk jacket and pyjama trousers were de rigueur for English travelers in the heat of India, and his fowling piece is of a type manufactured in France and Flanders around 1620. His well-fed, lumbering physique is not flattered by the costume, although one scholar perceives a recollection of the Apollo Belvedere in the pose. Nonetheless, Denbigh was well enough satisfied to present it to his powerful son-in-law, in whose inventory it already appeared in 1643.

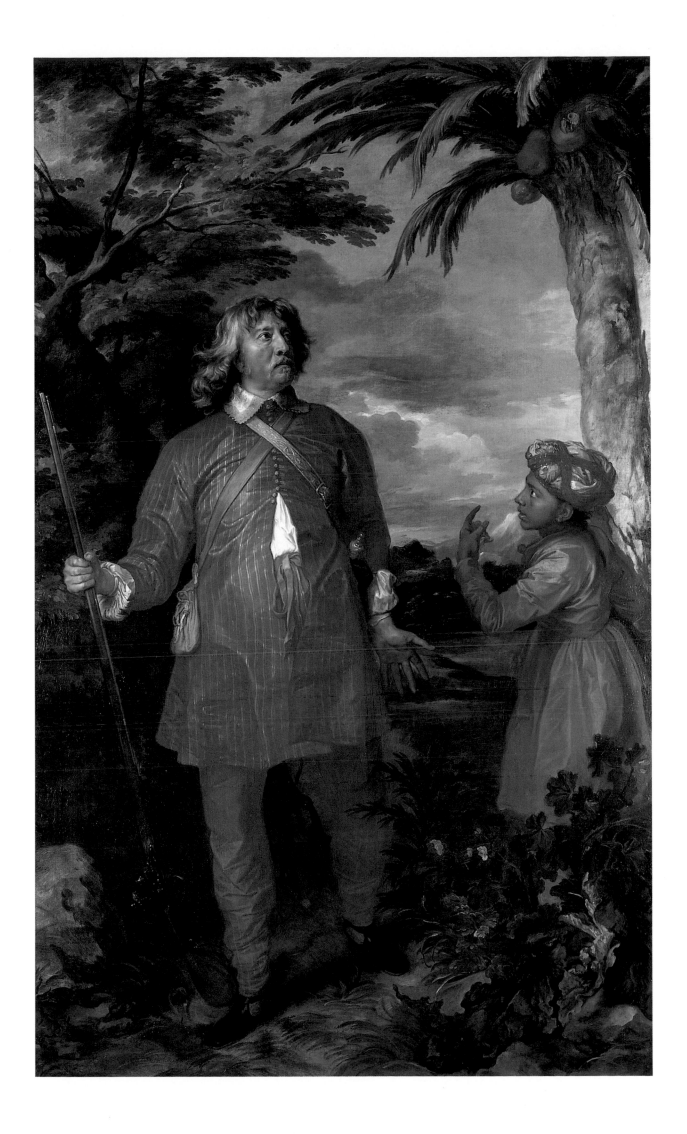

PORTRAIT OF ROBERT RICH, THE EARL OF WARWICK

1634
Oil on canvas, 81⅞ × 50⅜" (208 × 128 cm); with an addition at the top, 2⅛" (5.4 cm)
The Metropolitan Museum of Art, New York.
The Jules Bache Collection, 1949

Robert Rich (1587–1658) was a sailor. The eldest son of the first earl, he was honored in 1603 with a knighthood of Bath. Thirteen years later, he was licensed by the duke of Savoy as a privateer, a kind of legal pirate, a career brought to an end when he inherited the earldom in 1619. During the following two decades he was active in the royal service, commanding a small English fleet against Spain during 1627–28, commemorated in the naval engagement of 1627 in the background. After Charles's refusal to call Parliament from 1629 onward, however, he found himself increasingly in opposition to the king, resisting the royal forest laws and ship taxes. Despite this resplendent court costume and his adventuresome career, he was a Puritan, active in promoting the settlement of Bermuda and the colonies that were to become the states of Massachusetts, Virginia, Connecticut, and Rhode Island by emigrants seeking religious freedom. After being arrested in 1640, he took an active role on the parliamentarian side in the Civil War, being appointed Admiral of the Fleet in 1642 over Charles's veto and serving as Lord High Admiral from 1643 to 1645.

Van Dyck painted two portraits of the earl, one in armor (in the Wadsworth Atheneum, Hartford, Connecticut) and this, in civilian costume. Inscribed in the lower left corner "Robert Rich 2nd Earle/Warwick Uncle to Lady Mary/Countess Breadalbane," it is a formally posed court portrait, comparable to the many others calculated to flatter the noble sitters (compare figs. 34, 55, 62–65, 68–70). But Warwick is characterized as not only benign in personality but even approachable, smiling faintly and looking off to the left, as if seeing some distant, satisfying vision. And he is one of the very few patrician adults in Van Dyck's oeuvre who seems to feel entirely self-confident, without a trace of the wariness characteristic of most of his aristocratic male sitters.

Van Dyck must have taken much pleasure simply in the process of painting the highlights on Warwick's silver and gold brocade doublet and in contrasting the colorful costume with the magnificent gold brocade behind the earl. By combining half a dozen fabrics of different colors and textures with the glittering metal armor at his feet and the atmospheric landscape in the background, Van Dyck created for himself an opportunity to show off his technical virtuosity. His success in doing so without intruding on the characterization is itself proof of his virtuosity.

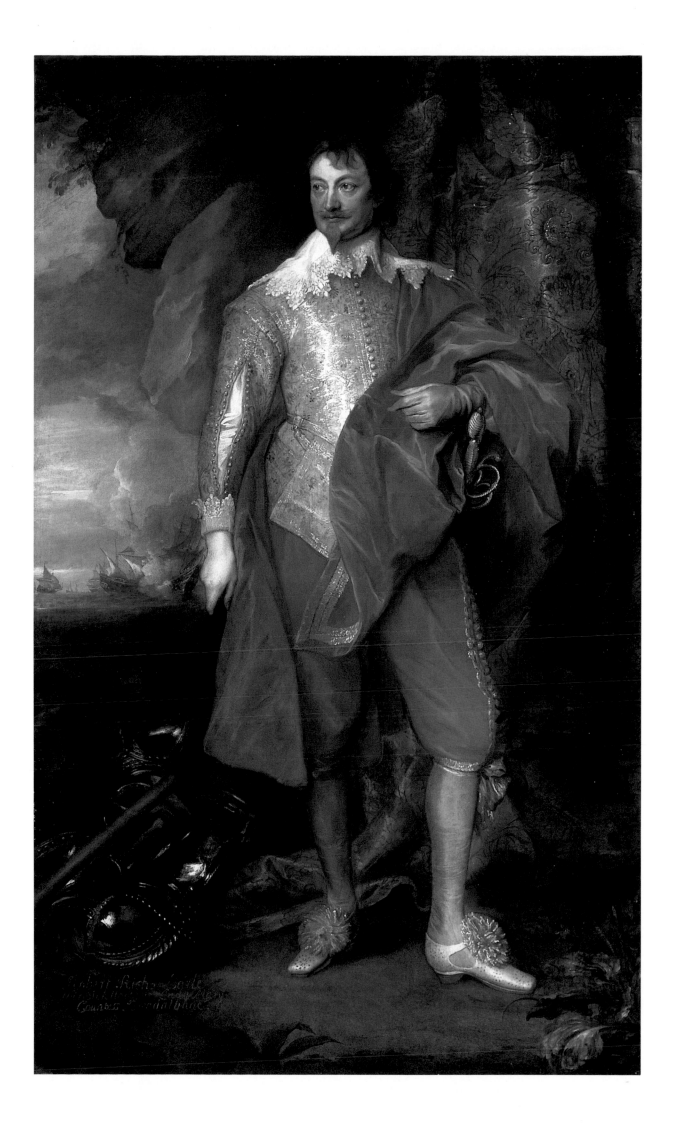

PORTRAIT OF THE EARL OF PEMBROKE AND HIS FAMILY
1635–36
Oil on canvas, 10'9⅞" × 16'4⅞" (330 × 510 cm)
Collection of the Earl of Pembroke, Wilton House, Wiltshire

Philip Herbert (1584–1649), the fourth earl of Pembroke, was said to own more portraits by Van Dyck than any other patron except the king; this enormous canvas is the climax. It was intended to celebrate a political triumph for the earl: the marriage of his eldest son, Charles, to Lady Mary Villiers (1622–1685; see fig. 61), daughter of the duke of Buckingham and beloved ward of the king; she was later to marry the duke of Lennox and Richmond (see plate 31 and fig. 62). The marriage to the Pembroke heir took place in January 1636 in Whitehall Palace. Unfortunately, young Charles, who soon after was sent to Florence for military training under the grand duke of Tuscany, died of smallpox within the year, aged only sixteen. The disappointment for Lord Pembroke was not only dynastic, it was also economic, because he lost the large dowry that Lady Mary brought—and with which he had intended to pay for the remodeling of the family seat, Wilton House.

The painting certainly aggrandizes the earl and his family. If Van Dyck had no exact model, there were a number of precedents for the composition, most representing rulers: Mantegna's fresco of the Gonzaga royal family, in Mantua; closer home, both Hans Eworth's strikingly comparable painting of King Henry VIII, at Sudeley Castle, and Holbein's mural of Henry VIII and Jane Seymour, which was destroyed by fire in 1698 but in the 1630s was at Whitehall, where Lord Pembroke had his London accommodations; and the portrait of the Buckingham family (in the royal collection) by an anonymous artist close to Cornelis Johnson. This painting may have hung at Pembroke's Whitehall rooms until it was installed at Wilton House sometime before 1683.

The earl and the countess, both in black court dress, are enthroned among his children in front of the many-quartered Pembroke coat of arms. He wears the insignia of the Order of the Garter and the key symbolic of his office as Lord Chamberlain, whose staff he carries in his left hand as he gestures toward the bride with his right. Van Dyck has subtly increased his domination of the group by depicting him in a slightly larger scale than the others. Judging from Van Dyck's several other portraits of the earl, this stern, worn, wintry face is a good likeness. The countess, Ann Clifford, was Pembroke's second wife. She is singularly withdrawn, her face expressionless and her hands locked together—and well she might be. The couple had obtained a legal separation in 1634, so her presence in the gathering is at best simply for the sake of dynastic form, and is probably fictive.

In fact, recent criticism has interpreted the whole painting as stagecraft, as it certainly would be even without the inclusions of the imaginary setting and the three little angels (conceivably the souls of three of the earl's children who had died in infancy) fluttering in the upper left of the canvas and scattering roses on the company. Van Dyck's staging might even be likened to a cast's curtain call, with all the actors gathered around the star according to their rank: the ill-fated heir at his father's right, with his wife given a prominent position just in front; his younger brother Philip, who succeeded as the fifth earl in 1649, standing behind him with unwitting presentiment; and the three youngest sons, still schoolboys, occupying the left foreground with their dogs, balancing the earl's eldest child and only daughter, Anne Sophia. She is holding hands with her rather dashing husband, the earl of Caernavon, who is dressed like the king for the hunt (see plate 29). All of the young adults wear bright colors, forming a vivid counterpart to the somber black of the earl and the countess.

If the painting seems conceived like stagecraft, it still serves the earl's real and important purpose of asserting the preeminence of his position in the hierarchy of the Stuart court. The significance Pembroke gave to it can be gauged by his hope that Van Dyck would carry out for him a companion portrait of the king and queen and their children.

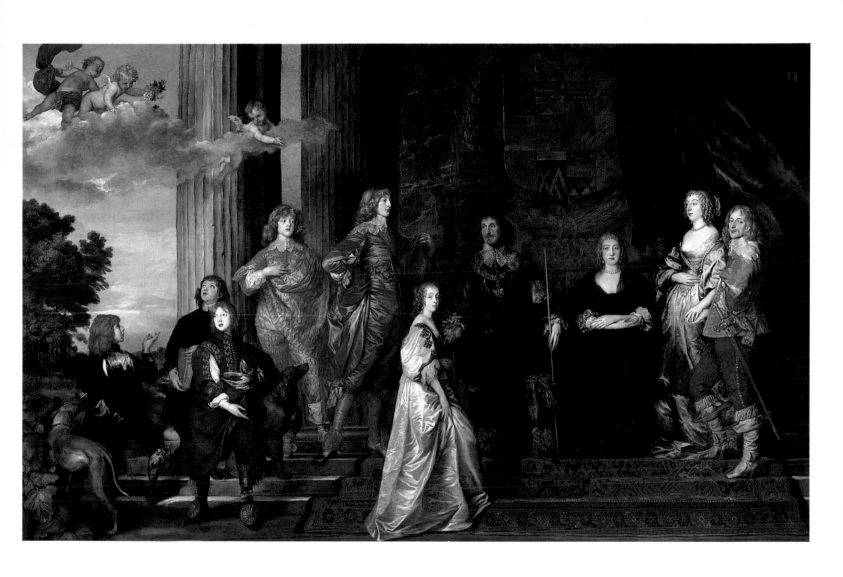

COLORPLATE 35

PORTRAIT OF THE EARL AND COUNTESS OF DERBY AND THEIR DAUGHTER

c. 1636
Oil on canvas, 97 × 84⅛" (246.4 × 213.7 cm)
The Frick Collection, New York

Despite the stiff conventionality of this portrait, both parents were quite exceptional among their contemporaries in the English aristocracy. The father, James Stanley (1607–1651), seventh earl of Derby—"The Great Earl"—succeeded to the earldom in 1642. He was less a courtier than an independent who believed in constitutional restraints on royal power. The author of some historical and religious works, he was the hereditary suzerain of the Isle of Man, which he ruled with much severity. Perhaps the Isle of Man is depicted in this landscape background; at the time of the Civil War in 1643 he withdrew there. However, his loyalty to the king led him to join the royal army. He served with Prince Rupert and eventually was captured by Cromwell's forces and executed.

The countess, Charlotte de Trémoille (1599–1664), was a granddaughter of the Dutch hero William the Silent and as formidable as her forebear, in the absence of the earl in 1643–44, successfully defending Lathom House, the Stanley seat in Lancaster, against the Roundheads. The color of the little girl's dress may have been chosen to signify her descent from the House of Orange. One of the Derby's nine children, she has been identified as either Henrietta Maria (died 1685), who grew up to marry the second earl of Strafford, or Catherine, later the marchioness of Dorchester.

Evidently, the parents' moral worth and strength of character did not strike a sympathetic chord in Van Dyck, for he treated the commission as a routine court portrait. His arrangement of their two figures is perfunctory. He portrayed the countess as notable primarily for her large pearls and beautiful satin dress (and for his own finesse in creating with paint and brush the effects of the opalescence of its shimmering colors). The earl, ironically in the costume of the court that he avoided, appears pompous and supercilious, although Lord Clarendon described him as "a man of great honor and clear courage." The painting is redeemed by the ethereal landscape and the charming little girl. Clearly, Van Dyck made sympathetic contact with her; her sweet, bright, playful innocence accentuates all the more her parents' artificiality.

The leaves in the lower right corner appear to be the same *Sonchus arvensis* as in one of Van Dyck's botanical studies (see fig. 76).

The inscription at the lower left of the painting, "Earl of Derby his Lady and Child," is a later addition.

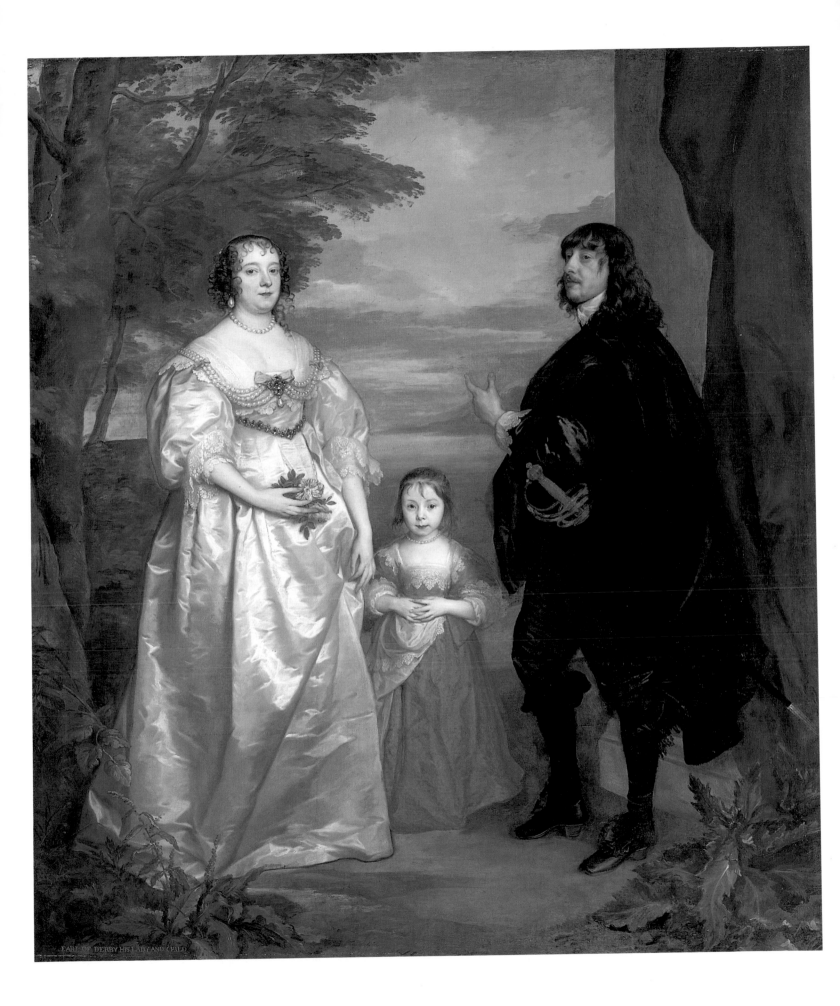

PORTRAIT OF THE EARL AND COUNTESS ARUNDEL
(THE "MADAGASCAR" PORTRAIT)

1639
Oil on canvas, 55 × 83¾" (139.7 × 212.7 cm)
Reproduced by permission of His Grace The Duke of Norfolk

Thomas Howard (1585–1646), second earl of Arundel, and his wife, Aletheia Talbot (died 1654), are remembered for many reasons: he was a man of unequaled integrity but a difficult and contradictory character, the premier peer of England, rightfully the duke of Norfolk, and eventually one of Charles's most valuable advisors; she was a rich heiress, daughter of the famous Bess of Hardwick and hardly less determined, although not political. Together they were indefatigable travelers, insatiable art collectors, and patrons of scholars and artists, including not only Van Dyck but also Rubens, Inigo Jones, Wenceslas Hollar, and Lucas Vorsterman the Younger.

In this portrait, however, they appear as potential explorer-colonizers. The Portuguese in 1500 had been the first Europeans to set foot in Madagascar, but the island and its inhabitants had not yet been exploited. In 1636 Lord Arundel had become interested in the island's potential for commercial development, with Prince Rupert (see plate 25) proposed as governor. Three years later, with the king's permission and the support of some investors, the project was under way, and a party prepared to set sail. This portrait may have been done at just that moment, with the earl and the countess presented as its promoters.

They wear their most impressive costumes, their ermine coronation robes, the countess with a small coronet and the earl with the chain and insignia of the Order of the Garter. He also wears a breastplate as a military commander and holds the baton of the office of Earl Marshal in his left hand while pointing with his right to Madagascar on the globe. Perhaps as he gazes into the distance he envisions a flourishing tropical colony. The countess has an astrolabe, the predecessor of the sextant, in her lap and directs her compass also toward the globe and Madagascar, "like some elderly Muse of Navigation," according to the recent Arundel biographer. The paper balanced precariously on the globe's frame carries their heraldic animals, the Howard lion and the Talbot dog, together with Arundel's motto, Concordia cum Candore. In the background right are two ancient sculptures from their collection, one of bronze, perhaps now in the British Museum, the other of marble, now in the Ashmolean Museum in Oxford. Despite all the preparations and the justification implied by the emphasis in this portrait on their rank, the project was canceled: the earl fell ill, he was terribly in debt, and the countess (to quote the same biographer) had no interest in "holding court in a jungle," as her melancholic facial expression might suggest. Before long they would leave England forever and go separate ways.

The portrait was nonetheless popular. Another version in the Kunsthistorisches Museum, Vienna, is thought by some authorities to be the original, although this painting was inventoried in 1655 after the countess's death and has been in the possession of the Howard family ever since. A third version (in the collection of Lord Sackville at Knole) includes another man who may be the Arundel's librarian, Franciscus Junius, but more likely is their art agent and beloved companion the Rev. William Perry, who died in September 1639. And there are still other painted versions, perhaps reflecting not only admiration for the Arundels but also the fascination for exotic foreign lands awaiting exploitation (compare plate 32).

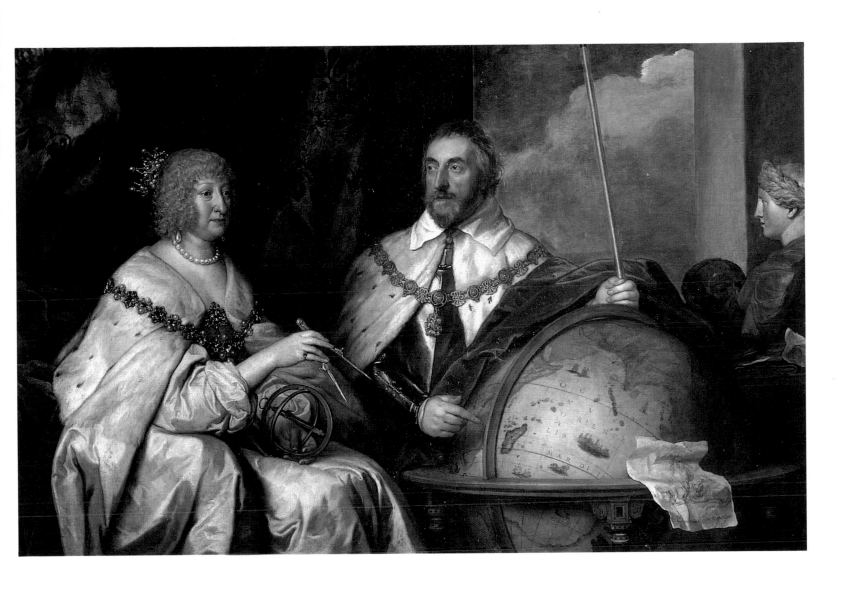

PORTRAIT OF THOMAS KILLIGREW

1638
Oil on canvas, 41¾ × 33⅞" (106 × 86 cm)
The Trustees of the Weston Park Foundation / Bridgeman Art Library, London

Despite this arrogant characterization, Thomas Killigrew (1612–1683), the son of a knight, was a wit, a poet, a gentleman-dramatist, and a theatrical promoter rather than a peer. He served as a Page of Honor in the court of Charles I and was faithful to the Stuart cause. After surviving the Commonwealth, eventually in 1677 he became Master of Revels in the restored court of Charles II, and according to Samuel Pepys served as a kind of court jester privileged to mock high and low with impunity. He also founded the Theatre Royal in Drury Lane in 1663. He married an aristocratic wife, Cecilia Crofts, who died two years later in 1638. Her death and that of the wife of her brother, Lord Crofts, just two weeks later, inspired Van Dyck's great double portrait of the two newly bereaved young men (now in the royal collection). This double portrait belonged to the leading portraitist of the Restoration court, Sir Peter Lely (1618–1680), who was also a discriminating collector, particularly of drawings.

The identity of the sitter is verified by his likeness in the double portrait, despite his quite different mood. It is confirmed by the inscription of his name and family's coat of arms on his affectionate mastiff's collar, which has disappeared from this version of the portrait but is still legible in an excellent second version at Chatsworth. Van Dyck signed and dated this canvas "Ant Van Dyck F. / 1638."

Although there is no documentation of contact between Killigrew and Van Dyck, they were surely acquainted in the royal court and presumably friendly, both because of their status there and their mutual involvement in the arts. Correspondingly, the image is in the half-length format, like Titian's *Man with a Glove* (in the Louvre), that Van Dyck often used for portraits of his intimates, with attention concentrated on the sitter and unencumbered by any setting or more supplementary detail than the dog.

It is, however, not only a character study, compelling as Killigrew's personality may be. Rather, as in the *Portrait of the Painter Martin Van Ryckaert* (see plate 26), the costume has been given nearly equal attention. Killigrew clearly was not only clever but also very stylish, affecting great elegance of manner and dress, even to mimicking the king's hairstyle, with much longer locks falling on his left shoulder than on his right. Despite the breastplate (which may have been an afterthought), the hilt of the sword, and the riband across his chest, this costume seems a dandy's rather than a soldier's, and more suitable to the salon than the battlefield. The overall effect of personality is that of a subtle young sophisticate. However different, this characterization is as convincing in its impact as that of the forthright old burgher Van Ryckaert. Van Dyck's approach to both portraits is the same: to take full advantage both of his extraordinary insight into character and of his equally brilliant technique to create images uniquely individual that simultaneously seem archetypal.

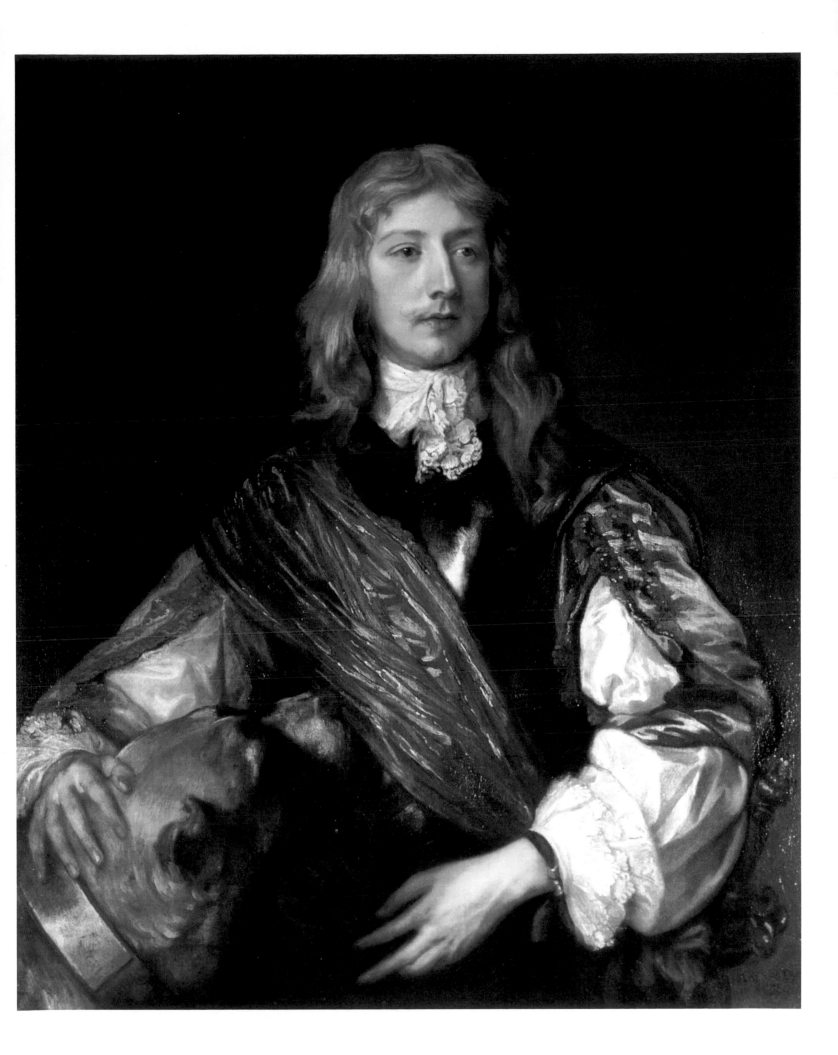

COLORPLATE 38

MADONNA AND CHILD WITH THE ABBÉ SCAGLIA

1634—35
Oil on oval canvas, 42 × 47½" (106.7 × 120 cm)
The National Gallery, London

One of the rare religious subjects Van Dyck carried out during his years at the English court, this picture was probably painted during his visit to the Spanish Netherlands during 1634—35. It was commissioned by Cesare Alessandro Scaglia (see figs. 70 and 71), an Italian who had a long career as a diplomat, known as 2X in secret documents. He had served the duke of Savoy, France, and Spain at different times, and was then living in Brussels acting on behalf of the Spanish prime minister, the Count-Duke of Olivares, and as an aide to Prince Thomas of Savoy-Carignon (see fig. 69). Scaglia had spent some time in Rome in 1622—23, in Turin in 1623, and in England during 1631—32 and was a connoisseur-collector, so he and Van Dyck may have had previous contact. In 1639, Scaglia retired to the Monastery of Recollets in Antwerp, where he died four years later.

Once again, Van Dyck consulted his Italian album before composing the picture. There he found a sketch of a (since lost) Titian of the Madonna and Child with a donor (folio 47) to suggest the specific composition of this painting, with the general concept of the devotional votive image. Traditionally this Madonna has been identified as a portrait of Henrietta Maria's sister Christina, the duchess of Savoy, the plump baby as a portrait of her eldest son, Francis Hyacinth, the heir to the duchy, and the mountains those of Savoy. But Scaglia had fallen out with the duke, and Van Dyck can have known the duchess and her child only through portraits. Therefore, appealing as the story may be, it is at best hypothetical, although the Madonna is surely regal enough to occupy a terrestrial as well as a heavenly throne. In any case, it is an attractive painting, with a handsome portrait of Scaglia as donor, pleased and honored to be in the divine presence, his devotion acknowledged by Christ's playful blessing, and with bright colors worthy of a heavenly or an earthly queen.

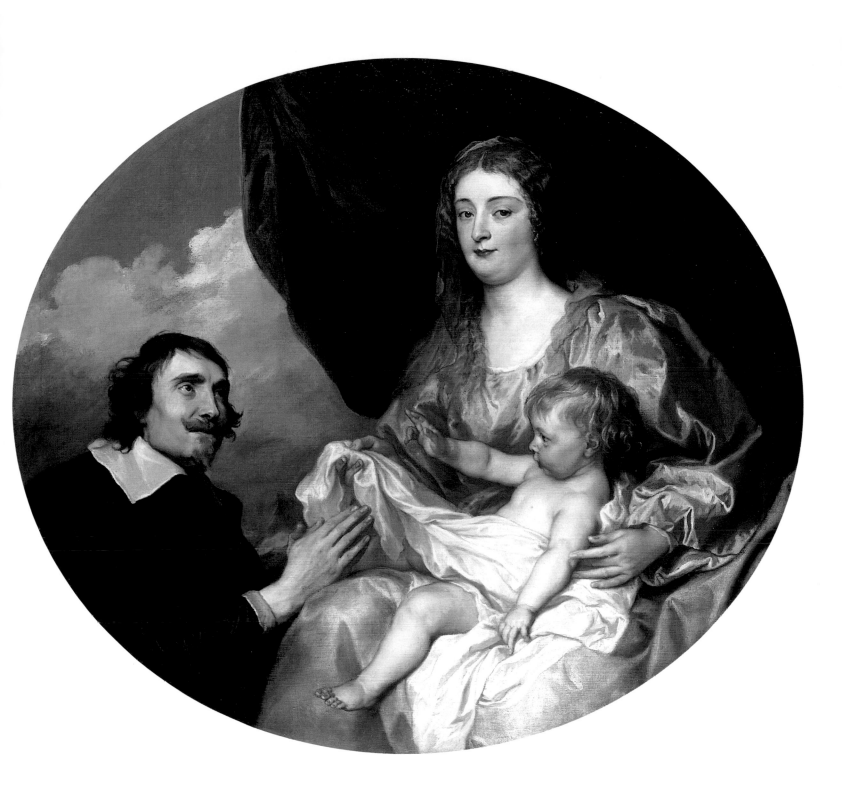

CUPID AND PSYCHE

1639–40
Oil on canvas, 78½ × 75½" (199.4 × 191.8 cm), with additions at the top,
3¾–4¼" (9.5–10.8 cm), and at the bottom, about 2¼" (5.7 cm)
Royal Collection, St. James's Palace

This magic picture is the culmination of Van Dyck's activity as a painter of fantasies. It shows how far he had evolved from such youthful Rubensian works as *The Drunken Silenus* (see plate 7) and anticipates the charming reveries of the Rococo. It may have been intended for Henrietta Maria's private sitting room—her "cabinet"—in the Queen's House at Greenwich, which was to be decorated with twenty-two paintings of Cupid and Psyche by Jordaens (whose massive ladies might have crushed Van Dyck's elegant little Cupid). But in Van der Doort's 1639 inventory of the royal collection, it is listed as unframed in the Long Gallery at Whitehall. A manifestation of the stylish Neoplatonism affected by dilettantes in the French court and brought to the English court by Henrietta Maria and her circle, the painting may have been inspired specifically by a masque by Shakerly Marmion performed in 1637 on the occasion of a visit of Prince Rupert (see plate 25) and his brother Prince Charles Louis, its theme the transcendence of the soul from transient sensual love (Psyche) to the divine (Cupid).

Van Dyck is supposed to have modeled Psyche on his mistress, Margaret Lemon (see fig. 80), perhaps identifying her, despite her notoriously evil temper, with Limone, mistress of the Latin author Aristaenetus, who described her face as "faire beyond nature" and her body as "fairer still." She is in fact the descendant of Titian's *Venus of Urbino,* but a little more abandoned in her sleep. Conceivably also Van Dyck modeled Cupid's body on his own; it is as small as the painter's but perfectly formed and proportioned, like an Apollo Belvedere brought to life. Whomever the models, they are as fine-boned and elegant as the Venus of *Venus at the Forge of Vulcan* (see fig. 48) and more closely resemble Watteau's children playing adult games than Rubens's stately Olympians come to earth. The fluency of the composition and the delicacy of Van Dyck's touch on the canvas seem echoes of the grace and lightness of Cupid's movement. The very thin summary *fattura,* particularly at the bottom of the canvas, may indicate that it was never carried to completion, which might also explain the heavy brown outlines of the lovers' limbs and backs, although they are so well integrated with the setting as to be hardly discernible. Unfinished as the misty background may be, it seems perfectly appropriate to the dreamy quality of the vision.

Sir Peter Lely, with his usual perspicacity acquired the painting during the Commonwealth, but returned it to the royal collection at the time of the Restoration.

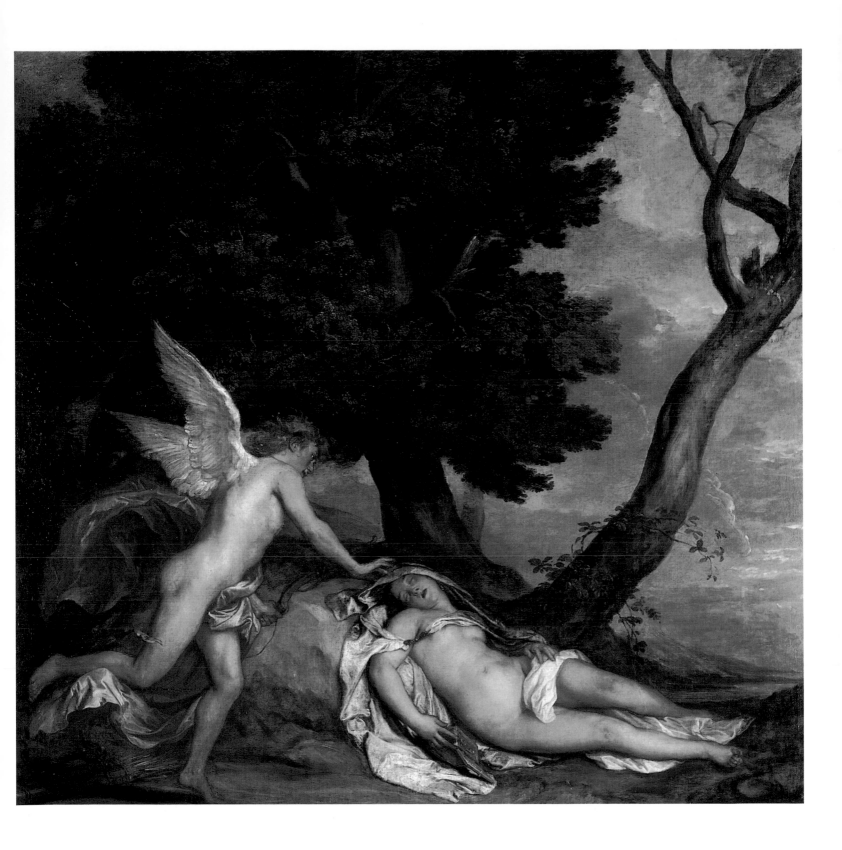

HILLY LANDSCAPE WITH TREES

c. 1635–40
Pen and brown ink and gray, blue, and green watercolor washes
on white paper, 8 ¹⁵/₁₆ × 13" (228 × 330 mm)
Devonshire Collection, Chatsworth.
Reproduced by permission of the Chatsworth Settlement Trustees

This watercolor was surely done in England and on the spot, spontaneously. It is one of several surviving studies of landscape by Van Dyck, most of the English countryside but a very few of the Italian (see fig. 27). While it is not impossible that, following the example of Rubens and some members of his circle, Van Dyck made similar sketches throughout his career, it seems more likely that the quality of the foreign scenery inspired him both to record its features and to give himself the pleasure of capturing them in watercolor. Perhaps also he had been infected by the English love of the land.

The frequency with which he inserted panels of landscape into the background of his portraits, often without any apparent relevance to the sitters, proves his interest in the natural environment. While he showed himself to be an observant amateur botanist and topographer, his primary response to the landscape was to its qualities of color, light and shadow, space, growth, and, particularly, atmosphere—and for the translation of these qualities into completely unpretentious works of art.

His attitude toward the landscape belongs to a northern European tradition quite different from the ideal, constructed landscape being developed contemporaneously in Italy. While there is no evidence that Van Dyck had any familiarity with Dürer's landscape studies of a century and more earlier, they are strikingly similar in their approach: freshly made in situ, apparently without ulterior purpose; deliberately unfinished and reflective of only certain aspects of the scene; the watercolor medium handled easily but controlled. Van Dyck, unlike Dürer, rarely depicted overwhelming natural phenomena, like the Alps. He favored instead this kind of tranquil countryside, with the tower on the ridge proving that it is inhabited and domesticated. Perhaps its simplicity and his solitude within it provided welcome relief from life at court.

This watercolor was not preparatory for any painting, as far as is known, but was made for the pleasure it gave its maker. He was very detached in transcribing what he saw and reserved in expressing his response, as if he were making a portrait of a pastoral rather than a human subject, allowing it to speak for itself.

The attribution on the back, "16 Landschappen van Van Dyck," was probably inscribed by the rich Dutch connoisseur and collector Nicolas Flinck (1646–1723), from whom the second duke of Devonshire bought many of the drawings in the Chatsworth collection.

BIBLIOGRAPHIC NOTES

The three hundred and fiftieth anniversary of Van Dyck's death was commemorated by two major exhibitions in 1991: of his paintings and oil sketches in the National Gallery of Art, Washington, D.C.; and of his drawings in the Morgan Library, New York, and the Kimbell Art Museum, Fort Worth, Texas. Both exhibitions were given permanent form in monumental catalogues: *Anthony van Dyck,* of the painted oeuvre, by Arthur Wheelock, Susan Barnes, and Julius Held, with essays on different aspects of his career by Wheelock, Barnes, Jeffrey Muller, Christopher Brown, Carol Christensen, Sir Oliver Millar, Zirka Zaremba Filipczak, and J. Douglas Stewart, published by Harry N. Abrams, New York, in 1990; and *Van Dyck Drawings,* of the drawings by Christopher Brown, published by Harry N. Abrams, New York, in 1991. Both catalogues are major contributions in English to the Van Dyck literature. A more modest exhibition, entitled "Van Dyck's Antwerp," was presented in Plantin-Moretus Museum and the Stedelijk Prentenkabinett of the city of Antwerp, with a catalogue in English, French, and Dutch by Alfred Moir, and focused on the *Iconography* and Van Dyck's contemporaries in Antwerp. It was published in 1991 by Museum Plantin-Moretus and Stedelijk Prentenkabinett van Antwerpen with the Pre-Press Group de Schutter, Antwerp.

These three catalogues represent the most recent Van Dyck scholarship. But they are not comprehensive monographs. For Van Dyck's complete painted oeuvre, one must turn to Eric Larsen's two publications, both in two volumes: the summary *L'opera completa di Van Dyck* (Milan, 1980) and the full-scale *The Paintings of Anthony Van Dyck* (Freren, Germany, 1988). Unfortunately, both of these publications are unreliable factually and can be used only with great care, and the more recent study was so expensive that it is not generally available. However, it is invaluable for the number of autograph paintings and copies catalogued and illustrated. *Van Dyck, des Meisters Gemälde* by Gustav Glück, vol. 13 of the Klassiker der Kunst series (Stuttgart-Berlin, 1931), remains useful, although many of the paintings have since been relocated.

The great majority of Van Dyck's drawings were included in the 1991 New York-Fort Worth exhibition, so Christopher Brown's catalogue is close to comprehensive; it also provides a bibliography of the drawings complete up to 1991. But for the entire oeuvre of the drawings, Horst Vey's two-volume *Die Zeichnungen Anton Van Dycks* (Brussels, 1962) remains indispensable, supplemented by Michael Jaffé's *Van Dyck's Antwerp Sketchbook,* 2 vols. (London, 1962), and by Gert Adriani's *Antoon Van Dyck Italienisches Skizzenbuch,* 2 vols. (Vienna, 1940–65).

The authoritative source for the *Iconography* remains Marie Mauquoy-Hendrickx's *L'Iconographie d'Antoine Van Dyck,* 2 vols. (Brussels, 1954), which includes not only a catalogue of all the prints but also detailed studies of their watermarks, the engravers, and the history of the series. It was published in a limited edition and is relatively inaccessible, but a new updated edition has recently appeared (Brussels, 1991). A recent summary is provided by Dieruwke De Hoop Schaeffer's catalogue of the exhibition "Antoon Van Dyck et son Iconographie" of 1981 in the Louvre.

The only accessible recent monograph on Van Dyck's career and oeuvre is by Christopher Brown (Oxford, 1982, and Ithaca, N.Y., 1983), which reportedly has a new edition in process. Invaluable, although less comprehensive in scope, are three recent exhibition catalogues: John Rupert Martin and Gail Feigenhaum's *Van Dyck as a Religious Artist* (The Art Museum, Princeton University, 1979); Alain McNairn's *The Young Van Dyck/Le jeune Van Dyck* (National Gallery of Canada, Ottawa, 1980); and Sir Oliver Millar's *Van Dyck in England* (National Portrait Gallery, London, 1982–83).

The numerous recent articles in periodicals concerning Van Dyck's life, career and oeuvre, and collections of his works are listed in the 1991 National Gallery of Art, Washington, D.C., and Morgan Library/Kimbell Art Museum catalogues, as are the major primary sources. To them should be added R. Malcolm Smuts's *Court Culture and the Origins of Royalist Tradition in Early Stuart England* (Philadelphia, 1987), and John Walter Stone's *English Travellers Abroad 1604–1677* (New York, 1968), from which the quotations of Overbury, Howell, and Carleton on pp. 7 and 9 were taken.

Michael Jaffé's reviews of, respectively, the 1991 National Gallery and Morgan Library/Kimbell Art Museum exhibitions, in *The Burlington Magazine* 133 (February 1991): 142–44 and (October 1991): 341–44, contribute new information and present some disagreement, notably with the attribution of *The Expulsion of Adam and Eve from the Garden of Eden* (see plate 6). The Abbé Scaglia's career has been clarified by an article by Arabella Cifari and Franco Moretti, "New Light on the Abbé Scaglia and Van Dyck," in *The Burlington Magazine* 134 (August 1992): 506–14. In addition to establishing many of the dates of Scaglia's life and diplomatic career, the authors have published his will, which has provided them means to elucidate his last years in Antwerp and to attempt to reconstitute his collection, which apparently included as many as eleven paintings by Van Dyck or his studio.

All quotations from Rubens's letters are from Ruth Magurn, *The Letters of Peter Paul Rubens* (Cambridge, Mass., 1955). The description of the Arundels on p. 118 is from David Howarth, *Lord Arundel and His Circle* (New Haven, 1985).